Giuseppe Castiglione

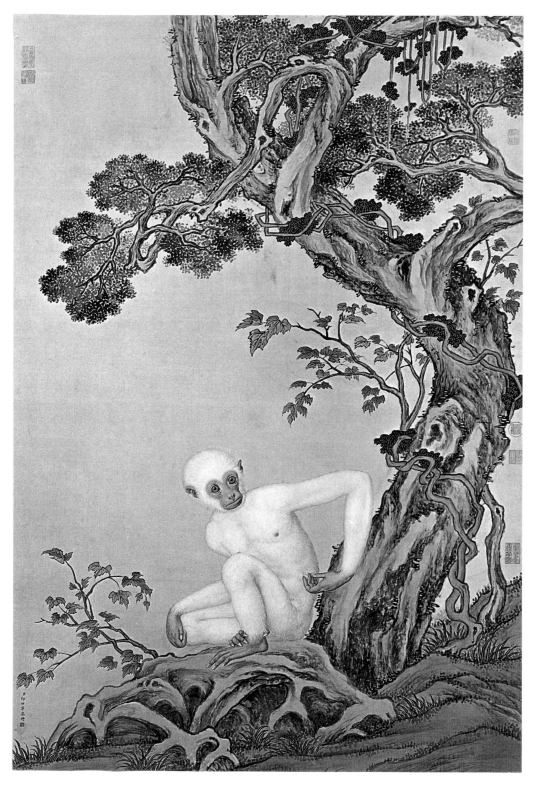

The White Monkey. Painting on silk.
1.69 × 0.99 m. Cat. 33. National Palace Museum,
Taipei, Taiwan.

GIUSEPPE CASTIGLIONE
A Jesuit Painter at the Court of the Chinese Emperors

BY CÉCILE AND MICHEL BEURDELEY

TRANSLATED BY MICHAEL BULLOCK

Charles E. Tuttle Company: Publishers
Rutland, Vermont and Tokyo, Japan

The publishers thank Professor Jerome Ch'en for checking
the English transcriptions of Chinese names.

Published by the Charles E. Tuttle Company, Inc.,
of Rutland, Vermont and Tokyo, Japan

Library of Congress Catalog Card Number 77-157257
International Standard Book Number 0-8048-0987-9

Printed and bound in Switzerland

Authors' Acknowledgments

We wish to express our particular gratitude for their assistance in the writing of this book to:

M. Chang-Fu-juei, Professor at the Sorbonne, who translated the Chinese texts and gave us his enthusiastic aid, as well as to Mlle Laurence Buffet-Challié, our loyal collaborator, and M. Lo Mei-sho.
Our warmest thanks also go to:
The Reverend Father Lamalle, Curator of the Archivum Romanum Societatis Iesu, Rome, who allowed us to study unpublished documents;
the Reverend Fathers Domingos Mauricio and Antonio Nogeira Gonçalves, in Portugal, and Joseph Dehergne, in Paris;
Mrs John Riddell and the Percival David Foundation of Chinese Art, London;
Mme Pirazzoli-t'Serstevens, Assistant Curator at the Musée Guimet;
Mrs Jean K. Cassill, Curator of the Oriental Department, Cleveland Museum of Art;

Dr Cheng Te-k'un, Professor at Cambridge University (England), who threw his collection open to us;
Dr Roger Goepper, Curator of the Museum für Ost-asiatische Kunst, Cologne;
Mr Basil Gray, former Curator at the British Museum;
Mr Ho Lien Kwei, Curator of the National Palace Museum, Taipei;
Mr Jean Lacerda, Curator of the Museum of Caramulo;
Mr Sherman E. Lee, Director of the Cleveland Museum of Art;
Mr Max Loehr, Professor at the University of Cambridge (Mass.);
Mr A. Ayres de Carvalho, Curator of the Ajuda National Palace, Lisbon.
To these must be added the collectors who gave us their kind assistance, and in particular:
Mrs Alice Boney, Tokyo;
Mr Edward Chow, Geneva;
M. Jean-Pierre Dubosc, Paris;
Mr Sammy Lee, Tokyo;
Mr Mottahedeh, New York.

Photographic Acknowledgments

The photographs reproduced in this volume come from the following sources:

Abilio Hipolito, Coïmbra: pp. 12, 91

Archives Nationales, Paris: p. 87

Archives Office du Livre, Fribourg: pp. 14, 15, 20, 24, 29, 36, 40, 114

Archivum Romanum Societatis Iesu, Rome: pp. 13, 22, 61, 153

Beurdeley, M. and C., Paris: pp. 21, 75, 93

Bibliothèque des Langues Orientales, Paris: p. 65

Bibliothèque Nationale, Paris: pp. 66, 67, 69–71, 80–83, 137, 145

Boney, Alice, Tokyo: p. 30

Cheng Te K'un, Cambridge: pp. 57, 133

Cleveland Museum of Art, Cleveland: pp. 41, 43, 98–101

Dubosc, J.-P., Paris: p. 42

Göteborg Museum: p. 84

Hinz, H., Basle: p. 49

L'Illustration, Paris: p. 72

Metropolitan Museum of Art, New York: p. 25

Musée Guimet, Paris: pp. 53, 85, 102 (right), 103, 104, 105

Musée National de Céramique, Sèvres: p. 47

Museu Nacional de Arte Antiga, Lisbon: p. 16

National Palace Museum, Taipei, Taiwan: pp. 2, 27, 34, 35, 37, 42, 51, 54, 55, 73, 107, 120–127, 129 (right) – 132, 134–136, 143, 144

Percival David Foundation of Chinese Art, London: pp. 31, 32, 96, 129 (left)

Riddell, J., London: p. 128

Routhier, Paris: pp. 17, 23, 33, 46, 60

Stanford University Museum of Art, Stanford, California: p. 151

Victoria and Albert Museum, London: p. 38

Yurin-kan Museum, Kyoto: pp. 58, 59

Contents

Foreword 5

The Life of Castiglione 11

The Voyage — The Position of the Christians in China — The Rites Controversy — From Macao to Peking — Arrival in Peking — Life at K'ang-hsi's Court — Castiglione's Predecessors — The Death of K'ang-hsi — The Emperor Yung-cheng — The Emperor Ch'ien-lung, Persecution of the Christians — Castiglione and the European Painters at the Court — At Jehol — Castiglione's Birthday — Castiglione's Death — The Break-up of the Society of Jesus

Castiglione the Architect: Yuan-ming-yuan 65

Castiglione and the Conquests of the Emperor of China 79

Castiglione and Religious Painting 91

The Portrait Painter 97

The Genre Painter 107

The Painter of Animals 119

The Painter of Flowers 126

The Painter of Landscapes 132

Castiglione and the Chinese Painters of his Day 141

Castiglione Seen by Chinese Critics 151

Castiglione's Correspondence 152

Extracts 154

Bibliographical Notes 156

Catalogue 161

Seal Inscriptions 192

Chronological Table 193

Biographical Notes of some European Persons referred to in the Text 194

Chinese Names of the Missionaries 198

Bibliography of Western Publications 199

Chinese and Japanese Bibliography 201

Index of Names 203

Foreword

In 1715, when Giuseppe Castiglione arrived in China, intellectual Europe was displaying great interest in Chinese culture. 'Men', says Thucydides, 'always have the greatest respect for that which is furthest away in space.' The enlightened despotism of the Emperor of China, the order that reigned in his empire, aroused the admiration of the greatest philosophers, such as Leibniz. Throughout the eighteenth century the writings of the missionaries were the subject of vehement controversy, and everyone pictured to himself a China that was idyllic or wretched according to his prejudices or the needs of his cause.

The work accomplished in China by the Jesuits is striking in its scope and diversity. At the end of this book are listed a number of works on mathematics, physics, geography, history, music, perspective and, naturally, the numerous books on religion published by these indefatigable and patient men of science in Chinese or Manchu, not to mention the translations of Chinese classics which they sent to Europe.

It must be admitted, however, that these works enjoyed only poor success in China. Thus the *Treatise on Anatomy*, written in 1698 by Father Parennin on orders from the Emperor and for his use, is not mentioned in any Imperial scientific encyclopaedia. K'ang-hsi considered this book far too 'strange' to be put in the hands of everyone. Whereas in Europe at the beginning of the eighteenth century all established facts—whether in history, astronomy or religion – were being questioned, China was dominated by a nostalgic veneration for the past. Instead of regarding the new knowledge introduced by the foreigners as a stimulant conducive to a fresh flowering, instead of bending tradition in the direction of the future, acquiring new techniques and making a contribution to the new age, the Chinese *literati* – deeply traumatized by the wars of the preceding century, which had brought the fall of the Ming and placed a foreign dynasty on the throne – turned in upon themselves in an effort to preserve their way of life and thought.

At the beginning of the eighteenth century there was no gulf between China and the West. The technical advances of the Europeans were recent and their scientific knowledge so limited as to be within the grasp of any human brain. If the Emperor of China regarded the pneumatic machine presented to him by Father Benoist as falling within the category of scientific toys, in Europe of the same period the Leyden jar served above all as an innocent plaything: fairground showmen took it from fair to fair, while blond marquises electrified

their parrots and gallants invented the electrifying kiss. The first multiplying machine, conceived by the great Leibniz in 1671, was not produced until 1820, and there were numerous similar cases.

On contact with the Europeans and with their assistance, the Chinese could quickly have mastered the new techniques and, even more important, have allowed their thinking to be permeated by the ideas that had given rise to these new techniques, thereby becoming capable of confronting the new problems that faced them. But the Chinese sovereigns embarked on this path only timidly, so that by the end of the century China was a hundred years behind Europe. K'ang-hsi, Ch'ien-lung and Yung-cheng adopted towards the Europeans a 'half-open-door' policy, which they considered prudent and conservative, whereas in fact it was timorous and condemned the country to a sclerosis which, in the event, endangered not merely national sovereignty but Chinese culture itself. It is perfectly true, of course, that the annexationist policy pursued by the French and British in India, through Dupleix and Robert Clive, was bound to increase Chinese distrust.

The first Manchu emperors were men of open and lively mind, but they had to battle with the xenophobia, and above all the vanity, of the high officials, who were humiliated at learning from foreigners. If in Europe a scientist felt no shame at manufacturing clocks and chronometers with his own hand, the Chinese considered this manual labour unworthy of a man of letters and reserved it for the 'lower orders'. Such an attitude was scarcely favourable to technical and scientific progress.

Conscious of the hostility of the Chinese, the Jesuits sought to spread their faith but not to impose their culture, which, in their eyes, would have been contrary to the evangelical spirit. The young missionaries who embarked for Peking knew that they would be considered subjects of the Emperor of China and would never again return to Europe. Therefore they forced themselves to adapt to the customs of the country. They hoped that their knowledge and their talents would guarantee them an audience and attract to the missions the Emperor's benevolence. Despite persecutions and the great effort demanded by the study not merely of Chinese but also of Manchu, this handful of men succeeded in establishing relations with the local notables on a plane of mutual esteem untarnished by monetary considerations.

An Italian Jesuit, such as Castiglione, who adopted Chinese pictorial techniques while preserving his religious convictions; an artist as renowned as Wu Li who became a Catholic priest while continuing to express himself in the traditional plastic language of his country; a 'Collegium Orientale Theologicum' at Halle; an institute for Chinese at Naples; a school for Chinese diplomats in Peking directed by a European, Father Gaubil; Jesuit scientists on the Peking Tribunal of Mathematics: such were the relations between Chinese and Europeans that were established thanks to the patience and good will of the Jesuits.

In 1774 the dissolution of the Sociey of Jesus threw everything into question in Peking. Sir John Barrow, the British geographer and secretary to Lord Macartney during the latter's diplomatic mission to Peking in 1793, was struck by the ignorance of the missionaries who had succeeded the Jesuits on the Peking Tribunal of Mathematics. France, then in the midst of revolution,

had lost interest in the Far East and the missions. Aware of China's weakness and encouraged by their respective governments, European merchants and navigators saw exchanges between themselves and the Chinese exclusively in terms of commercial profits. The 'Philadelphic Society' envisaged by Leibniz, in which scholars of the entire world, including the Far East, were fraternally to exchange 'the light of knowledge', was far from realization.

Of all the Jesuits gathered in China, Castiglione was incontestably the most gifted. His exceptional talents won him the favour of Ch'ien-lung. The commands of the Emperor left him no respite. Apart from a few paintings executed for the Christian communities of Peking, the major part of his work went to enrich the collections of the Imperial Palaces.

What happened to these collections during the political upheavals that have marked the history of China since the beginning of the twentieth century? In 1912, after the proclamation of the Republic, the Chinese government gathered together in one of the pavilions of the Forbidden City the treasures that had escaped the sacking and burning of the palaces of Yuan-ming-yuan and Jehol. In 1925 this pavilion, transformed into a museum, was opened to the public. An inventory drawn up between 1929 and 1932 makes it clear that a number of objects of art and paintings had been stolen.

In his memoirs the ex-emperor Pu Yi relates that in 1922, when he was sixteen, he had the eunuchs show him one of the rooms in which the Emperor Chia-ch'ing had piously stored the collections of his father Ch'ien-lung. He noticed, among other things, a large number of red teak chests which he ordered to be opened. They contained, carefully arranged, paintings by Castiglione. Pu Yi subsequently learned that the antique shops of Peking, whether they belonged to merchants related to officials of the administration or to eunuchs, were bursting with objects – bronzes, porcelains, paintings – that had originated from the rooms of the Forbidden City.

By attempting to put an end to this pillage Pu Yi aroused the rage of the officials. In 1923 criminal arson destroyed one of the pavilions housing the treasures of Ch'ien-lung. The administration estimated the number of paintings destroyed at more than one thousand one hundred and fifty-seven. With the complicity of his younger brother, Pu Yi, who hoped one day to leave the Forbidden City, succeeded in transferring about a thousand scrolls – among the best – to a house in the British Concession at Tientsin. This collection followed him to Mukden, where the Japanese had appointed him chief executive of the State of Manchukuo. But it disappeared in 1942 during the shattering defeat of the Japanese by the Communist forces.

During this Sino-Japanese War some five thousand crates containing pieces from the Peking Imperial Collections were deposited in Nanking. In 1948 they were transported to Formosa, where they arrived intact. Today the majority of Castiglione's works are to be found in the National Palace Museum of Taiwan, built especially to house these collections.

C. and M. Beurdeley

The Life of Castiglione

Giuseppe (or Joseph) Castiglione was born in Milan on 19 July 1688. Certain writers, such as the Abbé Groslier and Monseigneur Favier, put the date at 1698, but the epitaph engraved on the tombstone rediscovered at the beginning of the century by the Lazarist brother Ducarme bears the date 1688.[1] Of his family and his birth we know almost nothing. In 1707, at the age of nineteen, he entered the Society of Jesus at Genoa to go through his noviciate. His religious obligations, restrictive though they were, in no way prevented him from exercising his talents as a painter and very soon works were entrusted to him. For the chapel of the novices in Genoa he painted two pictures illustrating the life of St Ignatius. One represents *St Ignatius in the Cave of Manresa*, the other *Christ Appearing to St Ignatius*. These two paintings were listed in a guide to the town of Genoa written by Carlo Giuseppe Ratti in 1780 and that is how they came to be found by George Loehr in 1961.

The young novice had not entered Holy Orders so that he could paint, however, nor to lead a monastic life exclusively devoted to an inward spirituality. For at least a century the Jesuits had been sending missionaries to China, often the most eminent of their number, in order to spread the Christian faith. Young Castiglione asked permission to be among them, as soon as opportunity offered. As a matter of fact, this was scarcely an easy undertaking. At this period Portugal was claiming

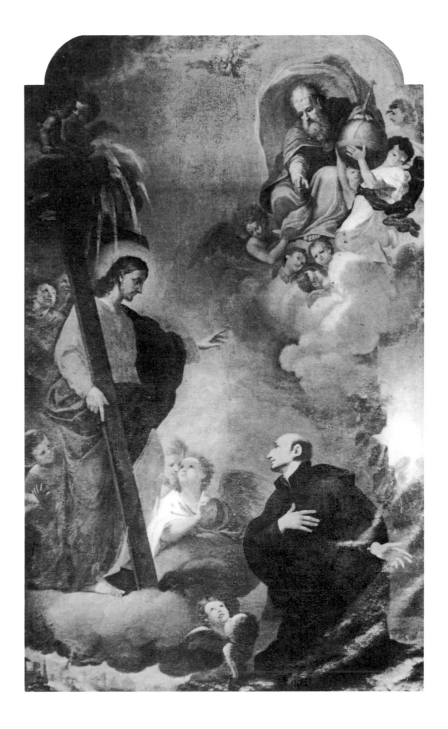

Christ Appearing to St Ignatius. Oil painting which was in the chapel of the novices in Genoa. Cat. 110.

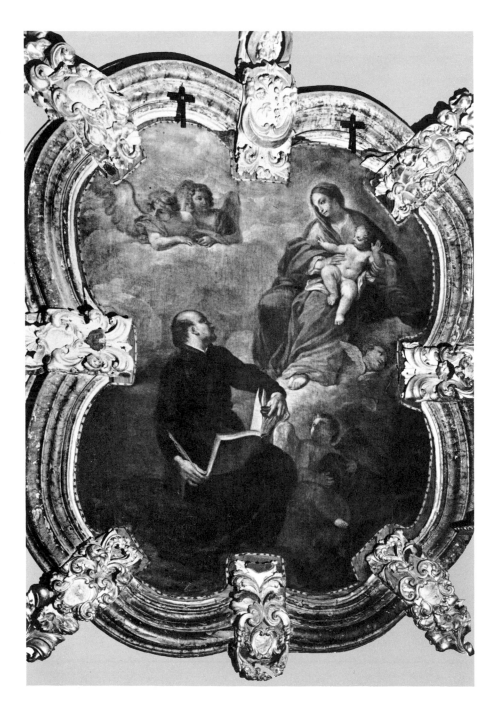

for itself sole patronage over all missions despatched to India or China, whatever their origin. Every bishop had to be presented by the Portuguese government, every missionary had to sail on a Portuguese ship.

This priority derived from the fact that the Portuguese were the first Europeans to land in China. Led by Fernão Perez de Andrade, they had opened a trading centre in Macao in 1517. The Chinese then called upon their assistance in ridding the seas of the pirates who swarmed around the coasts. In recompense, they were accorded in 1667 the right to establish a trading centre in Canton – a valuable privilege which the Portuguese took care to preserve. This all-powerful position compelled Castiglione to go first to Portugal to complete his noviciate. He was accepted by the famous Jesuit monastery at Coïmbra, where he was to remain for two years. No doubt there too he had an opportunity to employ his talents. Thanks to a letter from Castiglione and a manuscript in the National Library, Lisbon, we have some details on young Castiglione's artistic works in Portugal, where he is said to have painted some portraits of young princes and murals for the chapel of the College of Coïmbra.[2] On 11 April 1714 he embarked in the company of Brother Costa on the vessel *Notre-Dame-de l'Espérance* bound for Goa, which he reached on 17 September of the same year.

St Ignatius writing the 'Spiritual Exercises'. Oil painting. Cat. 111. Former chapel of the hospital of the University of Coïmbra, Portugal.

The Voyage

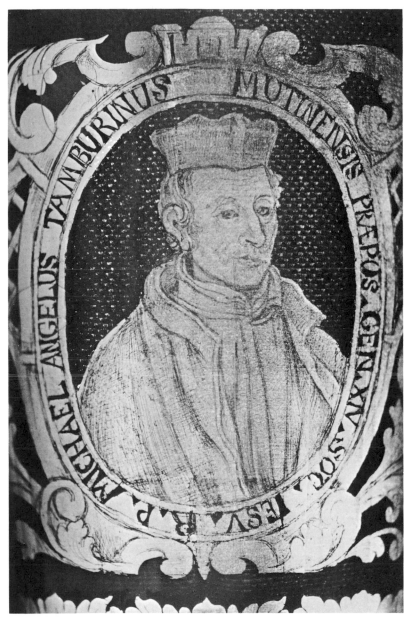

Portrait of Michele Tamburini, General of the Jesuits. Painting in gold on Bohemian glass. 18th century. Archivum Romanum Societatis Iesu, Rome.

At the beginning of the eighteenth century the voyage to China was a real adventure. To judge by various accounts of the period, missionaries accepted the risks of this long odyssey with enthusiasm.

The first port of call was Madeira, where the Portuguese had a post and where the natives were very favourably disposed towards the missionaries; the second was at Cape Verde on the little island of Gorée, which Marshal d'Estrées took from the Dutch on 1 November 1617. There was no question then of evangelizing the Blacks. Nevertheless, more than one Jesuit expressed surprise that no mission had been established on these shores. 'These unfortunates do not cease to believe that their country is Paradise on earth... But for the fear of blows with sticks which the Europeans by no means spare them, they would not change places with any one whatever. There are some of these peoples who believe that white is the colour of Devils and count it among the privileges of their nation to be the blackest Peoples in Africa.'[3]

The route then followed the shores of Africa – of Gambia and Senegal – that were haunted by corsairs. At the least sign of danger the batteries had to be prepared and the crew had to arm themselves with axes, cutlasses and pistols in preparation against a possible attempt to board. Some encounters, in fact less dangerous, were nevertheless terrifying. It could happen that the vessel sailing 'with the speed of an arrow' collided during the night with an enormous whale whose length was more than half that of the ship itself.[4] While the monster spurted jets of salt water into the passengers' faces the monks reassured themselves by repeating the fine words of the three children

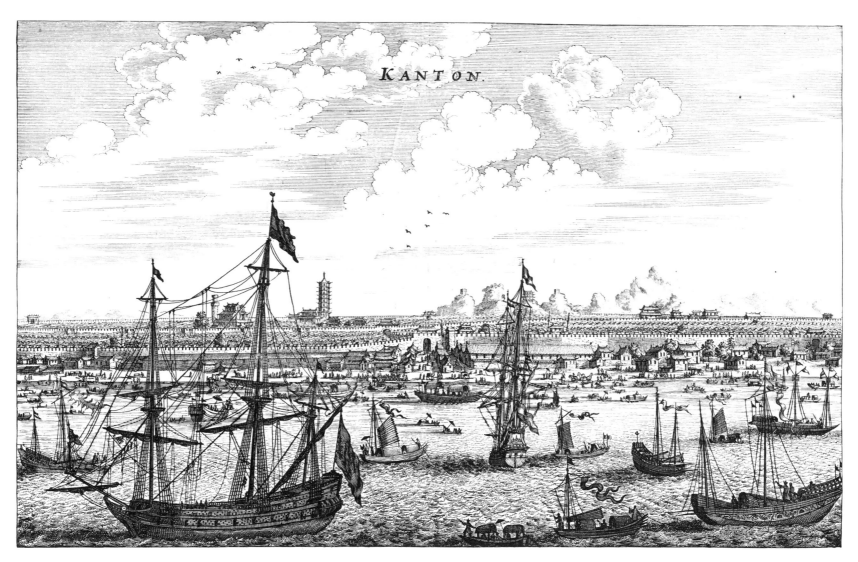

KANTON.

Canton. Etching from *L'Ambassade de la Compagnie orientale des Provinces Unies*. Collection M. Beurdeley, Paris.

of Israel cast into the fiery furnace of Babylon: *benedicite, cete*, etc. Despite these vicissitudes, however, the voyage was not without its pleasures, and when the weather was fine and the wind was not blowing the trip resem-

bled a cruise; the desire to bathe was strong, but the travellers dared not do so for fear of the sharks, 'which are so hungry for human flesh'. Nevertheless they were caught, and so were flying fish: 'We caught birds

with fishing lines'.[4] Porpoise hunting was no less appealing. These creatures were harpooned as they leaped up out of the water.

In fine weather the ship travelled eighty to a hundred leagues a day. But when the terrible winds that infest the China seas blew up, crew and missionaries joined

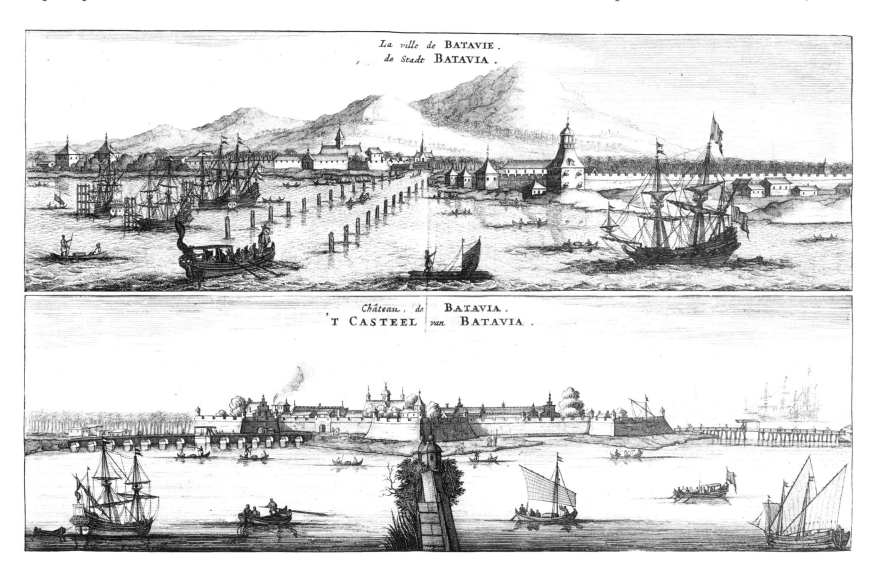

Town and castle of Batavia. Etching from *L'Ambassade de la Compagnie orientale des Provinces Unies.* Collection M. Beurdeley, Paris.

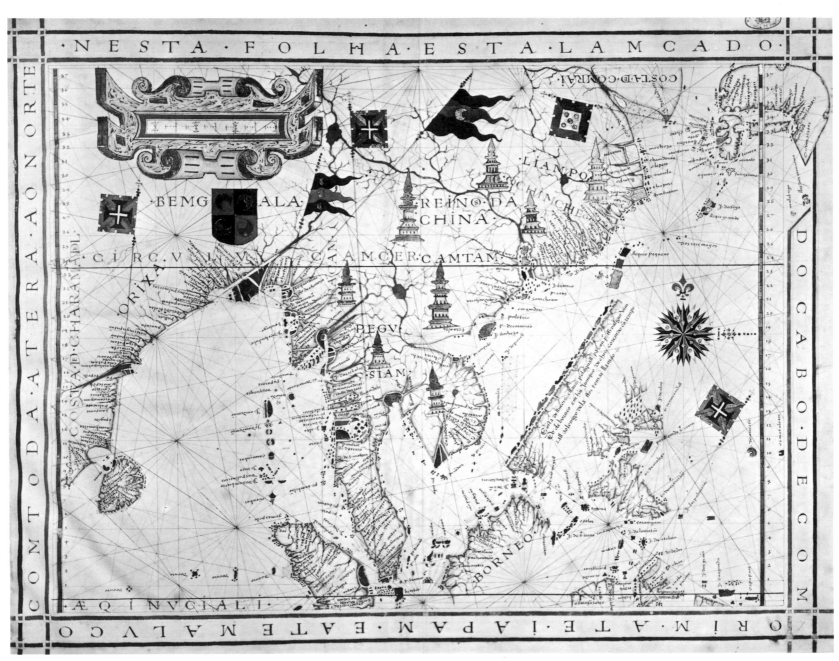

16 Portulan of South-East Asia. Museu Nacional de Arte Antiga, Lisbon.

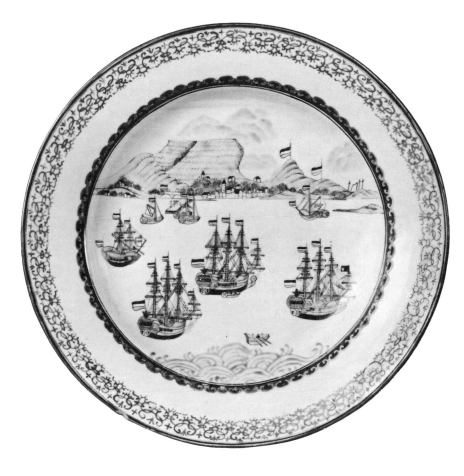

Plate in 18th-century Chinese porcelain depicting Dutch ships lying at anchor in Table Bay (Capetown). Rijksmuseum, Amsterdam.

a spectacle,' writes Father de Tartre. 'Injured sailors crying for mercy and begging for something with which to free themselves from the halyards and sails in which they were enveloped; the whole bow of the vessel devoid of its anchors and tackle... We picked ten sailors out of the sea half dead; two were drowned. The stays of the broken masts were quickly cut and all efforts were directed towards steadying the mainmast, whose chief supports were gone.' [4]

But the mainmast fell in its turn, the poop deck was carried away by the wind, the mainsail was ripped to shreds and so was the mizzen-sail... In this chaos the missionaries were busy giving fresh courage to those prostrated by the fear of imminent death. 'They heard confessions, implored the aid of Heaven, exhorted everyone to receive from the hand of God life or death, as He thought fit.' [4]

Through these first-hand accounts we vividly relive the dramatic adventures encountered on these voyages, the courage of men battling with the tempest and the zeal of the missionaries even in the midst of the most frightful chaos. The latter never forgot that their aim was the propagation of the faith. 'The fear of death', writes de Tartre, 'rendered two of our sailors, one of them a Swede, the other Dutch, more willing to listen to our instruction and later to abjure Lutheranism. The calm was scarcely less fearful than the storm. Currents could then cast you ashore with impunity – and heaven knows what awaited you there! The lack of motion discouraged the crew and made them ill.' [4]

Scurvy often ravaged the ship's company on these long voyages: swollen legs and gums in ribbons. Only one cure was known: to bury oneself alive in the sand.

forces to avoid shipwreck and death. In a few minutes the gallant vessel, shaken by a violent tempest, was nothing but a tangle of masts, rigging and ropes. 'What

An apparently simple remedy, but almost impossible for the mariners to put into practice... They did not always dare to put the sick ashore on these unknown coasts inhabited by tigers... And there was also the risk of seeing a ship flying the Dutch flag heave into sight from behind a headland of the island, whereupon the sick would re-embark with all possible speed, almost before they were installed in the sand. The Dutch, who had established themselves in Java, kept the whole country respectful and the fear they inspired prevented the Malays from giving any food whatever even to a starving crew. Other voyagers admired from a distance this island covered by mountains 'as high as the Vosges' and by an infinitude of trees that were always green and grew right down to the seashore. A vision of Paradise for these men who had been shut up in a vessel for several months. What could be more miserable than to see nothing for months on end but a ship and the ocean?

Soon the ship approached the shores of China, through a labyrinth of small islets of which the most dear to the eyes of Christians was Sancian (now St John or Shang-ch'uan), where St Francis Xavier died on 2 December 1552. The sailors of the *Amphitrite*, on the French ship's second voyage to China, had thought themselves about to perish off the island. Having escaped the storm by a miracle, they vowed to build on St Francis Xavier's tomb a chapel which other missionaries did not fail to visit in passing. At the beginning of the eighteenth century the only people on Sancian were poor natives who lived by fishing and a little rice which they grew for food.

The arrival of a ship in this wild place was always an event. After saluting the tomb with five cannon shots, the crew thundered a rousing Te Deum. The missionaries went ashore to celebrate Mass in the little plaster chapel, the interior of which sparkled with red and blue glaze in the Chinese manner. [4]

Father Matteo Ricci and his disciple Li Paulus. After a painting in the Zikawei Observatory.

The Position of the Christians in China

Giuseppe Castiglione arrived in Macao in July 1715 – the fifty-fourth year of the reign of K'ang-hsi (1662–1722), second emperor of the Ch'ing dynasty. The Christians established in China had barely emerged from a difficult period. The persecutions had started at the beginning of K'ang-hsi's reign. Since the Emperor was too young to govern, power had been in the hands of regents, who were very jealous of the privileges won by the Jesuits under Shun-chih, the late emperor. A number of them occupied important positions, like Father Adam Schall, a German Jesuit who had become

one of the highest dignitaries in the Empire. Thanks to his scientific knowledge and his work on the official Calendar he had been appointed director of the Peking Astronomical Office. As soon as Shun-chih was dead Father Schall was accused of the blackest crimes, imprisoned and condemned to be strangled. An earthquake that shook the city of Peking led to a stay of execution. The cataclysm was seen as an expression of Heaven's disapproval and the Jesuit was allowed to return to his home, where he died soon afterwards. [5]

Persecution none the less continued to be rife throughout the Empire. Only four missionaries remained in Peking, the others having been expelled or imprisoned. When K'ang-hsi attained his fifteenth year his first Imperial act – after ridding himself of the regents – was to protect the foreign monks, whom he admired for their competence in various fields, notably that of the exact sciences. He requested Father Ferdinand Verbiest to teach him the rudiments of science. He also instructed the latter to cast three hundred and twenty pieces of artillery, which the Father naturally did with reluctance. But to get his own back, he gave each cannon the name of a saint, after sprinkling them with holy water. Verbiest took advantage of his position to obtain an edict annulling the decree of persecution promulgated in March 1671 by the regents. Henceforth, missionaries were allowed to live in China in comparative peace, but the Chinese were not allowed to adopt their religion. In 1685 a decree opened the trade ports. In 1692, yielding to pressure from various sources, K'ang-hsi authorized missionaries to exercise their ministry. in 1700 China had nearly 300,000 Christians, and churches in Macao, Canton and Peking.

Fathers Matteo Ricci, Adam Schall, Ferdinand Verbiest, Paul siu Calao and his daughter. Etching from *Description de la Chine* by Father du Halde. Paris 1735. Bibliothèque Nationale, Paris.

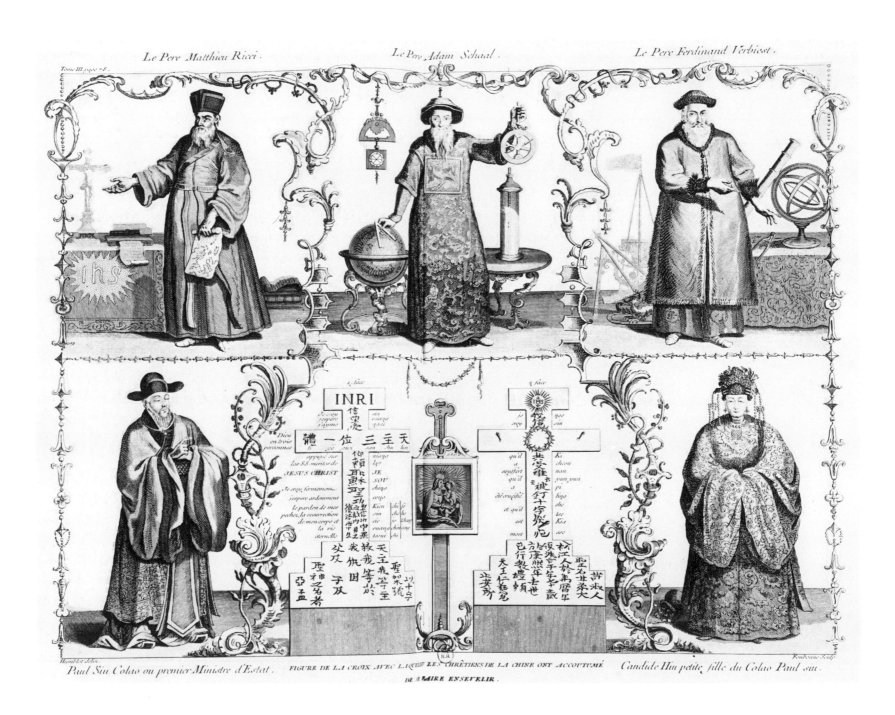

The Rites Controversy

This pleasing situation was soon to be spoiled by the Rites Controversy. Up to now, the Jesuits of Peking, in order to facilitate the introduction of Christianity, had regarded the Chinese rites, and especially ancestor worship and the cult of Confucius, as reconcilable with Christian morality. The missionaries of the other Orders, on the contrary, saw in these ceremonies only superstition and idolatry. The Papacy, confronted by these contradictory points of view, hesitated to pronounce itself. To resolve the problem, Rome sent out Cardinal de Tournon, who landed at Canton in 1705. The legate, a man of integrity but intransigent, decided to promulgate Clement XI's decree condemning the

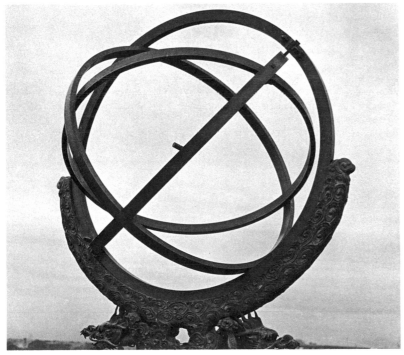

Armillary sphere from the Peking Observatory, made by the Jesuits during the Ming era.

Chinese rites. All those who did not respect this decree were to suffer excommunication. The indignant K'anghsi saw in this decision an interference by the Papacy in the affairs of China. He ordered the Portuguese who had the concession for the city of Macao to arrest the unfortunate legate and imprison him. He survived his sufferings for three years and died in 1710. The same year, the sovereign pontiff issued a decree approving Cardinal de Tournon's conduct. In 1715, the year of Castiglione's arrival, he published a solemn constitution rejecting all appeal in favour of the Chinese rites and compelling missionaries to a strict observance of the decisions of the Holy See. In Macao there was a particularly tense situation, on the one hand between Chinese functionaries and missionaries, and on the other between the Portuguese monks and those of other Western countries. The Bishop of Macao was appointed by the King of Portugal, who, as we have seen, had the right of patronage over all the missions of India and China. To combat this abuse of power, the Pope created 'Apostolic Vicariates of the Sacred Congregation of Propaganda' under the exclusive domination of Rome. In this way French missionaries, encouraged first by Colbert and then by Ponchartrain, were able to go to Peking, where their knowledge and their artistic talents were very much appreciated. (First and second voyages of the *Amphitrite* in 1698 and 1701.)

The Portuguese, who looked askance at these French Jesuits occupying important positions at Court, welcomed Castiglione with open arms. Although an Italian, he was part of the Portuguese mission; moreover, despite his youth, he was a painter of acknowledged talent.

From Macao to Peking

On his arrival in China, Castiglione had to learn to live according to the customs of the country, to get used to the food and to dress like a Chinese. The founder of the missions in China, Father Matteo Ricci (1552–1610), had been the first to realize that in order to enlarge his audience, and above all to be received by the high officials, it was advisable to present himself not as a humble missionary who had made the vow of poverty, but as an ambassador of Western science. Dressed in the Chinese manner in a long silk robe and wearing on his head a small bonnet 'in the shape of a truncated cone', with a little fan in his hand, Ricci went about in a sedan chair with parasols and servants. [6] The Jesuits, under the reign of K'ang-hsi, adopted the same behaviour. Their names also had to be sinified, since the Chinese were incapable of pronouncing the European names. Castiglione became Lang Shih-ning – Lang Calm Life. The young novice also had to learn the essential rules of Chinese politeness and some rudiments of the language. Nevertheless, his stay in Macao was of short duration. In August he found himself in Canton, in the company of another Italian Jesuit, Father Costa, a physician and likewise a new-comer to China. [7]

Canton made a vivid impression on the European travellers:

'It is not a city, it is a world, and a world in which all sorts of nations are to be seen. It has a splendid situation. It is watered by a large river which, through its canals, flows into various provinces. The city is said to be larger than Paris. The houses are not magnificent on the outside: the most imposing building is the church built by Father Turcotti, a Jesuit.' [8]

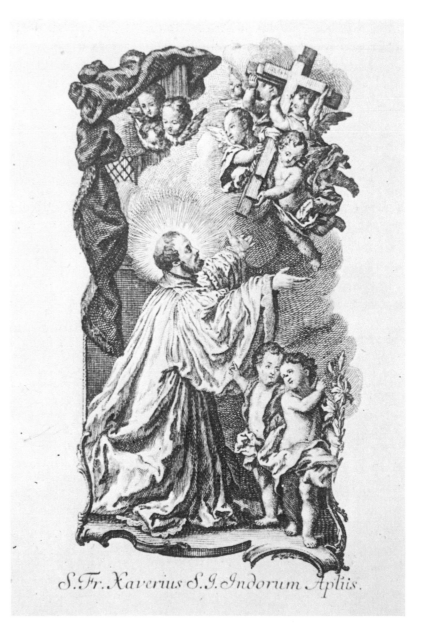

S. Fr. Xaverius S. G. indorum aptiis. Etching by Klauber after a work by Castiglione made in Peking. Cat. 120. Archivum Romanum Societatis Iesu, Rome.

In Canton an official took charge of the missionaries and accompanied them to Peking, the last stage of their odyssey. He made them travel short distances each day because, he said: 'You are foreigners; you do not know our customs; by order of the Emperor I am in charge of your precious persons. It is very hot and I must take care not to expose you to falling ill. Moreover, only base men can travel hurriedly.' [9]

'We had to be content with these arguments', relates Father Amiot, 'and make up our minds patiently to swallow all the boredom of the most irksome journey there can be in the world, for do not believe, I beg you, that one travels here as one does elsewhere. Shut up in a litter as though in a box, it is barely permissible, in order to breathe, to half open the little windows on each side. After arriving at the inns to take food and rest, it would be a monstrous indecency to go out and feast one's eyes on whatever curious sights there might be in the town or village. On a journey of five hundred leagues in one of the most beautiful countries in the world, there is not enough to keep the traveller entertained for more than a quarter of an hour.' [9] Father Attiret and other Jesuits also complained of the monotony and discomfort of this journey. [10]

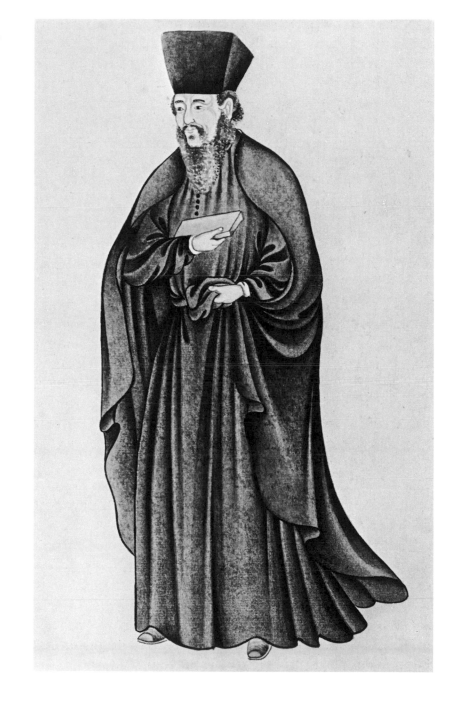

Missionary. Gouache from an album signed Lang Shih-ning, but probably executed by one of his pupils. Collection Mottahedeh, New York.

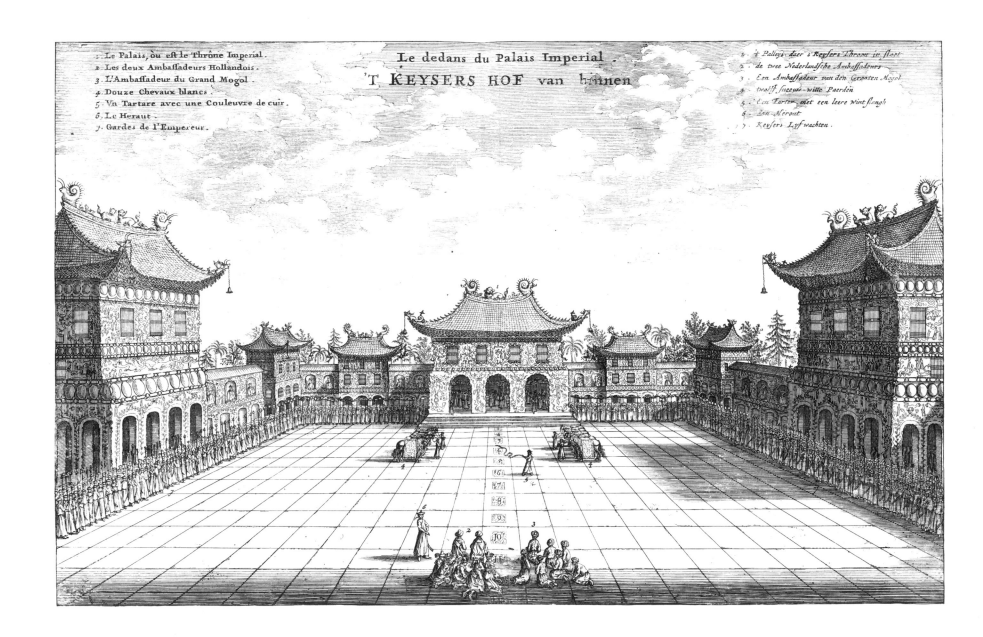

24 *Inside the Imperial Palace*. Etching from *L'Ambassade de la Compagnie orientale des Provinces Unies*. Collection M. Beurdeley, Paris.

Arrival in Peking

It was customary for the missionaries already established in Peking to go ahead of the travellers to encourage them. They led Brother Castiglione to the Portuguese mission of Tung-t'ang, close to the Eastern Gate of Peking. Tung-t'ang, also called the St Joseph Mission, was the former residence of Father Adam Schall. The monks were comfortably housed there. 'Our houses are clean and comfortable without there being anything contrary to what is proper to our estate. Our food is quite good; except for the wine, we have here everything that is to be found in Europe.' [11]

In November 1715 Castiglione was presented to the Emperor K'ang-hsi, under the aegis of Father Matteo Ripa. This Jesuit, of Neapolitan origin, a painter and engraver, had arrived in China in 1710. His knowledge of Chinese enabled him to act as interpreter when opportunity offered. In his memoirs, Matteo Ripa gives the following account of the presentation of Castiglione and Father Costa to the Emperor:

'In November, 1715, I was summoned into the presence of the Emperor, to act as interpreter to two Europeans, a painter and a chemist, who had just arrived. While we were awaiting his Majesty's pleasure in one of the anterooms, a eunuch addressed my companions in Chinese, and was angry because they returned no answer. I immediately told him the cause of their silence, upon which he said, that we Europeans were all so alike that it was scarcely possible to distinguish one from another. I had often heard the same remark from other persons, our resemblance being generally

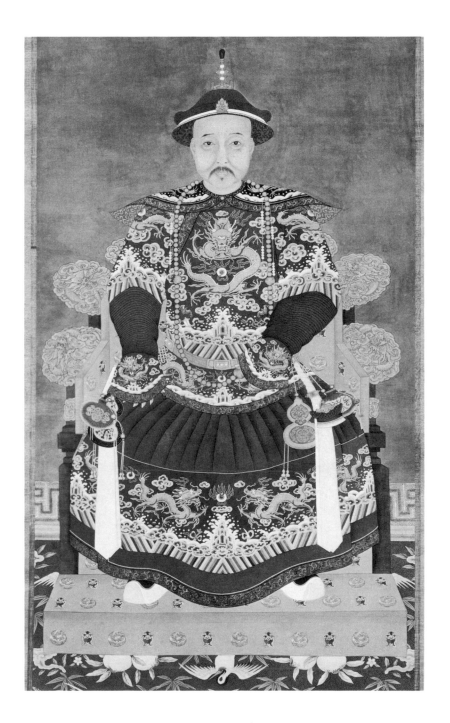

The Emperor K'ang-hsi. Painting on silk by a Chinese artist. Metropolitan Museum of Art, New York.

25

attributed to the long beards we all wore. The Chinese do not shave; but their beards are so thin that the hairs might be counted: the few they have, however, they value even to ridicule.' [12]

Etiquette was strict. In the presence of the sovereign, every gesture, every attitude was regulated with minute care. 'And there we stood a few moments, with closed feet and arms hanging down. Then, at a signal given by the master of ceremonies, we bent our knees;... at another signal we inclined slowly our heads till we touched the ground with the forehead; and this was repeated a second and a third time. After these three prostrations we arose to our feet, and we again repeated them in the same manner, till they amounted to nine.... Subsequently, when we went into the presence of the Emperor, which was a frequent occurrence, we only knelt once.' [12a]

The Emperor, writes Father Ripa, nevertheless proved very affable. He spoke slowly, patiently repeating the words to make sure he was fully understood, and never failed to compliment the Father on his progress in Chinese.

Custom required the missionaries, on being presented to the Emperor, to offer him gifts of European origin. Father Ricci, for example, had presented the Emperor Shun-chih with a Bible, a statuette of Christ, a watch and a pendulum clock. The Emperor was so delighted with these objects that he sent them to be shown to his mother, but he gave orders that the clock was not to be wound up for fear she might wish to keep it.

Unfortunately, Father Ripa does not mention the gifts presented by Castiglione and Father Costa, but we may assume that they included some of the enamel objects which K'ang-hsi prized so highly.

At the time of Castiglione's arrival K'ang-hsi, son of Shun-chih, was sixty-one. Remarkable for his noble bearing, his intelligence and his love of the arts and sciences, he displayed a sincere esteem for the Jesuits and appreciated at their true worth the services they rendered him. 'The men of the West', he said, 'have put the calculation of the Calendar in good order; in time of war they repaired the ancient cannons and manufactured new ones; thus they exerted themselves for the good of the Empire and took great pains.' [13]

With regard to the Christian religion he showed greater reserve. At the time of the Rites Controversy the monks had addressed to him a petition soliciting his protection – a clumsy step that aroused his indignation. How dared the foreigners discuss the 'doctrines of the Chinese' without knowing their language? Furthermore, he wrote with astonishment: 'Is it possible that you are always concerned about a world you have not yet entered and count for almost nothing the one in which you are now living? Believe me, everything in its own time.' [14]

K'ang-hsi appreciated not only poetry and painting, but also music. The Jesuits introduced to him certain European instruments, among them the trumpet marine. Of all the Jesuits living at Court, Father Tomás Pereira, promoted to the rank of 'First Master of Music', was the one whom the Emperor saw most frequently.

Four Steeds of Ai-wu-han. Painting on paper (detail). 'Moon Horse'. 0.40 × 2.97 m. Cat. 27. National Palace Museum, Taipei, Taiwan.

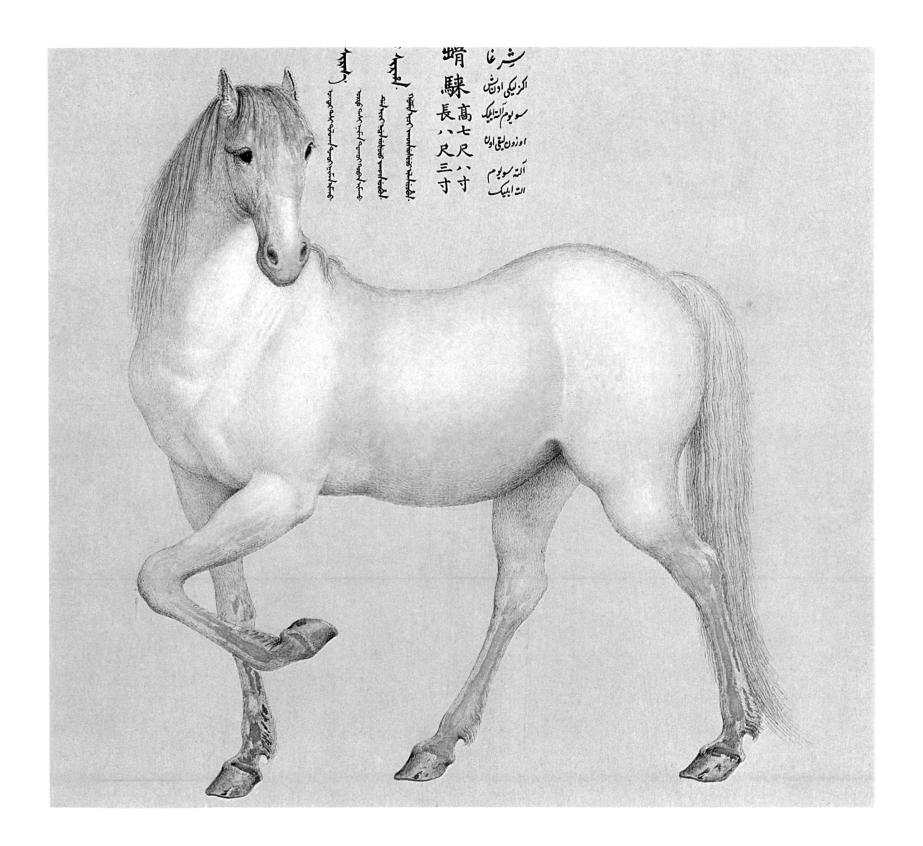

蛸騋長八尺三寸　高七尺八寸

Castiglione's Predecessors

Before Castiglione's arrival several monks had been working as painters at K'ang-hsi's Court. The first, an Italian, Cristoforo Fiori, could not stand up to the hard life of a missionary and asked to be repatriated. Father Joachim Bouvet, taking advantage of the voyage of the *Amphitrite* (1698), had brought with him eight missionaries, two of whom were painters. One of them, Giovanni Gherardini, who was born in Modena and had worked in France for the Duc de Nevers, had not yet taken his vows. The other, Charles de Belleville, was at once a miniaturist, a sculptor and an architect. To these painters who had worked in Peking we must add the name of an Armenian, a layman, sent by the Propaganda, Michael Araïlza. K'ang-hsi treated these artists with solicitude. Thus Brother Gherardini, who also had difficulty in adapting to the rule of the missionaries, one day complained of the attitude of the French monks with whom he was lodged, and was immediately sent by the Emperor to live with one of his favourite mandarins. Alarmed, the French at once began to make a series of approaches to persuade the painter to return to their monastery. But Gherardini, after executing *trompe-l'œil* decorations inside the dome of the church of Pei-t'ang (Northern Church) in Peking, preferred to return to Europe. [15] After Father Belleville had been ill, K'ang-hsi took him to Tartary to distract his mind and provide him with a change of air. Castiglione was therefore assured of the Emperor's goodwill towards foreign artists. He was well aware, however, that he would have to submit to the rigours of an implacable etiquette and face the snares of life at Court. While working at the start with Ripa, Castiglione learned from his elder to distrust the kowtowing and rites of a ceremonial which he, like all newcomers, found 'most irksome and most embarrassing'.

Every morning at seven the missionaries had to present themselves before the wall surrounding the palace. The guards then informed the eunuchs of their arrival and, after a more or less long wait, the gate was opened and immediately closed again. The monks crossed the first courtyard, then waited anew for other eunuchs to be informed. They passed thus through several gates before being introduced into the place where they had to paint until five in the evening. The studio, situated between courtyard and garden, was icy in winter; to prevent the paint saucers from freezing, they had to place them on a small stove. The Emperor sometimes sent dishes from his table, but it seems the Fathers did not greatly appreciate this favour. Rather than Chinese cooking, they preferred fruit accompanied by rolls 'cooked in a double saucepan'. On rest days the Jesuits, with Imperial authorization, could visit important personages and paint their portrait. [16]

The eunuchs never missed an opportunity to wound the Europeans, so jealous were they of the attention lavished upon them by the Emperor. 'To mortify cruelly without seemingly intending to do so', writes Father Amiot, 'without giving him who is mortified the slightest excuse for a legitimate complaint, to mortify him in such a manner that he cannot honestly avoid some expression of gratitude, this is an art which people in Peking have brought to the pitch of perfection.' [17]

In their studio the painters were constantly spied upon by the eunuchs. Not one moment's respite! Were they engaged upon some major work? Quick, they had to paint flowers on a fan. [17] To be continually

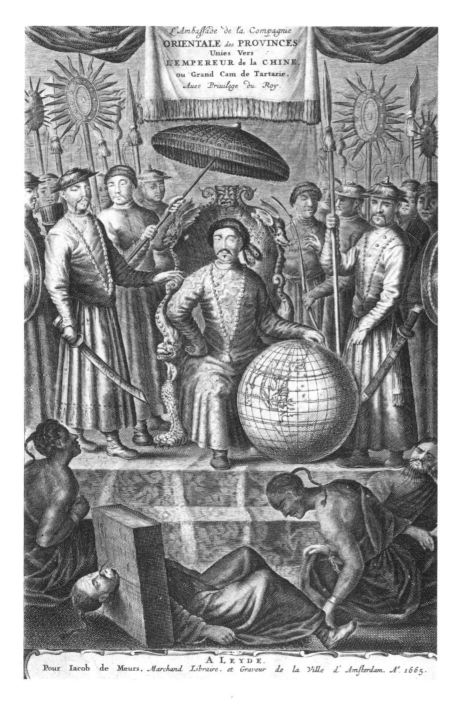

L'Ambaſſade de la Compagnie ORIENTALE des PROVINCES Unies Vers L'EMPEREUR de la CHINE ou Grand Cam de Tartarie. Auec Priuilege du Roy.

A LEYDE.
Pour Iacob de Meurs, Marchand Libraire, et Graveur de la Ville d'Amſterdam. A° 1665.

at people's beck and call, to hide their impatience, to be diplomatic at all times – life at Court brought more trials than rewards. K'ang-hsi himself, despite his solicitude, sometimes made tyrannical demands. Father Ripa relates how, enchanted by the beauty of European enamels, he insisted upon Ripa and Castiglione teaching the technique of this art to the Chinese artists. The two Jesuits protested their incapacity. In vain, they had to obey. To work in a studio surrounded, as Ripa put it, 'by a crowd of corrupt individuals who happened to be in the palace'[18] seemed to them an intolerable obligation unworthy of their rank. They worked with such ill will that the result was disappointing. The Emperor realized that it was no use insisting. Some years later, in 1719, the Jesuits sent to China an expert in enamels, Father Jean-Baptiste Gravereau. He stayed only three years, but the Chinese quickly absorbed his teaching.

Religious unrest was not slow in reappearing. In 1720 a new papal legate, Giovanni Ambrogio Mezzabarba, arrived in Peking. A sagacious man and a skilled negotiator, he was amiably received by the Emperor but did not obtain from him any concession – except permission to take back to Europe the coffin of his unfortunate predecessor, Cardinal de Tournon. However, before leaving Macao (in 1721), he published a decree according eight concessions relating to the cult of

Frontispiece from *L'Ambassade de la Compagnie orientale des Provinces Unies*. Collection M. Beurdeley, Paris.

Confucius and the ancestor cult. What a relief for the Jesuits and all those who, like Castiglione, were in touch with the Court and obliged to take part in numerous official ceremonies on pain of appearing suspect. The same year, 8 December 1721, Castiglione was officially nominated 'temporal coadjutor'.

Fan with decoration of peonies. Painting on paper. Cat. 99. Collection Alice Boney, Tokyo.

The Death of K'ang-hsi

Having caught cold one day while walking in Hai-ts'ui park, the Emperor K'ang-hsi was obliged to take to his bed. He died shortly afterwards or, as the Chinese phrase has it, 'became a dragon again' – on 30 December 1722 at eight in the evening. He was sixty-nine.

This prince, whose reign had lasted sixty years, was incontestably the greatest of the Manchu rulers. He was aware of the technical progress achieved in Europe during the previous hundred years and wished China to catch up with it, particularly in the field of metallurgy. (The Chinese army at this period was still using the bow.) To K'ang-hsi the European ambassadors were no more than bearers of tribute; if he tolerated negotiations with foreign powers, it was only to the extent that the latter supplied the Treasury with the 'white metal' (silver). By contrast, as we have seen, his esteem for the Jesuits was sincere. On the other hand, he regarded them as his own subjects and no missionary could leave China without his authority.

All those Jesuits who, like Castiglione, had been able to approach him and get to know him personally, felt real admiration for him. He had a lively, penetrating mind, sound, reliable judgment and a memory from which nothing escaped. [19] One of these missionaries adds candidly: 'He had too many virtues not to be a Christian.' In actual fact, K'ang-hsi felt no leaning towards Christianity, the 'teaching of the West' as the Chinese called it. 'It is contrary to orthodoxy and it is only because these apostles have a thorough knowledge of the mathematical sciences that the State employs them. Take care not to forget that.' [20] Nevertheless, it did not escape the Jesuits that in the person of K'ang-hsi they had lost a benevolent master and a protector.

The Emperor's body was immediately transported to the Ch'ang-ch'un-yuan palace in Peking. All the mis-

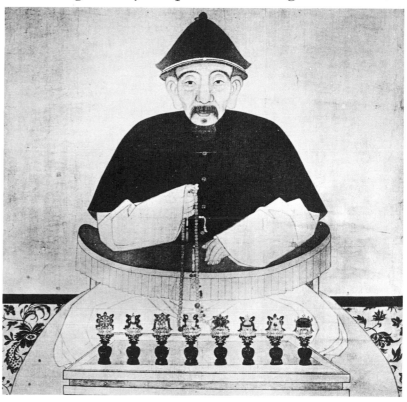

Painting from the *Ch'ing-tai ti-wang-hsiang* depicting Emperor K'ang-hsi in old age holding a string of beads. Percival David Foundation of Chinese Art, London.

sionaries working at the Court made their way to the Imperial Palace to take part in the funeral and join their lamentations to those of the officials and servants. Not without some disquiet, however, for by lending themselves to this custom they feared they were taking part in a pagan rite.

The Emperor Yung-cheng

The succession to the throne ought not to have raised any problems, because the late Emperor was the father of thirty-five sons – eleven of whom had died at an early age – and twenty daughters. On the day of his death K'ang-hsi had himself nominated his fourth son, Yin-chen, who took power under the name of Yung-cheng. The new emperor, aged forty-four, born of a concubine who had already been married, had to struggle throughout his reign against the intrigues of his brothers, who reproached him with his illegitimate birth. Some of them had been converted to Christianity, and Yung-cheng wished to avenge himself on the missionaries who, he thought, were responsible for the dissidence of his rebellious brothers. The princely family of Su-nu, several of whose members were Christians, was implicated in the plot along with the Portuguese Jesuit João Moura, their spiritual adviser.

The repression was pitiless: eight Su-nu princes imprisoned, Father Moura strangled or poisoned in prison (1726) before the Portuguese ambassador, Dom Metello de Souza e Menezez, could intervene in his favour. Finally, a mandate of expulsion was issued against all the missionaries, with the exception of those working in Peking, who were put under house arrest. Even Father Pedrini, Yung-cheng's former tutor, was imprisoned.

The Portuguese mission, in which Castiglione was living, had a difficult time. Compelled to share the anguish of the other missionaries, Castiglione took

Emperor Yung-cheng seated reading by a Chinese artist. After the *Ch'ing-tai ti-wang-hsiang*. Percival David Foundation of Chinese Art, London.

advantage of the days of forced seclusion to decorate the new church of Tung-t'ang, or St Joseph's Church. This building, which was begun in 1721, thanks to donations sent from Europe, on the site of a residence acquired by Father Adam Schall, was not finished until 1729. The architect, Brother Ferdinando Bonavventura Moggi, a Florentine, was also an engraver and sculptor. This church, though small in scale, is said to have been the finest in Peking and worthy of comparison with San Ignazio in Rome. Unfortunately it was seriously damaged by fire in 1811, and what remained was destroyed by the Emperor Chia-ch'ing, who took advantage of this incident to expropriate the missionaries.

At the beginning of the eighteenth century there were two other churches in Peking: Pei-t'ang, the Northern Church, and Nan-t'ang, the Southern Church. Pei-t'ang, the French mission church dedicated to 'Jesus Christ dying on the Cross' (Our Saviour), was built by Father Jean-François Gerbillon on a site within the walls of the Imperial City presented to the missionaries by K'ang-hsi as a reward for having cured him with quinine. The solemn opening took place in 1703.[21] In the interior, the *trompe-l'œil* decoration painted by Gherardini simulated a vista prolonging the sanctuary – an artifice that aroused the admiration of the Chinese. The façade bore a brilliant inscription, 'Church constructed by Imperial order', which was the missionaries' pride and added to their prestige. When the church was destroyed under Chia-ch'ing, and the outbuildings

Saucer in 18th-century Chinese porcelain depicting a church surmounted by a Cross. Formerly collection J. Mahé, Paris.

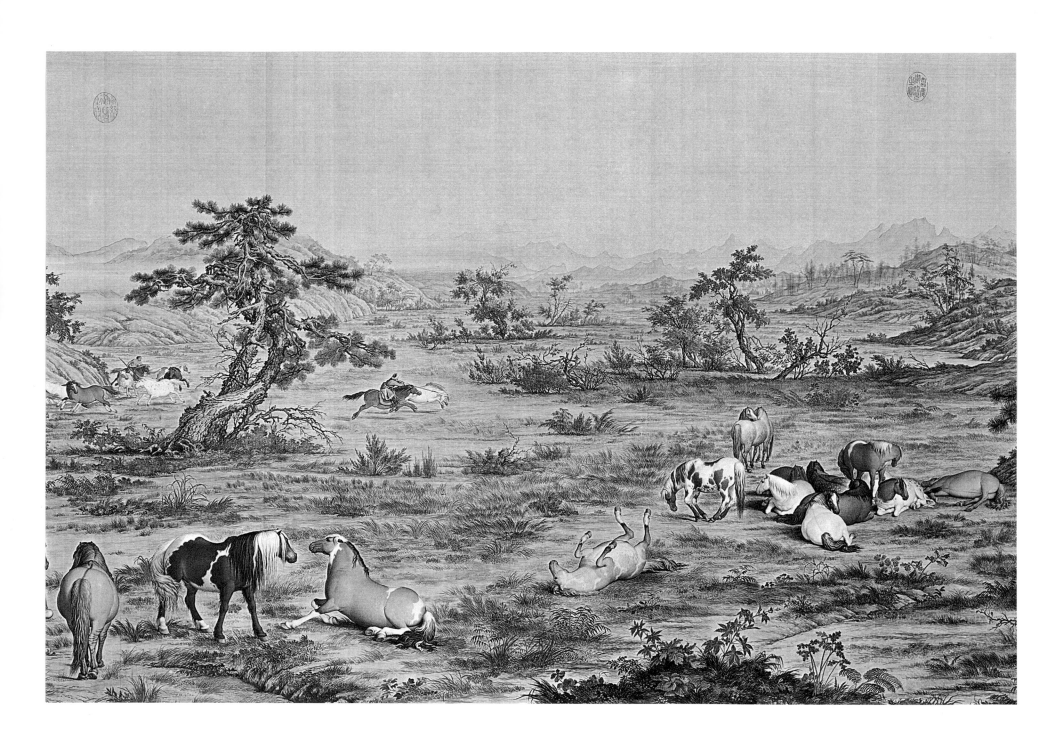

A Hundred Horses. Painting on silk (details). 0.94 × 7.76 m. Cat. 17. National Palace Museum, Taipei, Taiwan.

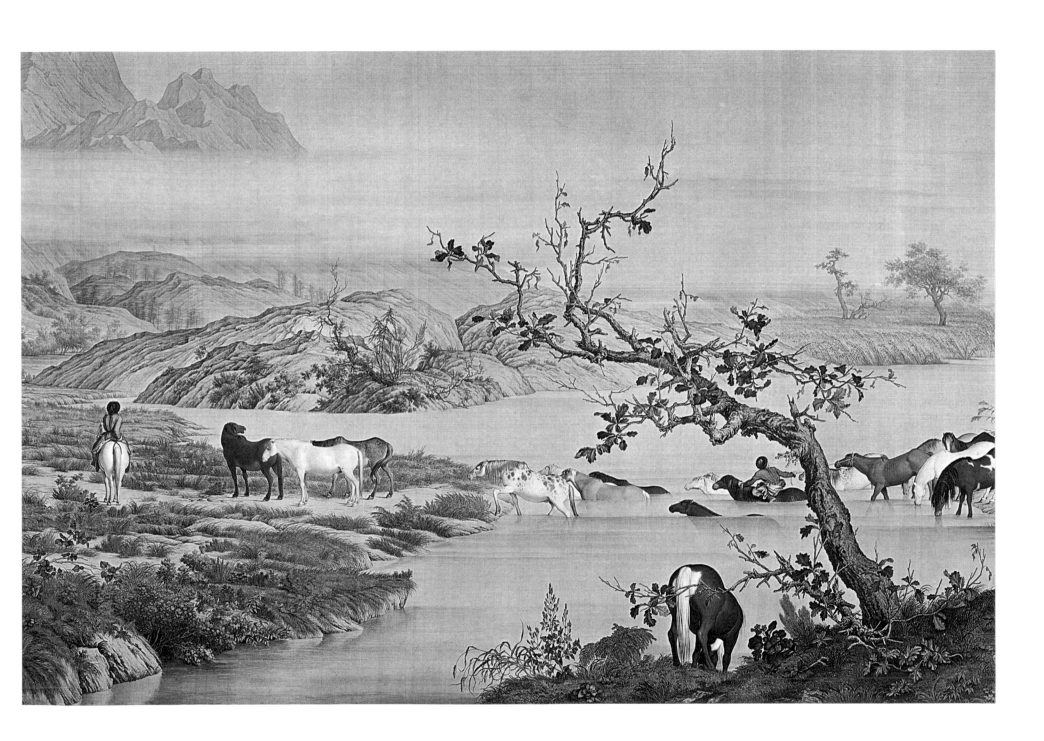

sold for the sum of five thousand taels to a certain Yu, the Imperial inscription was carefully wrapped in yellow silk and deposited in the palace storehouse.

Nan-t'ang, the Southern Church, had been built by Father Adam Schall in 1650 on a site presented to Father Matteo Ricci. This church, the oldest in Peking, had an annexe for women. On open days guards had to be placed at the door to prevent men from entering, because it was impossible for a Chinese woman to go into a temple frequented by men. The church was rebuilt in 1703 and its annexe housed the College of the Portuguese Jesuits. The library of this College contained several thousand books on natural history, medicine, astronomy and theology. Castiglione painted in the church two large pictures, one of them depicting *The Triumph of Constantine*, and two frescoes representing buldings in perspective. [22] In what year did Castiglione carry out these works? Was it before the earthquake of 1730 which damaged the churches of Nan-t'ang and Pei-t'ang and led to the disappearance of a hundred thousand people? Or a little later, during the restoration of Nan-t'ang? It is hard to say.

No painting by Castiglione dating from K'ang-hsi's reign has come down to us. On the other hand, the National Palace Museum in Taiwan possesses three works dating from the reign of Yung-cheng: *Auspicious Object* painted in 1723, *Pine, Peak, Hawk and Mushroom* (1724), and *A Hundred Horses* (1728). Castiglione certainly painted other scrolls for this emperor, but no doubt they were either undated or they have disappeared.

According to a letter from the Jesuit Ignatius Kögler to Father Michele Tamburini, General of the Jesuits (discovered by George Loehr in the archives of the Society of Jesus), Emperor Yung-cheng decided in 1723 to put the talent of Lamxinim (Portuguese for Lang Shih-ning) to the test.

Imperial inscription affixed to Pei-t'ang (Northern) Church, Peking. After an etching from *Lettres édifiantes et curieuses*. Collection M. Beurdeley, Paris.

36

Castiglione, writes Kögler, was employed in the palace daily, either decorating enamels or executing paintings in oils or water-colour. 'Frequently—on 12 May, 15 June, 2 August—dishes were sent from the imperial table; again the emperor rewarded him with 12 rolls of the best silk, accompanied with a precious stone, carved in the shape of a seal, with the effigy of Christ Our Saviour, on a cross. Latterly he was presented with a summer hat, which gift denotes great honour...' [23]

Nevertheless, relations between the Emperor and the missionaries who received special treatment because they worked in the palace were very tense at times. Persecution was in full swing, Jesuits were imprisoned, tortured, put to death. When Fathers Kögler, Parennin and de Moyria de Maillac attempted to plead their cause before the Emperor, the latter declared that his purpose was indeed to prohibit and combat Christianity.

It was also during Yung-cheng's reign that Castiglione, who called himself a disciple of Andrea Pozzo, assisted Nien Hsi-yao, superintendent of customs, to adapt Pozzo's treatise *Perspectiva Pictorum et Architectorum* into Chinese. This adaptation appeared in 1729 and was reissued in 1735.

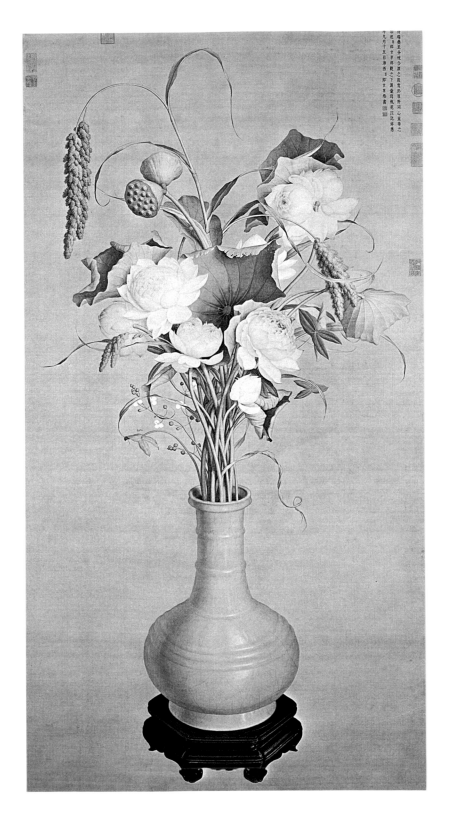

Auspicious Object. Painting on silk. 1.73 × 0.86 m. Cat. 28. National Palace Museum, Taipei, Taiwan.

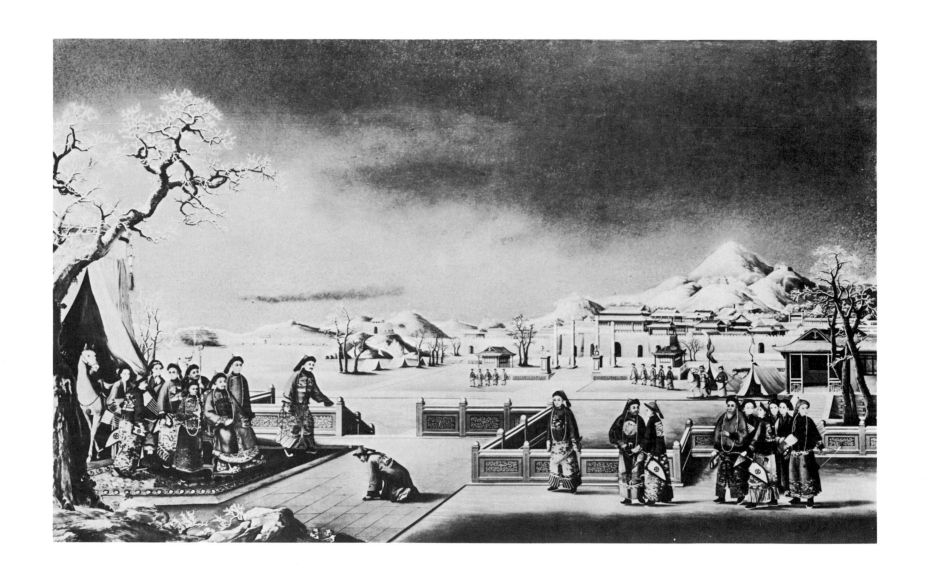

The Emperor Ch'ien-lung at Jehol receiving foreigners. Painting under
glass. Victoria and Albert Museum, London.

The Emperor Ch'ien-lung, Persecution of the Christians

It was with 'ceremonial tears' that the missionaries learned, on 7 October 1735, of Yung-cheng's death. He was succeeded by his son, Hung-li, under the title of Ch'ien-lung. The young sovereign was twenty-four and the missionaries hoped that he would be more tolerant than his father, since his first Imperial act was to set free his uncles thrown into prison by Yung-cheng. Although filled with a love of justice as well as being a man of great literary culture, Ch'ien-lung felt great distrust of the Christian doctrine. When he approved the decrees forbidding the Jesuits to spread their religion they were intensely disappointed. Castiglione, then forty-seven, had acquired great experience of Court affairs. He had had many opportunities of conversing with the Emperor who, although in mourning, went to his studio almost every day to watch him painting. Indeed, according to Father Cibot, the Emperor actually called himself Castiglione's disciple, though this is something of an exaggeration. The superiors of the mission therefore charged Castiglione with a request to be presented to the Emperor. This was a dangerous undertaking, for if Castiglione saw the Emperor frequently, 'he was nevertheless not permitted to speak to him about any matter unless first questioned'.

On 3 May 'the Emperor came as usual to sit by him and watch him paint. The Brother laid down his brush and, suddenly assuming a sad expression, fell to his knees and after uttering a few words interspersed with sighs concerning the condemnation of our Sacred Law drew from his breast our Memorial wrapped in yellow silk. The eunuchs of the presence trembled at this Brother's audacity, for he had concealed his purpose from them. However, the Emperor listened to him calmly and said to him kindly: "I have not condemned your religion; I have simply forbidden the people of the Banners to embrace it." At the same time he signed to the eunuchs to receive the Memorial and turning to Castiglione he added: "I shall read it, do not worry, and go on painting." [24] Nevertheless, from that day forth, Castiglione was expressly forbidden to present any similar request. Every morning he was searched to make sure he did not have upon him any such document to present. The Emperor informed him that it was not proper for the Manchus and the Chinese to embrace the Christian doctrine but that he would leave the missionaries free to practise their religion. The Jesuits heard this order on their knees. The persecution, which had lasted two months, abated, but decrees of proscription were posted in every square and even on the doors of the churches.

The following year a catechumen of the Portuguese Fathers, Liu Erh, who was baptizing abandoned children, was accused of using 'magic water'. He was flogged and put in the cang with a notice saying: 'A criminal because he became a Christian.' Castiglione, accompanied by the Jesuit Fathers Ignatius Kögler, president of the tribunal of mathematics, Dominique Parennin, superior of the French mission, Domenico Pinheiro, superior of the Portuguese mission, and Chalier, a clockmaker, called upon one of the grand masters of the Imperial household and requested him to transmit to the Emperor, this time with all due formality, a *placet* in favour of the unfortunate Chinese. The Emperor was content to refer the case to the Grand Tribunal, which declared: 'The religion of the Europeans inspires great skill in deceiving people.

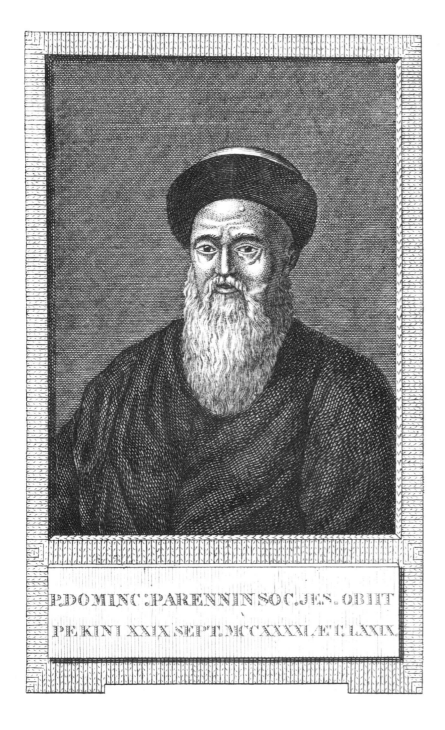

P.DOMINC:PARENNIN SOC.JES. OBIIT

PEKINI XXIX SEP'T.MCCXXXXI.ÆT.LXXIX.

There would be serious objections to according it the slightest liberty.'[25] Braving all prohibitions, Castiglione resolved once more to intervene personally.

'... On 14 December at ten in the morning the Emperor entered the apartment in which Brother Castiglione was busy painting. He asked him a number of questions concerning painting. The Brother, overcome by grief and sorrow at the order given the previous day, lowered his eyes and did not have the strength to reply. The Emperor asked if he was ill. "No, Sire", he answered, "but I am deeply dejected." Then, throwing himself to his knees: "Your Majesty, Sire, condemns our holy religion. The streets are full of posters proscribing it. How can we, after that, calmly serve Your Majesty? When the order that has been given is known in Europe, will anyone be willing to come to your service?" "I have not forbidden your religion to you Europeans", said the Emperor. "You are free to practise it, but our people must not adopt it".'[26] Ch'ien-lung, related another missionary in 1750, was by no means touched by Castiglione's supplication. 'His face filled with fury, he turned his back on him and for some days did not return to the place where he took pleasure in watching him paint.'[27]

At the end of 1746 Castiglione intervened a third time in favour of his unfortunate co-religionists. Sentence of death had been passed by the Tribunal of Peking upon five Dominican missionaries, Spaniards, among them Father Pedro Sanz. There was no question

Portrait of Father Dominique Parennin. Etching from *Lettres édifiantes et curieuses.* Collection M. Beurdeley, Paris.

乾隆元年八月吉日

letter the difficulties and cruel persecutions suffered at this period by Christians who had settled or been converted in China. Ch'ien-lung was greatly worried and intrigued by the Westerners' teaching, as is shown by another passage in the same letter. 'The Emperor, according to his habit, was in the studio of Brother Castiglione, who was working with several Chinese and Tartar painters. "Do Christians fear death?" asked the Emperor. The Brother replied: "Those who have lived a good life do not fear it. Those who have lived an evil life fear it greatly." "But", said the Emperor, "how is one to know if one has lived a good or an evil life?" "One knows", said the Brother, "by the evidence of one's conscience."

'The Emperor then addressed a Chinese painter. "Tell me the truth. I have seen you for a long time with the Europeans: have you embraced their religion?"

'The Chinese said that he was not a Christian; what had always stopped him was the incarnation of a god. Castiglione then intervened to give some explanations. "But this mystery", he added, "is developed at length in our religious books." Then the Emperor declared to the Chinese painter: "It is because you cannot read the European books that you have not become a Christian." Castiglione protested that such books existed in Chinese characters. The Emperor concluded drily with two words addressed to Castiglione: "*Hua-pa* – Get on with your painting".' [29]

The Emperor did not always have such serious conversations. He also liked to joke. Having noticed Castiglione's embarrassment when he was surrounded by his concubines, he asked him one day when he was with his first eight favourites: 'Which of them do you consider the most beautiful?' 'The wives of a Son of Heaven are all equally beautiful.' 'Look, you shall paint the portrait of the one you like the best.' 'Who would dare to choose after the Emperor's choice?' 'Among those of yesterday, did you find any who were more to your taste?' 'I did not look at them, I was counting the porcelain tiles of Your Majesty's palace.' 'Then how many are there?' 'Thirty.' The Emperor ordered eunuchs to count the tiles. The Jesuit was right. After this Brother Castiglione was teased no further. [30]

Castiglione and the European Painters at the Court

Castiglione was not the only painter appointed by the Emperor. Jealous of the great reputation he had acquired, both at the Portuguese mission and at Court, the French Jesuits sent for Father Jean-Denis Attiret to show that they too had a compatriot who was full of talent. Attiret, who was born at Dole in 1702, had studied in Rome and had entered Holy Orders at the age of thirty. The works which he executed in France before leaving are still little known. Four pendentives in the Jesuit church at Avignon are attributed to him, as well as two portraits, one of the Cardinal of Auvergne, the other of a certain Monsieur Perrichon. On his arrival in Peking in 1738 he was presented to the Emperor and made him a gift of a painting depicting the Adoration of the Magi. Ch'ien-lung was so pleased with this work that he had it placed in one of his state rooms. He conceived such esteem for the young painter that he invited him to work every day in his presence. But Father Attiret scarcely appreciated this honour. Despite his years of noviciate, he had retained a touch of 'Gallic fire' and found the vexations inseparable from life at Court hard to bear. Castiglione, his elder, strove to quieten the vivacity of the young man and initiate him in the subtleties of Chinese etiquette. Far from being rivals, the two painters quickly joined forces, sharing the same studio, the same commissions and often being the target of the same rough jokes – such as being forced to work standing on a chair while touching up certain paintings in the palace.

In 1743 there were twenty-two Jesuits in Peking, ten Frenchmen and twelve Portuguese, Italians and Germans. Seven of these twenty-two Jesuits were employed exclusively in the service of the Emperor.

When the latter left Peking for his summer residence (where he spent almost ten months of the year), the missionaries followed him to work in the studios set up at the entrance to the gardens of Yuan-ming-yuan at Ju-i kuan. Clockmakers, enamellers, carvers of ivory and precious stones – almost all the artistic crafts were represented. In addition to the Europeans, there were also five Chinese Jesuits, who were allowed into certain places and houses forbidden to the Europeans. At Yuan-ming-yuan, as in Peking, the missionaries had to be constantly prepared for any task required of them by the Emperor. 'The Europeans at the Court are supposed to know everything, to judge by the way they are treated. If there is in the Emperor's storerooms some machine, some instrument, some mineral or some drug of which they know neither the use nor the name, it is to us that they turn for information.' [31] The Europeans had always to be ready with an answer.

It was thus that Father Chalier invented the famous vigil clock, 'a work which, even in Europe, would pass for a marvel or at least for a masterpiece of art'; that Father Benoist, in 1747, produced wonderful fountains to decorate the gardens of the European houses; that Brothers Gilles Thibault and Sigismond created fantastic automata, among them 'a lion that walks a hundred paces like an ordinary animal and conceals in its breast all the springs which make it move.' [32]

Castiglione and Attiret had to display the same skill in all techniques, whether it was painting in water-colour on silk, in oils on glass or a portrait. There was no question, for the Europeans living at Court, of specializing in a 'genre'. According to Father Perroni

(in a letter dated 1722), Brother Tomacelli, on orders from the Emperor, had to work in the palace enamel workshops – although he had never used this technique before – and to help him Castiglione supplied him with designs. [33] Certain porcelains manufactured at Ching-te-chen, the most important factory in the Empire, were sent to these Imperial workshops unpainted so that they could be decorated there. At this period there was a great fashion in China for the very fine porcelains called 'eggshell' ornamented with glazes belonging to the *famille rose* (a glaze invented by Andrea Cassius of Leyden in the eighteenth century) which the Chinese called 'foreign colours' or 'soft colours'. A number of these pieces are glazed on the reverse with a ruby red ('ruby back') and decorated with family or rustic scenes displaying European or Chinese figures. These decorations are sometimes slightly shaded in the Western manner. A bouquet of flowers painted by Castiglione for the Pi-shu shan-chuang, 'Mountain Residence to Escape from the Heat', the Summer Palace, at Jehol – now in the collection of Mrs J. Riddell – depicts a bottle-vase of the *famille rose* type called *ku-yüeh-hsüan*, in which the European influence on the decoration is evident. Some authors suppose that this manufacture goes back to the reign of K'ang-hsi. But according to Yang Hsiao-ku, author of the *Ku-yüeh-hsüan tz'u-kao*, all the pieces in this style were decorated by Castiglione. Chi-yuan Sou, 'the Old Man of the Tranquil Garden', author of the *Tao Ya* (treatise on the

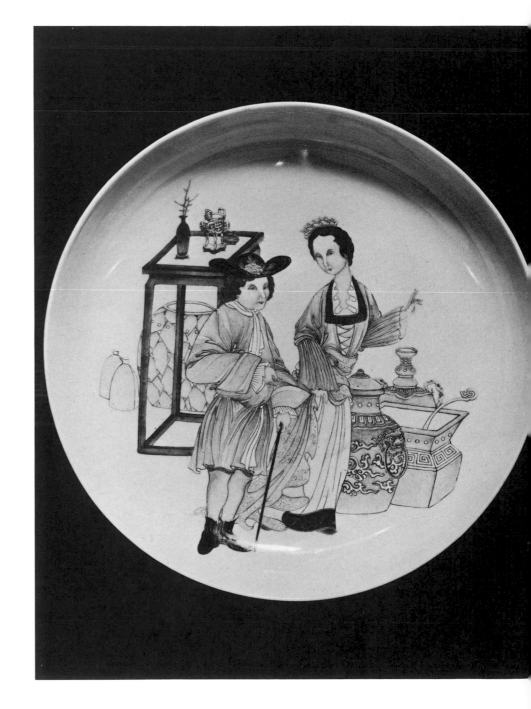

Bowl in 'egg-shell' porcelain depicting two Europeans. On the reverse, mark of Yung-cheng. Collection Compagnie de la Chine et des Indes, Paris.

46

Statuette in Sèvres *biscuit* porcelain depicting the Emperor Ch'ien-lung. It was sent to him as a gift in 1772. Musée National de Céramique de Sèvres.

porcelains of the Ch'ing period), writes that porcelains manufactured by Lang T'ing-chi, governor of Kiangsi during the reigns of K'ang-hsi and Yung-cheng, have been erroneously attributed to Lang Shih-ning.[34] However that may be, Lang Shih-ning's reputation is such in China today that many antique dealers and collectors are strongly inclined to attribute to him porcelains in which the decoration is particularly carefully done and painted with shadows in the Western manner, or represents a European subject. Do not certain porcelains dating from the beginning of the twentieth century bear the mark Shih-ning? [But Castiglione's relations with such personages as Nien Hsi-yao, who, as superintendent of customs, was responsible for the Imperial porcelain factory, enable us to state that Castiglione supplied designs to Chinese artists, that he supervised work and that he painted certain decorations himself.]

Not only did Ch'ien-lung love the fine arts but he was also a skilled painter. Sometimes he asked the Europeans to correct or finish the work he had started. Most often, he imposed a subject and followed its execution with the greatest interest. In any case, there was no question of discussing the tastes of the Emperor, 'who knows everything, or at least flattery tells him so very loudly and perhaps he believes it: he always acts as though convinced of it'.[35] No missionary was better able than Father Attiret to conjure up life at Ch'ien-lung's Court. His accounts, lively, vivid, recreate the atmosphere with almost the same intensity as the camera would do today. We shall not resist the pleasure of quoting certain passages.

'... The place where we usually paint is one of those little palaces of which I have spoken to you. This is

where the Emperor comes to watch us working almost every day, so that there is no means of staying away; but we do not go any further, unless what is to be painted is of such a nature that it cannot be transported, for then we are taken inside, but with a large escort of eunuchs. We have to walk hurriedly and soundlessly, on tiptoe, as though about to commit some crime. This is how I have seen and traversed the whole of this beautiful garden and entered the apartments. The Emperor stays here nine to ten months each year... By day we are in the garden and dine there at the Emperor's expense. For the night we have a house we have bought in quite a large town or village. When the Emperor returns to the city we go too; then we spend the day inside the Palace and in the evening we go to our Church.

'Just imagine that I am considered well rewarded by seeing him [the Emperor] every day. This is about all the payment I receive for my work, if you except a few small gifts of silk or something else of little value and which in any case come rarely. But this was not what brought me to China nor is it what keeps me here. To be on a chain from one sun to the next; barely to have Sundays and feast days on which to pray to God; to paint almost nothing in keeping with one's own taste and genius; to have to put up with a thousand other harassments which it would take too long to describe to you; all this would quickly make me return to Europe if I did not believe my brush useful for the good of Religion and a means of making the Emperor favourable towards the Missionaries who preach it. This is the sole attraction that keeps me here as well as all the other Europeans in the Emperor's service.' [36]

Ch'ien-lung rewarded the missionaries with gifts and dignities. In 1750 Castiglione was appointed mandarin of the third rank. As the mandarinate was incompatible with the status of a monk he had already refused this honour three times and the intervention of the Empress-Mother was required before he would accept. But to strut at Court in a robe embroidered with a peacock and wearing a hat with a sapphire stud was a hard trial for the man who had chosen the humble role of coadjutor... The German Jesuit Ignatius Sickelpart (or Sichelbart), likewise a painter, and Father Hallerstein, a member of the Tribunal of Astronomy, received the same distinction. Father Attiret always refused it with the greatest vigour and an obstinacy typical of a man from the Franche-Comté. [37]

At the end of 1750 all the painters, sculptors, architects and joiners of Peking and the surrounding provinces were required to make 'masterpieces of their craft' for the celebration of the Emperor's mother's sixtieth birthday. [38] From Yuan-ming-yuan to the Peking Palace the whole route was to be decked with flags – not merely the land route but also the river route. As it froze hard at this time of year, thousands of workers were employed day and night beating the water to prevent ice from forming. A fruitless measure. The water froze and sledges had to be used. The Emperor was so displeased that the responsible official was deprived of his income for a year. On both sides of the river buildings were constructed, either on the bank or on piles, and linked together by little bridges. All these edifices were gilded. Inside, musicians and actors employed all their ingenuity to charm the Emperor and his mother. From the city gate to the

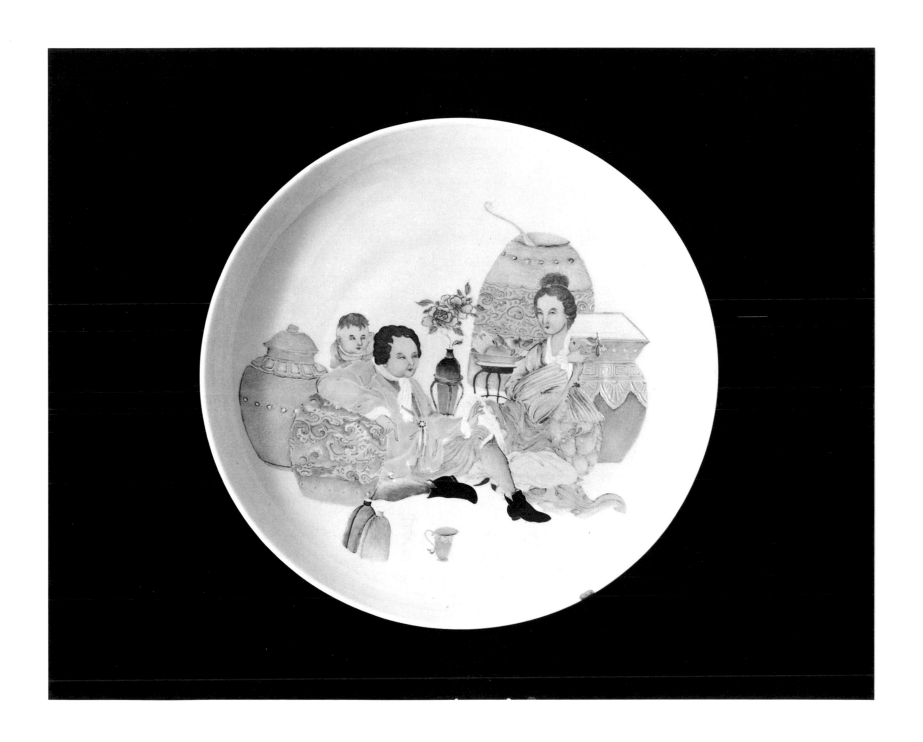

gate of the palace there were nothing but peristyles, pavilions, colonnades and galleries decorated with silk garlands and gold ornaments with imitation gems. Mirrors had been placed here and there to multiply the reflections of the spectacle. Children dressed up as birds in silk garments stood on columns flapping their wings; others disguised as monkeys and other animals wandered about the gardens. On 6 January the Emperor on horseback, the Empress in a sedan chair and the high dignitaries on foot made their way through the streets of the city to the palace, stopping here and there as the whim took them. But the streets were empty, the houses barricaded, for no one was authorized to cast his eye on the Imperial cortège.

In this orgy of the imagination, the Europeans were not eclipsed. The gift which they presented to the Emperor was a marvel of ingenuity: a miniature theatre measuring three feet in height, with three stages on each side, decorated with *trompe-l'œil* vistas. At the back rose the statuette of a young Chinese woman carrying an inscription welcoming the sovereign and wishing him ten thousand years of life. Every hour the statuette bobbed up followed by little figures, automata in the form of musicians who intoned celestial music.[39] It is probable that Castiglione and Attiret themselves conceived the décor of this toy worthy of the Emperor's curiosity and tastes. The Emperor was enchanted and placed the automata clock in one of the rooms of the palace. He rewarded the missionaries with a considerable gift of money. In addition, Castiglione dedicated to the Empress a painting representing a 'stag of good omen' *(An Auspicious Stag)*.

Reindeer from Tung-hai. Silk scroll (detail). Cat. 58. National Palace Museum, Taipei, Taiwan.

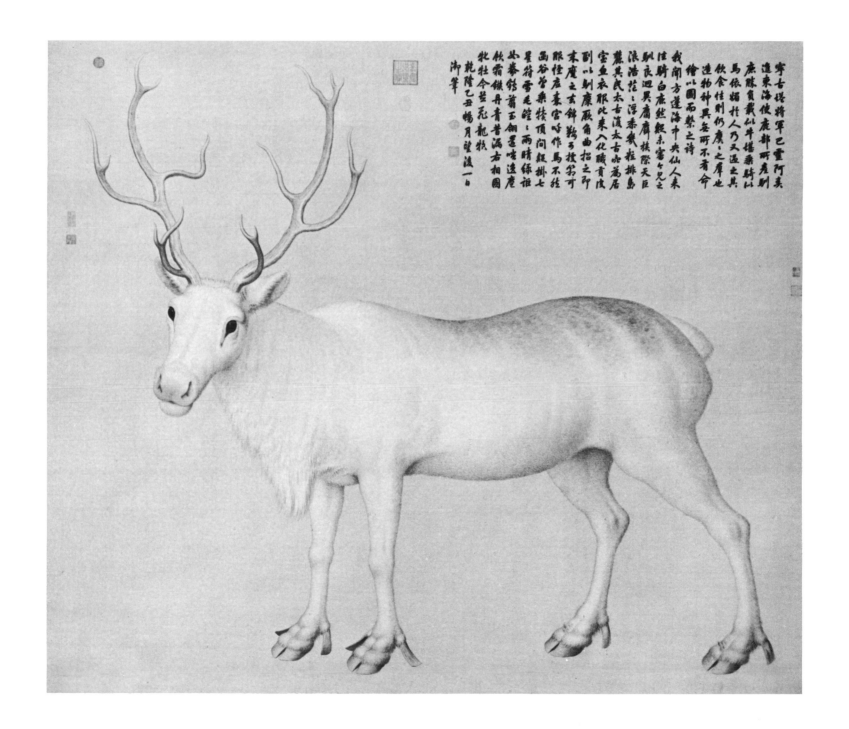

寧古塔將軍巴靈阿美
進東海使鹿部所產馴
鹿陳貢戴仙牛搭乘時以
馬依媚作人乃又温此其
飲食佳則作廄之犀也
連物神其至呵而不肖令
繪以圖而繫之詩

我聞方蓬海中央仙人来
住騎白鹿然銀束富午兄之
馳衣迎吳廉麾枝際天巨
浪浩茫浮茶我粒排島
麓其民太古濱太古為居
寶烏衣服比来入化職貢方
刷以馴廉取角曲招之即
東庭之玄錦鞃万授弟可
眼怪居素宫呼作馬不経
畫谷管乘裝頂問鈒掛七
星特雪毛皓ニ两晴綠渾渾
必卷餘前玉翺蓮嗟達廉
秋霜鉄丹青普漏右相圖
牡牡令益充龍牧
乾隆乙丑暢月望後一日
御筆

At Jehol

In 1754 the Emperor went to Jehol in Chinese Tartary, a place he visited each year to hunt. But this time he went there to receive with great ceremonial Amursana, chief of the Kalmucks, whom he had just forced into submission. The Emperor, accompanied by his Court, ordered Father Attiret to follow him 'to paint everything that happened in the ceremony.' [40]

There was no backing out. If the journey was picturesque (camping *à la Tartare* was not without its pleasures), the stay in Jehol proved a nightmare. In six days Attiret had to paint eleven portraits of military chiefs decorated with new titles – a wager that had to be kept. 'It is said that these Tartars, unaccustomed to seeing themselves reproduced thus, were amazed to recognize themselves on a canvas and to see themselves with all their adornments. They laughed at each other when, after a few brushstrokes, they observed some slight resemblance; but when they were complete they were ecstatic. They could scarcely understand how it was done. They did not tire of looking at the palette and the brushes; none of the painter's actions escaped them. The Chinese and Manchu lords who were present also laughed with all their hearts, not at the copies, but at the originals themselves, whose faces, whose bearing, whose whole behaviour had so little in common with Chinese politeness and decorum. Probably of all those present, the painter alone did not feel at his ease.' [41]

From the portraits of the Tartars Attiret had to pass to a portrayal of the ceremony, of the games, and to submit to all the caprices of the Emperor, who watched over him, corrected him and, if necessary, added a few brushstrokes. When the Korean paper, oiled and ready to receive the paint, was all used up, a courier was quickly despatched to Hai-tien to demand fresh sheets from Castiglione, who had not taken part in the first trip.

After fifty days of purgatorial labour Attiret, worn out and moreover suffering from sciatica, had to return to Peking. He rested there for a short time, then returned to Jehol, this time accompanied by Castiglione and Father Sickelpart.

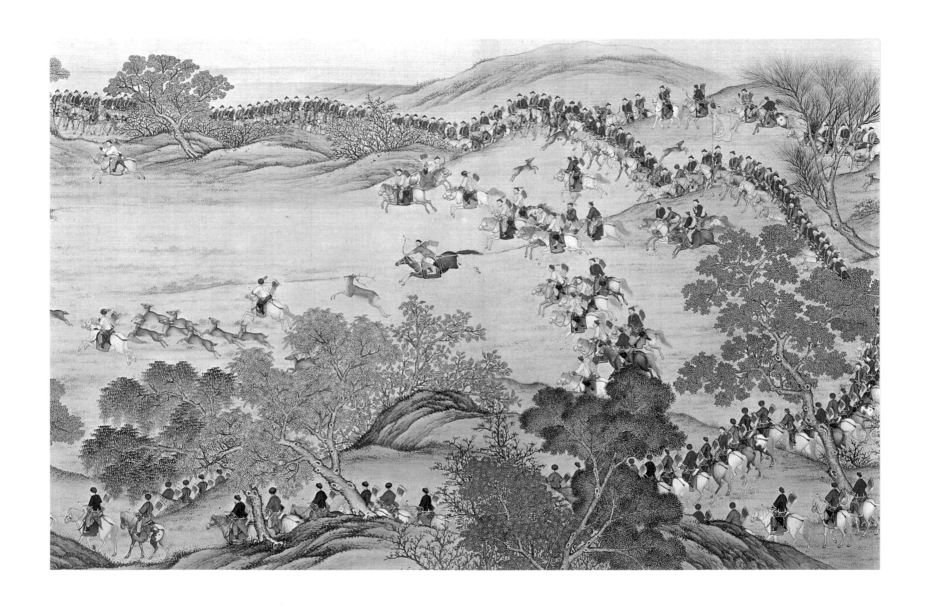

Mu-lan IV. The Emperor aiming his bow at a deer. Painting on silk (detail). *Ca.* 0.77 × 27 m. Cat. 49. Musée Guimet, Paris.

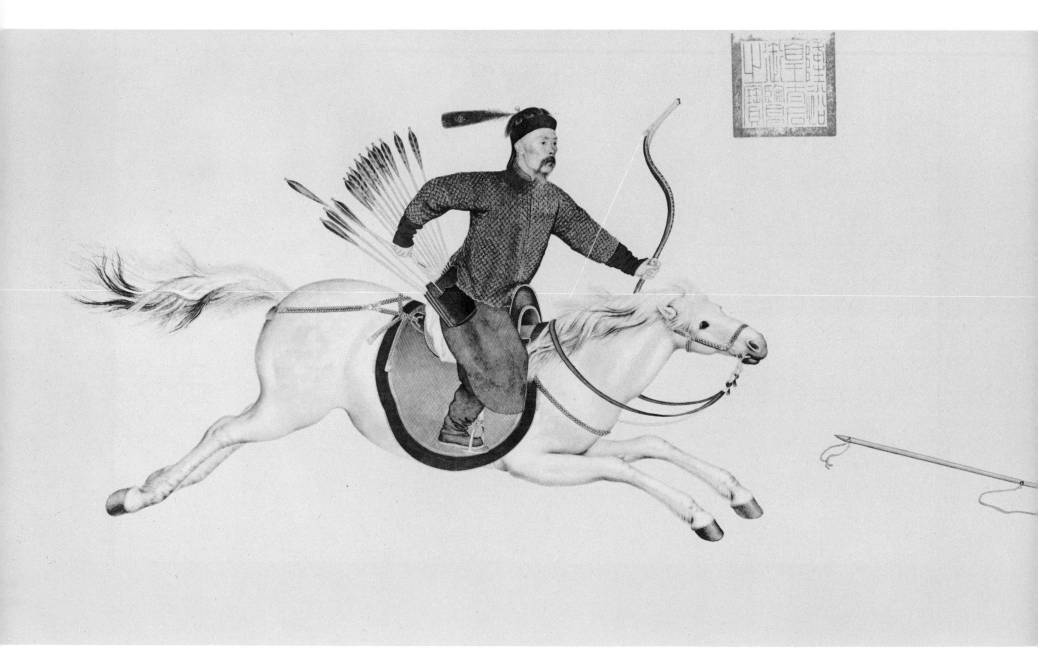

54 *Ma Chang Attacking the Enemy's Camp.* Painting on paper (detail). 0.38 × 2.85 m. Cat. 25. National Palace Museum, Taipei, Taiwan.

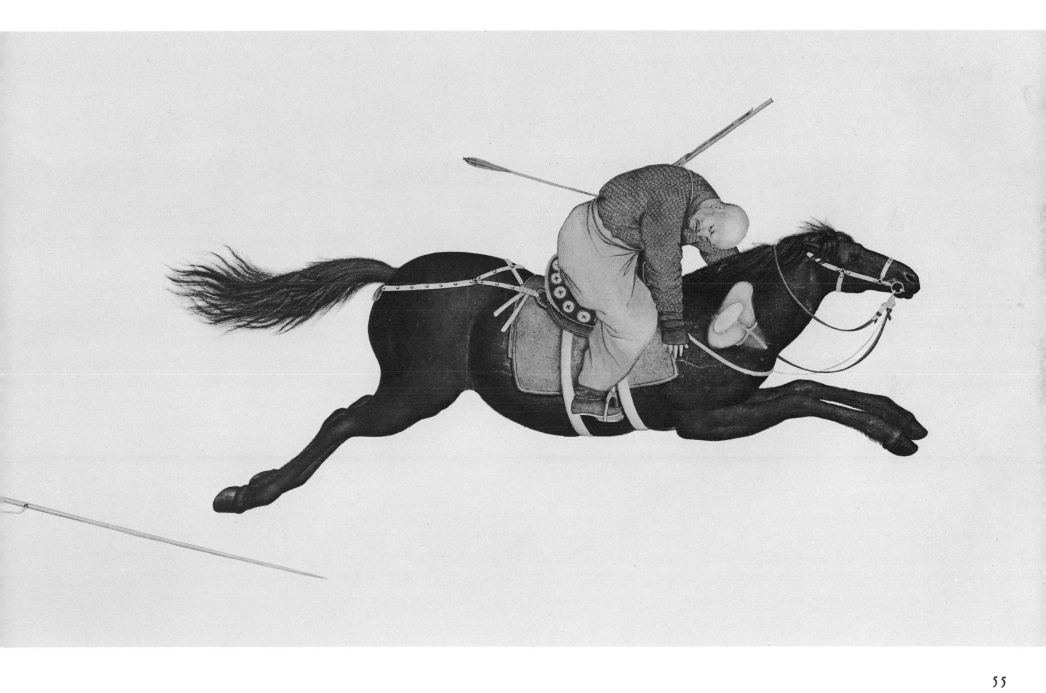

Castiglione's Birthday

In China growing old is not considered as a decline, but as a rare privilege bringing with it the greatest honours. From the age of fifty onwards, every ten years brings with it ceremonies of greater or less pomp, according to the person's rank. For the Emperor it was an opportunity for an act of special favour, whatever its motive – personal friendship, political considerations or the recognition of services rendered. When Castiglione reached the age of seventy Ch'ien-lung decided that the event should be celebrated with as much brilliance as if it had concerned a high Chinese official. Through this jubilee, the Emperor's favour was addressed to all the Europeans in China, that is to say, to the missionaries. There is no exact account of the ceremony dedicated to Castiglione. But a letter from a missionary traces in detail an identical ceremony that took place ten years later in honour of Father Sickelpart. The Emperor had demanded that the same protocol and the same gifts should be repeated as for Castiglione. [42]

Festivities began at the palace of Yuan-ming-yuan on the monk's birthday. A baldachin was set up at the gate beneath which the Imperial gifts were laid out: six pieces of silk of rare quality, a mandarin's robe, a large agate necklace. Even more precious: a message of congratulation comprising four characters written in the Emperor's own hand.

The baldachin was carried by eight bearers armed with stretchers. A long procession consisting of twenty-four musicians, four mandarins on horseback, a delegate from the Emperor – the *tung* – and the celebrant himself accompanied the Imperial gifts as far as Peking. At the western gate of the city a detachment of soldiers joined the procession, which then wended its way toward Nan-t'ang, the Jesuits' church. Musicians and soldiers 'made a great deal of noise' – which was reinforced by the cheers of the spectators lining the route.

At Nan-t'ang, the doors ornamented with festoons and the suite of rooms 'created a very pleasant effect'. The musicians installed themselves on mats or in a 'rustic room' situated between two dwelling blocks, a sort of courtyard lined with two rows of yew trees. Finally they entered the finest room in the College, embellished with pictures painted by Castiglione in his youth: *Constantine on the point of Victory* and *The Triumph of Constantine* and by *trompe-l'œil* decorations which the monks of the period called 'perspectives that deceive'. Then a mandarin respectfully placed the Emperor's gifts in a niche alongside those prepared by the missionaries.

In principle, all the European churches of Peking were represented at Nan-t'ang. On the day of the celebrations the Emperor, fully aware of their quarrels, insisted on this point. Jesuits, Franciscans, Dominicans, in palace dress, prostrated themselves nine times, touching the earth with their foreheads – according to the Chinese ceremonial – in homage to the sovereign of the Celestial Empire. Finally, all the rites accomplished, the atmosphere relaxed and tea was taken. The birthday celebrant addressed his thanks to the Emperor in writing, while the *tung* went to give him an account of the smooth running of the ceremony.

Horses Presented in Tribute by the Ta-wan. Painting on silk (detail). 0.66 × 6.58 m. Cat. 104. Collection Cheng Te-k'un, Cambridge.

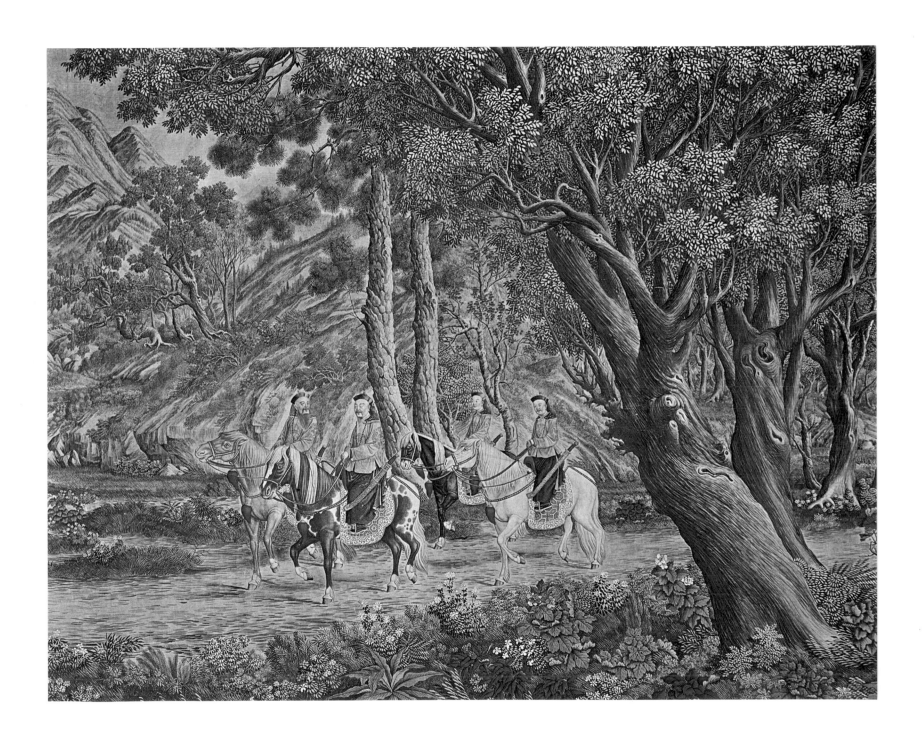

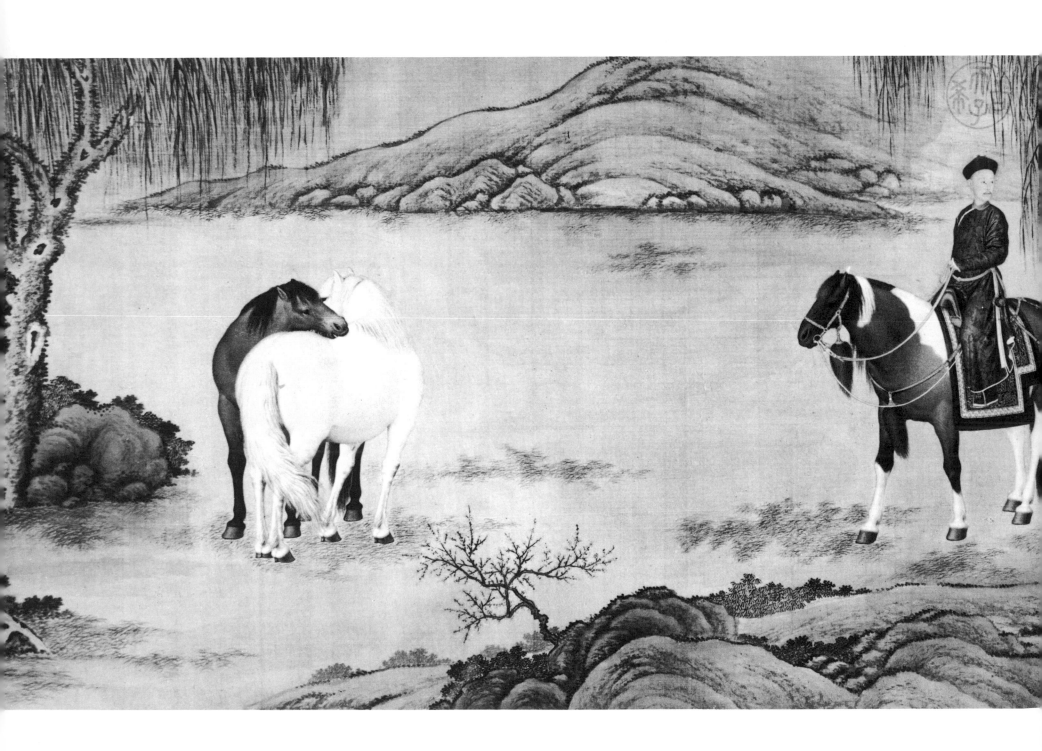

Castiglione's Death

Castiglione died in Peking on 17 July 1766. The Jesuits, as we have seen, no longer enjoyed the same prestige as in K'ang-hsi's time. In spite of trials and misunderstandings, Ch'ien-lung was sincerely attached to the old missionary. He proved it by himself composing the epitaph to be engraved on his tomb.

No description of Castiglione's funeral was written down. Nevertheless, it is easy to imagine the ceremonial, several accounts of which as performed on other occasions are given in the *Lettres édifiantes et curieuses*. [43] The Christian rites were mingled with Chinese customs. All the monks, for example, were dressed in white, which is the colour of mourning in China. Grief was manifested noisily by repeated cries and sobs – a decorous silence would have appeared the height of indifference.

The cortège formed. At its head a group of musicians playing various instruments preceded the bearers of standards, streamers and festoons. Then came the Cross, under a large baldachin ornamented with columns and silk embroideries. The Christians followed, two by two, brandishing banners and candles, with the Virgin and Child under a baldachin.

The coffin, of gilded and lacquered wood, rested on a stretcher under a richly ornamented canopy supported by four columns. The latter, covered in white silk, were linked by festoons of coloured silk. The stretcher, attached to two poles one foot in diameter and of a length proportionate to their thickness, was carried by sixty or eighty men divided between the two sides.

Mandarins, sometimes members of the Imperial family delegated by the Emperor, escorted the body of the deceased on horseback as far as the tomb, two

59

leagues from Peking. The 'infidels' took part in all the prayers accompanying the burial. For their part, the monks prostrated themselves three or four times before the coffin in the Chinese manner – and the cries of the spectators, redoubling their violence, drew tears from the most phlegmatic.

Giuseppe Castiglione's tombstone was found in the plain of Peking by a missionary, Father Ducarme, at the beginning of this century. [44] He himself has described this discovery:

'After crossing the Yung-ting River at Lu-kou-ch'iao, on the Marco Polo bridge, we headed south, following the embankment of the river. Two *li* from there a road opened up. Bordered on one side by a thirteen-foot high bank and on the other by fields at a lower level, the road ran between six rows of centuries old trees which afforded us a shade we greatly appreciated during these dog-days... Chatting as we went, ... we reached a small village directly opposite Chang-hsin-tien, from which it is separated by the width of the river. "Father," said the Christian, "it is here. ... This is Pei-tien-t'ang, the Northern Church, and over there is Nan-tien-t'ang, the Southern Church." Strange, I thought to myself, these names have a Christian ring about them. "And where is the stele?" I asked. "This way." We went through the village, which perhaps contains a bare hundred or so inhabitants, and came to a large, well preserved stone whose base was buried in the sand. The inscription is flanked by two dragons. At the top are engraved the two characters which indicate that the stele was erected by order of the Emperor.

Basin in 17th-century porcelain with the monogram of the Society of Jesus. Museu Nacional de Arte Antiga, Lisbon.

The inscription recalls that the Emperor Ch'ien-lung, wishing to reward the services of the European Lang Shih-ning, erected this stone in his memory and gave him all the surrounding land.'

The Break-up of the Society of Jesus

Castiglione was dead; other talented painters, such as Father Joseph Panzi, had succeeded him; but his memory remained very much alive at Court.

The future was dark for the disciples of St Ignatius Loyola. On 5 August 1774 news reached China of the arrest of the General of the Jesuits, Father Laurent de Ricci, imprisoned in the château de Saint-Ange, and of the papal brief of extinction 'Dominus ac Redemptor noster' proclaiming the dissolution of the Society of Jesus. This decision by Clement XIV, elected Pope following Court intrigues between Portugal and Spain, was a disaster for Christianity in China. Neither the Lazarists nor the Fathers of the foreign missions were ever to regain the privileged positions the Jesuits had formerly enjoyed at the Imperial Court. This setback to peaceful penetration in China was to have serious consequences. During the following century the Europeans employed very different methods to impose their will: the cannon took the place of the sermon.

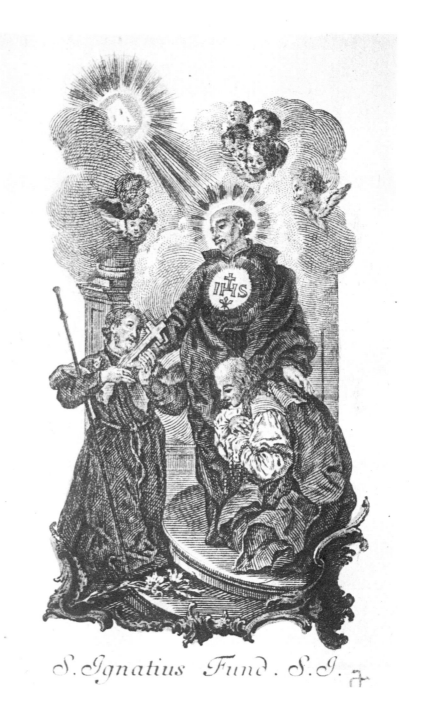

S. Ignatius Fund S. I. Etching by Klauber after a work by Castiglione made in Peking. Cat. 119. Archivum Romanum Societatis Iesu, Rome.

Castiglione the Architect

Yuan-ming-yuan

Facsimile of a transfer of a drawing by Castiglione. After Maurice Adam: *Yuen-ming-yuen*.

Six miles north-west of Peking, on a fresh and shady site, stands the Summer Palace, the favourite residence of the emperors of China. The horizon to the north is formed by the Wan-shou-yuan 'Hill of a Myriad Years of Long Life', while to the south stretches the K'uen ming lake. The first residence was built here in 1153 by Emperor Wanyen Liang of the Chin: the Garden of the Golden Waters. The Yuan emperors increased the dimensions of the lake. Under the Ming there appeared the Yuan-ching-ssu, 'Temple of Perfect Tranquillity', and various pavilions forming with the garden a complex called the Hao-shan-yuan, 'Garden of Miraculous Hills'.

Thus each dynasty made its contribution towards the embellishment and enlargement of these Summer Palaces. K'ang-hsi occupied the Ch'ang-ch'un-yuan, 'Palace of Flowering Spring', of which two entrance pavilions exist today, almost opposite the Red Gate of the present University. His son Yung-cheng, then a prince, laid out the Yuan-ming-yuan, 'Garden of Perfect Clarity', a name which soon came to be applied to the totality of the buildings and gardens. But it was incontestably Emperor Ch'ien-lung who contributed most to the embellishment of these pleasure houses. Close to the Yuan-ming-yuan he laid out the Ch'ang-ch'un-yuan, 'Garden of Luxuriant Spring' (*ch'ang* is written here with a different character and means long and not flowering, as above), so-called in memory of the place where he had spent his youth, and the Wan-shou-yuan, 'Garden of a Myriad Years of Long Life'. Without a doubt, he had long intended to erect here palaces in the European style in imitation of those which he had seen in the engravings brought

65

The Great Fountain. The hydraulic masterpiece by Castiglione and Father Benoist in the gardens of the Yuan-ming-yuan. After a collection of etchings in the Bibliothèque Nationale, Paris.

by the Jesuits. The Emperor himself decided on the position of the future building: the whole of the northern section of the Garden of the Long Spring. He then instructed Castiglione, his favourite painter, to draw up plans and choose his collaborators. It is interesting to note the role of architect falling to Castiglione, known above all as a painter and draughtsman. To assist them in this work, the missionaries sent to Europe for a certain number of works on architecture, among them *Le premier volume des plus excellents*

一面南趣奇諧

The Palace of Delights and Harmony (Hsieh-ch'i-ch'ü) in marble with Corinthian motifs. After a series of etchings made by the pupils of the Jesuit Fathers *ca*. 1785. Bibliothèque Nationale, Paris.

bâtiments de France by Androuet du Cerceau, three versions (Latin, French and Italian) of Vitruvius' *De Architectura* and several Italian books. [1]

The designs submitted to the Emperor by Castiglione were a fascinating kind of Baroque. Architectural motifs, colonnades and volutes were combined together with an exuberance reminiscent of the style of Borromini. Had not Ch'ien-lung called for palaces 'in the manner of the European barbarians' in the midst of a multitude of jets of water, cascades and fountains?

67

Castiglione placed the hydraulic aspect of the work in the hands of a French Jesuit, Father Michel Benoist.

In the building itself he was assisted by two other Jesuits: a German, Father Ignatius Sickelpart, and a Florentine, the architect Ferdinando Bonavventura Moggi, designer of the new church of Tung-t'ang. For the heavy labour he made use of Chinese craftsmen trained by himself. Their work stretched over a rather long period, from 1747 to about 1759.

In the beginning, the missionaries' movements were governed by a strict protocol. They entered the Yuan-ming-yuan only at certain hours and under the surveillance of eunuchs, servants and mandarins. Little by little, the orders were relaxed. First Father Benoist, then all the other European Jesuits, were given freedom to come and go as they pleased in the vast precincts. In the evenings they returned to their house in Hai-tien, a small village half-way between Peking and Yuan-ming-yuan. They made this journey on mules, but one of them wrote: 'To travel this distance, although it is in beautiful gardens, is no longer a pleasant outing when it takes place every day and sometimes several times a day.' The missionaries had to travel constantly from one site to the other. 'As soon as Father Benoist had put his workers to work in a garden he had to go either to one workshop or another, half a league and sometimes two leagues from the palace; then he hurried back to the garden to wait for the Emperor. The heat, the rain, the wind and the blazing sun of the dog-days were no reasons to slow down the work'. [2]

The garden of Yuan-ming-yuan comprised three precincts. In the first stood the Hsieh-ch'i-ch'ü, 'Palace of Delights and Harmony'. This building, said the French Jesuits, 'would bear comparison with the châteaux of Versailles and Saint-Cloud'. All of marble and majolica, with Corinthian motifs, it was flanked by two pavilions linked by a glazed gallery – pavilions intended for the musicians. But what most enchanted the Emperor was a complex of fountains designed by Father Benoist. From his window, seated on his throne and surrounded by his concubines, he could contemplate the jets of water spat out by bronze sheep and wild geese 'and the kind of war which the fish, the birds and the animals of all kinds in the pool, on its banks and up on the rocks are supposed to be waging'. [3]

A bridge and fountains in the manner of Frascati led to the second precinct where there was the maze and its central kiosk, all of marble. On the day of the Feast of Lanterns, the 15th of the eighth month, Ch'ien-lung organized a lantern race for the young girls of the Palace. Each of them carried at the end of a pole a waterlily of yellow silk with a lighted candle attached to its tip. 'It was like myriads of stars shining among a thousand green pine trees.' The first to reach the kiosk received a gift. This maze was called the Hua-yuan, the 'Garden of Flowers' (but also the 'Garden of Lanterns of Yellow Flowers'). In the centre rose the Hai-yen-t'ang, 'Palace of the Calm Sea', so-called on account of the vast reservoir placed on the terrace to feed the fountains and cascades. The architecture of the building, despite numerous Baroque details, was inspired at once by the Trianon and the court of honour at Versailles. Ch'ien-lung particularly prized the extraordinary water-clock decorating the foot of the monumental staircase. It had given Father Benoist a great deal of trouble: twelve animals, a rat,

The Palace of the Calm Sea (Hai-yen-t'ang) (West façade) so called on account of the vast reservoir placed on the terrace. After a collection of etchings in the Bibliothèque Nationale, Paris.

a bull, a tiger, a hare, a dragon, a snake, a horse, a goat, a monkey, a cock, a dog and a wild boar spat out water one after the other in turn for an hour. At midday alone the water spurted from all their mouths.

Castiglione also built other less important pavilions, such as the Hsü-shui-lu, 'House for Gathering the Waters', which concealed a hydraulic machine similar to the one at Marly; the Chu-t'ing, a pavilion of

69

The Palace of the Calm Sea (Hai-yen-t'ang) (North façade). After a collection of etchings in the Bibliothèque Nationale, Paris.

bamboo incrusted with coloured glass and shell ornaments; the Hsien-fa shan-men, 'Gate to the Hill of the Vista', with a three-arched triumphal arch of brick and glazed tiles; the Yang-ch'üeh-lung or aviary, whose walls were covered with paintings of boats and pheasants. Here peacocks and other rare and precious birds were reared. For this building Castiglione had designed a wrought-iron door with a jig-saw pattern. The casting was carried out by another Jesuit, Brother Gilles Thibault, a specialist in this technique. The Emperor greatly appreciated this work, which was entirely new to his eyes.

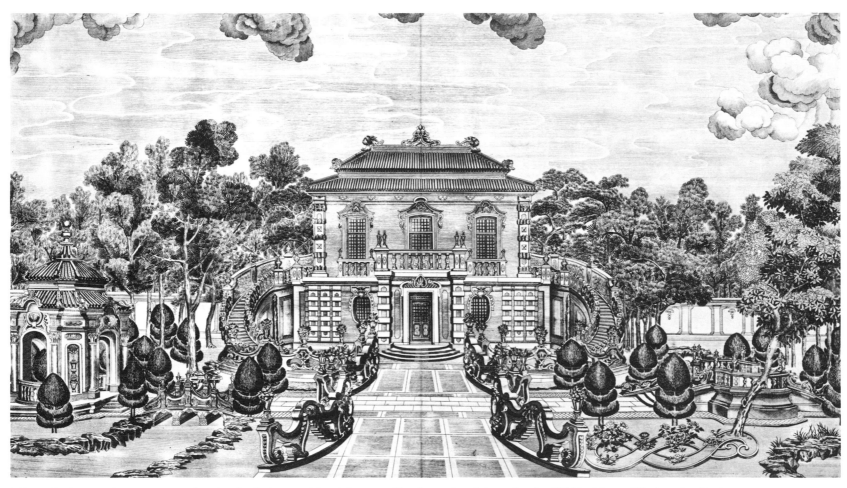

The Belvedere, with monumental stairs built in marble. After a collection of etchings in the Bibliothèque Nationale, Paris.

Let us add the Fang-wai-kuan or belvedere, with a monumental staircase, as at Fontainebleau, protected by a marble balustrade. Later, Ch'ien-lung was to transform this pavilion into a mosque for the beautiful Hsiang Fei, who came from Aksu in Turkestan. Her husband, the governor of Yarkand, had followed Amursana, chief of the Kalmucks, in his revolt against Ch'ien-lung. He was killed in battle and his widow taken prisoner and brought by force to Yuan-ming-yuan. Ch'ien-lung conceived a passionate love for the young Moslem woman, but nothing could shake the virtue of 'Model Beauty', who threatened with her dagger anyone who tried to approach her. One day when the Emperor was absent from the palace the

71

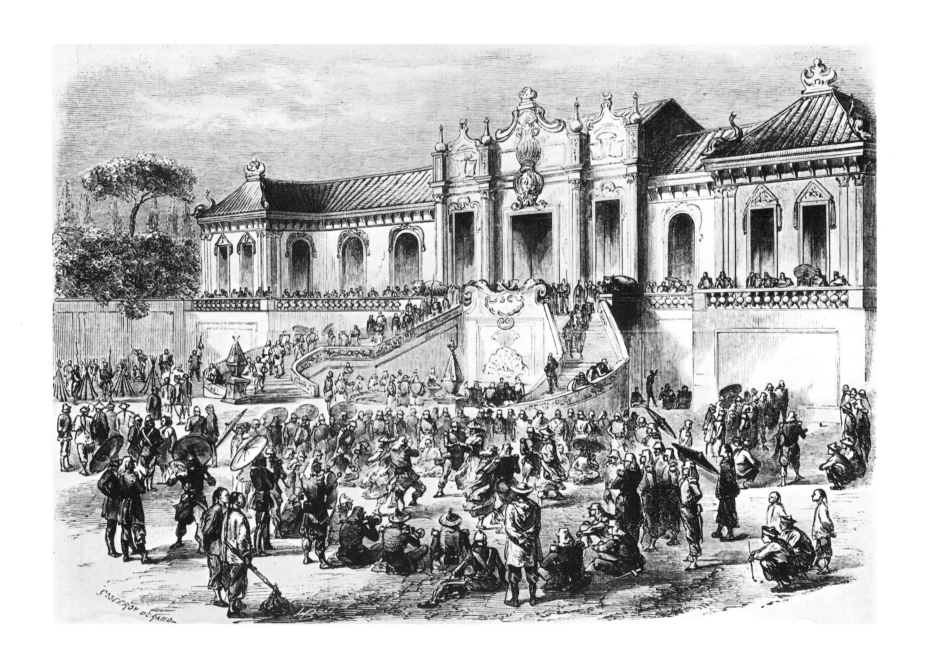

72 Pillage of the Yuan-ming-yuan in 1860. After a sketch by an officer published in *L'Illustration* on 22 December 1860.

Dowager Empress decided to bring matters to a head. She sent for the young princess and asked her: 'What is your intention?'. 'To die', replied the princess. The Empress had her taken to a room at the end of a far-off wing, where the Moslem hanged herself from the beams of the ceiling. Ch'ien-lung's grief was immense. He ordered for the unyielding young girl a funeral like that of a concubine of the first rank.

The Yuan-ying-kuan pavilion ('View of the Distant Lake') had been erected for Hsiang Fei. The decorations included multiple mirrors. A painting attributed to Castiglione, which was in the Lazarist mission in Peking, is said to represent the central room of this pavilion.

So that 'Model Beauty' should feel more at home, the Emperor requested Castiglione to execute oil paintings of sites at Aksu in Zungaria. These pictures were arranged in various planes to create the illusion of perspective. A system of runners enabled them to be interchanged and displayed like magic lantern slides. The intention was to comfort the young princess, but the effect of these precautions was merely to make her more homesick... [4]

In designing the interior of the palaces Castiglione had to take account of the Emperor's tastes. He had to forego internal staircases, because Ch'ien-lung did not wish 'to live in the air' like a European. 'One would have to be very poverty-stricken and lack land like the Europeans, to live like that', he said. He also disapproved of caryatids and nudes. [5]

Portrait possibly of Princess Hsiang Fei, a concubine of the Emperor Ch'ien-lung. Oil painting attributed to Castiglione. Cat. 84. National Palace Museum, Taipei, Taiwan.

A number of rooms were decorated with Gobelins tapestry presented by Louis XV in 1767, full-length portraits of beauties of the French Court 'with their names at the foot', and a profusion of magnificent pier-glasses. The Emperor had received from Europe so many mirrors that he had them cut up to serve as window-panes.

It is clear that everything in these buildings was aimed at effect: architectural motifs devoid of all sense, a Baroque profusion of superfluous ornaments. The pilasters of white marble contrasted with the walls of brick scrimmed with red plaster. The proliferation of colours recalls certain Italian or Portuguese palaces. But the roofs covered with yellow, blue or green tiles respected the Chinese tradition. Composite as it was, the total effect was none the less elegant. It was impossible, as the Jesuits put it, not to 'admire the art with which this irregularity was carried out'.

When the Franco-British troops led by Lord Elgin and General Cousin-Montauban pillaged the Summer Palaces in 1860, the paintings were already split, the European furniture dilapidated and 'all the finest things from France and England' in a very bad state. The soldiers found a profusion of jewels, gold snuff boxes and comfit dishes, table services, and sumptuous costumes in which they dressed themselves. It was a pretty masquerade. They enjoyed themselves to their hearts' content with the remarkable collection of automata which the Chinese emperors had received from Western sovereigns. 'The second night we spent in the Summer Palace was impossible, crazy, giddy,' the Comte d'Hérisson wrote in his diary. 'Every trooper had his bird, his music box, his alarm clock and his rabbit... Everywhere bells were ringing.' The pillage lasted two days and ended with a fire. The delirious soldiery tore down tapestries threaded with silver to try to put out the blaze. [6]

Thus the Arabian Nights palace of the emperors of China and their strange toys, monkeys, dancers, cymbal-playing rabbits, went up in flames, while the singing birds warbled madly in their golden cages. However, not everything was irreparably lost. What escaped pillage and destruction constituted a booty of which part was sent to Queen Victoria and part to Napoleon III. These jades, bronzes and porcelains are now for the most part displayed in the Victoria and Albert Museum and the palace of Fontainebleau. They do not all testify to the aesthetic judgment of the Franco-British Army.

At the beginning of the century there still remained some vestiges of the European palaces. This is reliably shown by Osvald Sirén's photographs. [7] As for myself, after much searching I found in a maize field the ruins of the Great Fountain, Father Benoist's hydraulic masterpiece, situated directly in front of the throne room. 'These stones', a peasant told me, 'used to be employed for making aerated water.' Thus even the memory of buildings once dedicated to all the refinements of pleasure has vanished.

There is nothing left today to bear witness to this magnificence but twenty copper-plates made in 1786 by Chinese pupils of the Jesuits. Work executed under the supervision of the Emperor in person, writes Father Bourgeois. 'The Emperor wished to have the plan of his European houses built at Yuan-ming-yuan to put with those of the Chinese palaces that had been painted at his orders. He called two or three of Castiglione's

disciples. They worked under the eyes of this prince, who often corrected the plans. Then he had them engraved on copper. It was the first test of the Chinese talent for copper-plate engraving.'[8]

Father Bourgeois, in giving these details, forgets that previously the missionaries and their Chinese pupils had engraved maps of the Empire on copper. The Father, who was the correspondent of Louis-François Delatour, librarian, collector and secretary to the King, sent him the Chinese engravings of the European palaces at Yuan-ming-yuan. In 1793 Delatour was imprisoned and to his great regret had to dispose of them. In 1954 a series of the same engravings was sold through my good offices at the Hôtel Drouot. It was valued at 250,000 francs and pre-empted by the Bibliothèque Nationale. A lithographic reproduction of this *Yuan-ming-yuan t'u* album was published in Shanghai in 1930. The missionaries' original drawings have disappeared, but there exists a copy made in 1794 for Van Braam Houckgeest, director of the Dutch trading station in Canton.

George Loehr, in an article on Van Braam Houckgeest in the *Princeton University Library Chronicle*, relates that Van Braam wrote a letter to Talleyrand offering his precious collection to the French Government. But the Directoire attached no importance to this offer and did not even deign to reply. Van Braam sent his collection to London, where it was sold at Christie's sale room in Pall Mall on 15 and 16 February 1799. I have found Van Braam Houckgeest's copy in the print room of the Bibliothèque Nationale in Paris. Thus, by a round-about route, the Dutch collector's wish has finally been fulfilled.

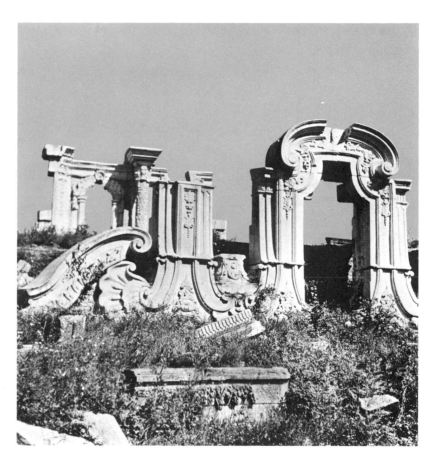

Yuan-ming-yuan. Ruins of the building behind The Great Fountain.

75

Castiglione and the Conquests of the Emperor of China

On the 26th day of the fifth moon of the thirtieth year of his empire – 13 July 1765 to be precise – Ch'ien-lung promulgated a decree translated at the time as follows:

'I wish the sixteen prints of the victories that I won in the conquest of the kingdom of Chumgar and the neighbouring Mahommedan countries, which I had painted by Lamxinim and the other European painters who are in my service in the city of Peking, to be sent to Europe where the best artists in copper shall be chosen so that they may render each of these prints perfectly in all its parts on plates of copper.' [1]

Thus engraving, another great expression of European art, interested the Emperor no less than painting. He had seen engravings of battles executed after the originals of the German painter Rugendas (1666–1742) and this had given him the idea of immortalizing his recent victories in Upper Asia.

The struggle carried on for several years against the Kalmucks (or Eleuths) had come to an end in 1759. Zungaria, in eastern Turkestan, had submitted. Kashgaria, for long a vassal of the Zungars, was annexed in 1759 under the name of Sin-kiang or New Territory. Thus the whole of Upper Asia had come under Chinese authority. The final conquest was followed, in April 1760, by a grandiose ceremony in the course of which Generals Chao-hui and Fu-te, victors in this campaign, were heaped with honours. Ch'ien-lung instructed the Court painters, and especially the Jesuit missionaries, to paint their portraits at the same time as a series of battle scenes destined to decorate the central hall of the Tzu-kuang-ko on the east bank of the central lake in Peking. It was in this hall, installed in 1760, that Emperor Ch'ien-lung used to receive tributary princes and European ambassadors. [2] Amiot, in his biography of Father Attiret, states that 'during the whole time that this war against the Eleuths and other Tartars their allies lasted, as soon as the troops of the Empire had won a few victories, the order was immediately given to the painters to depict them. Those of the principal officers who had played the greatest part in events were chosen for preference to figure in painting as they had done in reality.' The missionary painters were, in a sense, reporters before the word was thought of. According to the scholar Paul Pelliot the drawings to be engraved from, sixteen in number, reproduced on a reduced scale the mural paintings in the palace. [3] The latter had been executed by Giuseppe Castiglione, Jean-Denis Attiret, Ignatius Sickelpart and a barefoot Augustinian, Father Jean Damascène, who in 1788 became Bishop of Peking. The Emperor was very impatient. 'I wish this work to be executed with the greatest celerity', he wrote. But once the decree had been promulgated conflicts of influence divided England and France, each country wishing to attract attention to its own merits. As the final decision rested with the viceroy of Canton, the superior of the French Jesuits of Canton, Father Le Febvre, sent one of his mandarin friends to see him. This mandarin, 'a declared protector of the French, succeeded in convincing the viceroy that the arts were more cultivated in France than in any other country in Europe and that engraving especially was carried there to the highest point of perfection'. [4]

The importance of this order was not solely of an artistic nature. It was thought that it would also direct China's interest to France and enable precious advan-

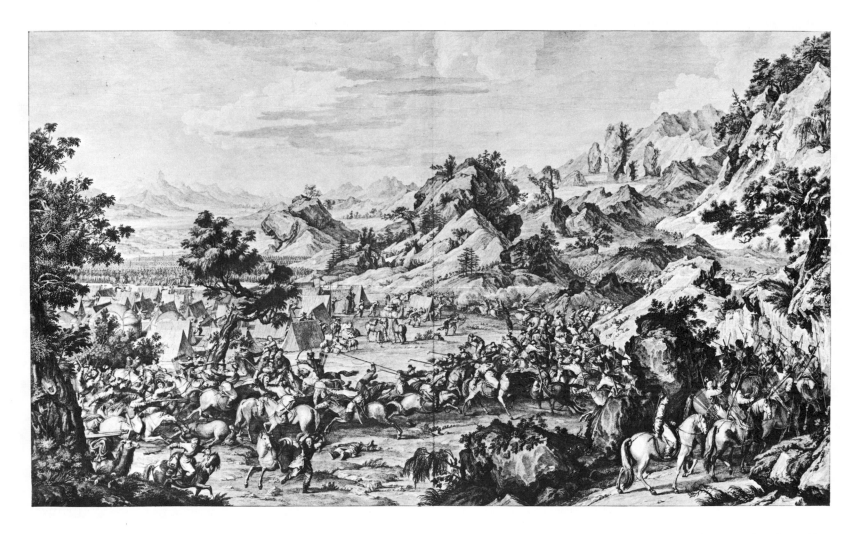

The Storming of the Camp at Gädän-Ola. Etching from the series *The Conquests of the Emperor Ch'ien-lung* after a drawing by Castiglione. Cat. 121. Bibliothèque Nationale, Paris.

tages from both the commercial and the religious point of view to be obtained. The Dutch, the Portuguese and above all the English constituted rivals from whom it was good, on any occasion whatever, to distinguish oneself.

Once the decision had been taken, the matter was concluded according to the rules. Transactions between Chinese and Europeans were governed by strict protocol. Only the Hong merchants privileged by the Emperor, were entitled to negotiate with the

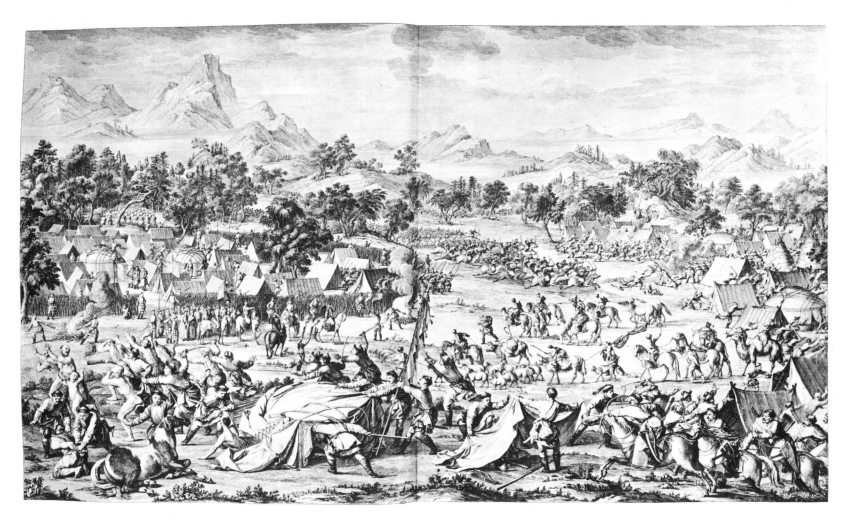

The Battle of Oroi-Jalatu. Etching after a drawing by Castiglione. Cat. 123. Bibliothèque Nationale, Paris.

'foreign devils'. Each nation had its own Hong. The contract for the execution of the engravings was signed by P'an T'ung-wen, the intermediary of the French, along with nine other merchants. Numerous precautions were taken to ensure the success of the enterprise. To reduce the risk of loss – shipwrecks were frequent at that time – the drawings were to travel on four different ships and to return in the same way. The prints were to be divided equally between two ships. The period allowed for execution was very short:

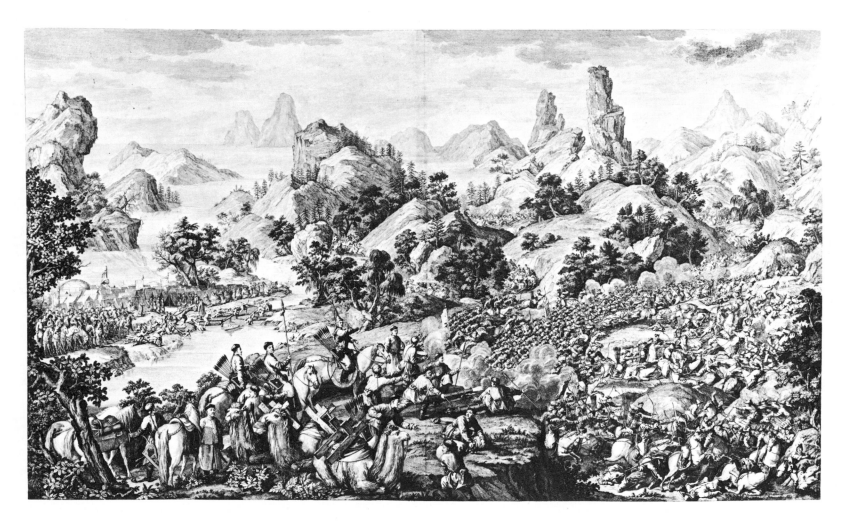

The Raising of the Siege at the Black River. Etching after a drawing by Castiglione. Cat. 122. Bibliothèque Nationale, Paris.

everything had to be back within the thirty-third year of Ch'ien-lung's reign, that is to say, in 1768.

It was not until 31 December 1766 – more than a year after its promulgation – that Ch'ien-lung's decree reached the Marquis de Marigny, director-general of the King's buildings and director of the Académie Royale de Peinture. It was accompanied by a letter from Castiglione, who had died six months earlier,

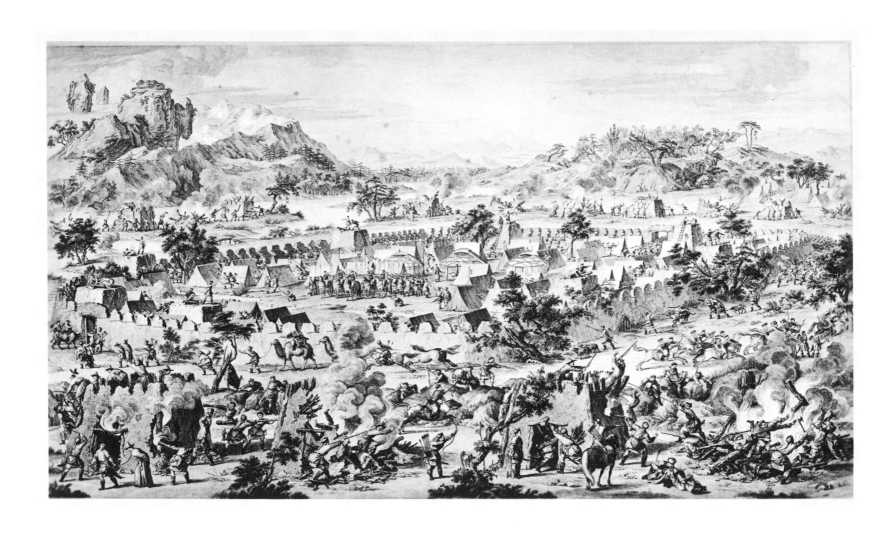

The Battle of Tongusluk. Etching after a drawing by Castiglione. Cat. 124. Bibliothèque Nationale, Paris.

giving very precise advice on the execution of the engravings. 'Although the Emperor's decree accompanying my letter according to his orders will be sufficient for the artist charged with engraving the prints to conform exactly to the original, in order to leave nothing for the Emperor to desire and for the sake of the reputation of European artists I have thought it proper to recommend two things to you:

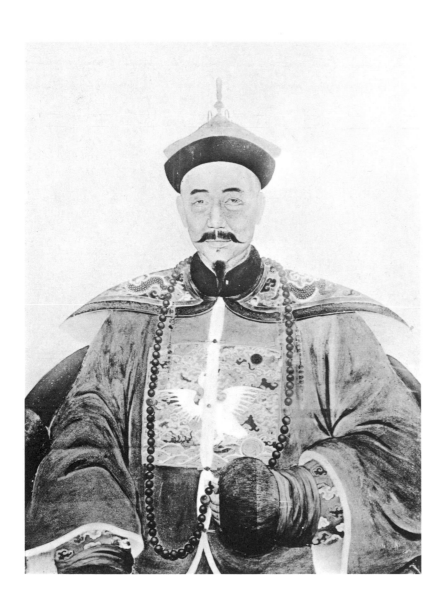

Portrait of the Hong merchant P'an Ch'i-kuan. Painting under glass. Goeteborg Museum, Goeteborg, Sweden.

'1. The first time the prints are engraved with the graver or etched with acid take care that they are expressed on the copper with the greatest and most graceful delicacy, and that the artist performs his task with the greatest possible exactitude and precision, as befits a work to be presented to such a great Emperor.

'2. If, after the number of prints requested by the Emperor, the plates prove to be faint or worn, they must be retouched and repaired before being sent to China, so that the new prints made from them in the country may have the same beauties as the first ones.' [5]

Charles-Nicolas Cochin, of the Académie Royale de Peinture et de Sculpture, was immediately charged with getting the work started.

Cochin chose artists whose talent he knew: Augustin de Saint-Aubin, Jean-Philippe Le Bas, B. L. Prévôt and Jacques Aliamet. These set to work, on 22 April 1767, engraving the first four plates 'after and in conformity with the drawings of the missionaries and with any improvements that might be made by Monsieur Cochin'. When the twelve other drawings arrived – in July – other engravers joined the undertaking to speed its completion: Denis Née, Louis-Joseph Masquelier, then Pierre-Philippe Choffard and N. de Launay.

Everything was done to ensure complete success. France's prestige was at stake. The Imperial order aroused tremendous curiosity. Henri-Léonard Bertin, deputy of the department of the Compagnie des Indes, had even suggested to the King, when the first drawings arrived, that they should be reproduced on vases of Sèvres porcelain and woven at the Gobelins. 'This would give the whole empire of China a high idea of the superiority of our artists, our manufactures and our

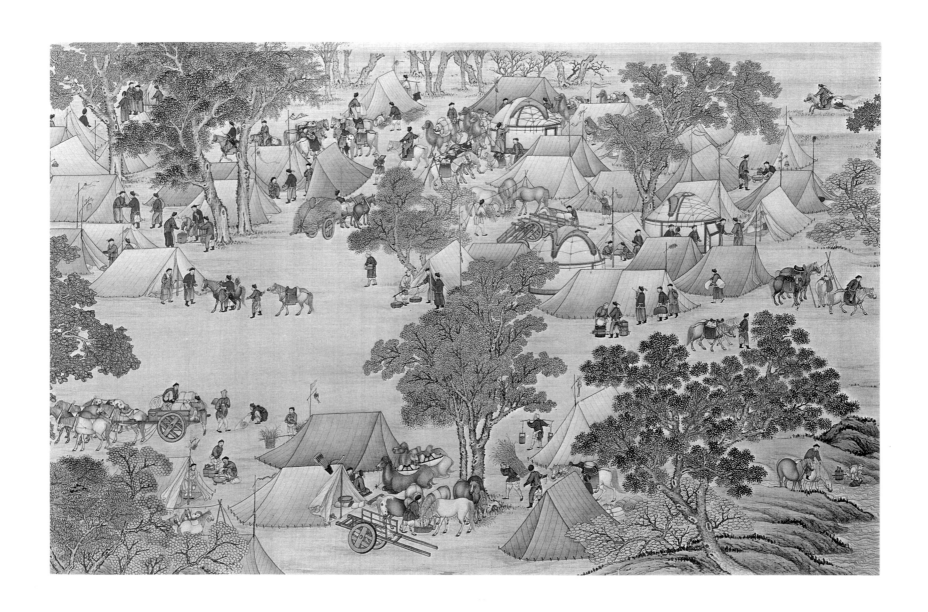

Mu-lan II. The Camp. Painting on silk (detail). *Ca.* 0.77 × 27 m. Cat. 49. Musée Guimet, Paris.

nation, and the French would no longer, as they are in China, be confused with the other nations under the name of Europeans.' [6] Did the King give his consent? A letter from Bertin to Marigny permits us to suppose so, as far as the Sèvres porcelain is concerned. Unfortunately, I have found no trace in the factory archives of any such order having been carried out.

Copper-plates were brought from England. As for the printing, paper of French manufacture was generally only thirty-six inches wide so Sieur Prudhomme, a paper merchant, was ordered to manufacture specially a paper called 'Grand Louvois' adequate to the dimensions of the drawings. The printer chosen, Sieur Beauvais, was 'the only one in whom one can place entire confidence, both as to his talents, which are above those of others, and as to his probity, which is well known'.

The correspondence exchanged between Cochin and Marigny bears witness to the slowness of the work. If we are to judge by the accounts found in the Archives Nationales, delays in paying the engravers scarcely encouraged rapid completion. On the other hand, inequalities in the standard of the originals created numerous difficulties. Father Damascène's drawing, for example – which was among the first batch to reach Paris – gave Cochin a lot of trouble. 'The second plate', he wrote to the Marquis de Marigny, 'is by Monsieur de Saint-Aubin. It has turned out quite well, but it arrived later than Monsieur Le Bas' because it had to wait until I had modified the drawing which, being by Father Damascène, was among the less good ones.'

Account also had to be taken of the Imperial taste.

'You have already been informed', writes Marigny to Cochin, 'that the Chinese prefer exactitude and finish of execution to everything which with us would characterize genius and talent. It is right that they should be given what they want.'

To enable Cochin to carry out his task, the King freed him from his other duties. He constantly intervened in the work of the engravers. 'I have been so pressed by Monsieur Le Bas for a drawing of China that is intended for him that I have been working to excess and without turning from it for a single moment', he wrote in 1771.

From time to time Bertin, general controller of finance, who kept up a regular correspondence with the Jesuit missionaries in Peking, requested Father Benoist, superior of the French mission, 'to inform the Emperor of China of the care being given this work'. And the Emperor did not omit to express his satisfaction.

Such a concern for perfection naturally occasioned delays in delivery far exceeding those that had been foreseen. The first seven engravings did not reach Peking until December 1772, the last batch in 1775. Castiglione, having been dead for more than nine years, did not have the joy of seeing the fruit of his labours! The Hong merchants of Canton paid the Compagnie Française des Indes the sum of 204,000 francs for these engravings. All the copper-plates were sent – as laid down by the contract – with a printing of two hundred copies. Every precaution had been taken to prevent any element of the work from remaining in the hands of the engravers. But some prints certainly slipped through the net. Apart from the copies for the royal family and the King's library, Bertin, a great collector

a garder pour nous servir a faire les distributions des sommes payées

22e. mars 1773. Tableau des acomptes qu'il paroit necessaire de distribuer pour parvenir a ce que touttes les Planches soyent achevées cette année, avec les temps ou il sera apportun de les donner.

En Avril.	a M. De St. Aubin	3000	5300 #
	a M. De launay	1000	
	Sur les fournitures du Papier	1000	
	Pour l'Imprimeur	300	
En may.	a M. Le Bas	2000	8300
	a M. Aliamet	3000	
	a M. Choffard	2500	
	a compte sur le Papier	500	
	Pour l'Imprimeur	300	
En juin	a M. Prevost	3000	4600
	a compte sur le Papier	1000	
	Pour l'Imprimeur	600	
En juillet	a M. Choffard	2500	3800
	a compte sur le Papier	1000	
	Pour l'Imprimeur	300	
En Aoust	a M. De St. Aubin	2800	3100
	Pour l'Imprimeur	300	
En Septembre	a M. Le Bas	3000	8900
	a M. Aliamet	3000	
	a M. Choffard	2000	
	Pour l'Imprimeur	900	

Il restera quelque somme mediocre a payer pour solder tant avec le Papetier qu'avec l'Imprimeur pour les Encaissages et autres frais, aussi bien que pour les honoraires accordés a M. Cochin.

who never lost sight of his interests, did not fail to reserve a complete set for his private collection (the Hôtel Bertin stood at the corner of the Rue Neuve des Capucins and the boulevards), but he refused this privilege to Attiret's brother, a painter in Dole. One set in a wooden coffer decorated with a five-clawed Imperial dragon, and another bound with the arms of France, are in the Bibliothèque Nationale, a third is in the Bibliothèque Mazarine, a fourth in the Musée Guimet (gift by Wannieck, 1925) and a fifth incomplete set of fifteen prints is in the possession of the Musée de Fontainebleau (left to it by Faucigny-Lucinge, 1964). Finally, Louis XVI presented a set to his Minister Necker, which is preserved in the château de Coppet, Switzerland.

The prints reserved for the Emperor bore manuscript poems by Ch'ien-lung accompanied by the seal of the Imperial Library and small seals indicating that this is the Emperor's calligraphy. What happened to these copies? After the Boxer Rising of 1900 the Imperial apartments were sacked by the Austrian soldiers quartered in the city. Among the booty seized were the celebrated engravings. After being sold to a famous collector, one series, through my good offices, was put on public sale at the Hôtel Drouot in 1952, together with a copper-plate engraved by J.-P. Le Bas representing the battle of Khorgos after a drawing by Father Attiret.

To avoid all confusion, let us note that in 1785 Isidore-Stanislas Helman, a pupil of Le Bas, engraved

List of advances to be paid to the artists for the series of etchings *The Conquests of the Emperor Ch'ien-lung.* 22 March 1773. Archives Nationales, Paris.

a new series of *The Conquests of the Emperor Ch'ien-lung* on a smaller scale. The Musée Guimet possesses two copies of these (numbers 33 534–97 and 1392–97). These engravings are not of the same quality as the original series. The captions that accompany them contain errors which Paul Pelliot has corrected in the *T'oung Pao* (1921). Moreover, Helman added to this series eight prints (*Ploughing Ceremony Performed by the Emperor of China*, *Banquet at the Palace*, etc.). One of Helman's prints in the Musée Guimet bears the following caption:

'Battles and conquests of the Emperor of China engraved by various French artists under the direction of C.-N. Cochin, by Sieur Helman, engraver of Monseigneur le Duc de Chartres and pupil of Le Bas.'[7]

The Emperor had been so satisfied with the engravings executed in France that he had fresh prints made from the plates in China, by Chinese disciples of Castiglione. After the Kalmuck campaign there were other 'colonial conquests', as Walter Fuchs puts it. Under the aegis of the missionaries, the Chinese engravers illustrated these military successes on the borders of Tibet, in Formosa, Nepal, Annam and Yunnan, using, it seems, sketches by the painter Feng Ning. Somewhat rough in execution, these plates do not possess the quality of the work done in Paris under the direction of Cochin. Their documentary interest is likewise debatable. Some authors allege that most of these glorious battles took place in the imagination of peaceful generals in their camps. Would not to vanquish without battle be one of the forms taken by Chinese wisdom?

Castiglione and Religious Painting

Castiglione felt great admiration for the Jesuit Andrea Pozzo, painter and architect, his senior by forty years. This artist, born in Trento, Italy, in 1642, died in Vienna in 1709, was considered one of the greatest artists of his day, a virtuoso of *trompe-l'œil*, of that famous Italian perspective known as *di sotto in su* (from below upwards). After painting the dome of the church of San Ignazio and the altars of the church of Gesù in Rome, he was called to Vienna to transform the interior of the University church. He then decorated the Summer Palace of the princes of Liechtenstein. On vaults and ceilings Andrea Pozzo liked to paint false architectural features, draperies in iridescent colours, scenes of the apotheosis in the Venetian tradition, or else cherubs whirling in a cloud of golden dust. It has been said, not without some malice, that he brought Paradise down to within sixty feet of the earth *ad majorem dei gloriam*, 'to the greater glory of God', according to the motto of the Society of Jesus.

Born, no doubt, in an artisan environment, Giuseppe Castiglione was probably trained in Genoa in one of the city's workshops. However that may be, by the age of nineteen he was completely master of his craft. Two pictures which he painted in 1707 or 1708 for the chapel of the novices in Genoa were rediscovered by George Loehr in 1961. [1] These works, which represent two episodes in the life of St Ignatius, *St Ignatius in the Cave of Manresa* and *Christ Appearing to St Ignatius*, bear witness to a deep knowledge of foreshortening, perspective and composition. This is a skilled painting in which we find many echoes not only of Andrea Pozzo, but of several great Italian masters of the beginning of the seventeenth century. Divinities appearing through

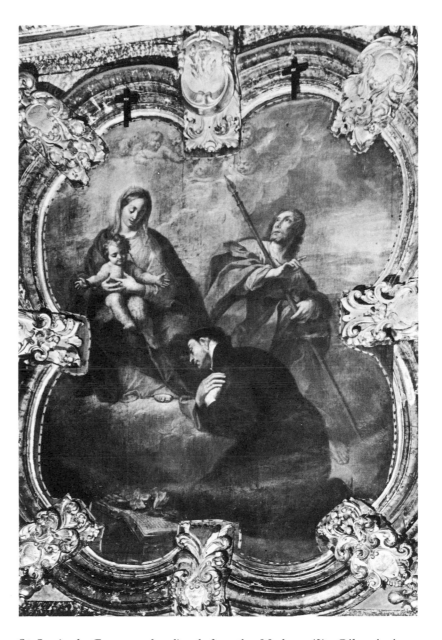

St Louis de Gonzague kneeling before the Madonna (?). Oil painting. Cat. 118. Former chapel of the hospital of the University of Coimbra, Portugal.

a rent in the clouds, mannerism of attitude and gesture, pathos in the expression of the faces, excessive mime – this is the sumptuous and solemn Christian art of the Counter-Reformation.

The paintings which today decorate the chapel of the hospital of the University of Coïmbra have been identified by G. Loehr and Reis Santos as those which Castiglione carried out in Portugal, according to his letter of February 1714.[2] We cannot be quite so definite. In fact these eight pictures do not correspond to the description given, in 1713 and 1714, in Father Antonio Franco's list *(Imagen do secundo secolo da Companhia de Jehsu da Provincia de Portugal)*. Though now in a very poor state of preservation, these paintings deserve more careful study. We set out our own views on page 188.

From his monastery, Castiglione's fame spread as far as the Court, where the Queen, Maria-Anna of Austria, is said to have requested him to paint the portrait of her children Maria Barbara and Pedro.

After such a brilliant start Castiglione, scarcely twenty-six, could hope for a career comparable to that of Andrea Pozzo; but he preferred the difficult, not to say dangerous, life of a missionary in China. In accordance with the principles of St Ignatius, he wished to use his gifts for the greater glory of God. He considered that the 'function' of art was spiritual, that images representing the saints, the episodes of the Gospel or the Bible should move, touch, strike the imagination of the faithful and that nothing was too luxurious for the temple of the Lord.

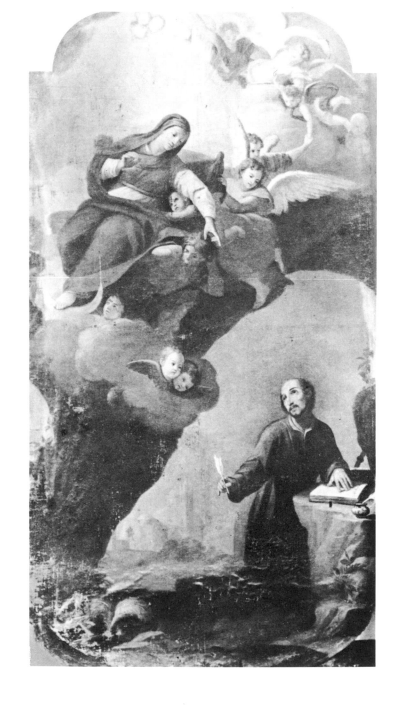

St Ignatius in the Cave of Manresa. Oil painting which was in the chapel of the novices in Genoa. Cat. 110 a.

It was in this frame of mind that Castiglione went to Peking. But the moment he arrived in the capital of the Celestial Empire he realized that freedom of expression was nothing but an illusion. To work for the Emperor of China meant to renounce all his own tastes and be compelled to adopt other criteria. Humble and pious though he was, this constraint must have appeared painful to the young artist. 'For long accustomed to dealing mainly with historical pictures and portraits, he was forced to set aside his early training', writes Father Régis-Evariste Huc, 'and resign himself to painting trees, fruits, all kinds of animals and on rare occasions figures in oils on glass or in water-colours on silk'.[3] Castiglione's time was so taken up by the puerilities of the Court that he scarcely had the leisure to finish two large paintings for the church in Peking, one representing *Constantine on the point of Victory*, the other *The Triumph of Constantine*. Unfortunately these works disappeared during the destruction of the church of Nan-t'ang, where they hung.

Mikinosuke Ishida, author of a remarkable study of Giuseppe Castiglione, quotes a Chinese text by a high functionary of Ch'ien-lung's time, Chao Shen-chen, who describes Castiglione's paintings in the church of Nan-t'ang as follows: 'In the reception room, on the east and west walls [more probably the north and south], a painting of riders at a triumphal parade. Inside the vestibule the saints of the foreign countries seem to be receiving respects. They are depicted full-length, surrounded by people, male and female, young and old, who are playing joyfully and adopting all sorts of poses. They are so beautiful one would think them alive.'

Façade of the Jesuit church in Macao, built in 1601-2.

Mikinosuke Ishida also quotes another text that appeared under the Ch'ing describing the *trompe-l'œil* paintings executed by Castiglione for the Nan-t'ang church:

'In the church of Nan-t'ang there are two paintings in perspective executed by Lang Shih-ning. They cover the whole of two walls, vertically and horizontally, to the east and west of the parlour. If you are standing at the foot of the west wall, close one eye and look at the completely raised bead curtains. The window to

the south-west is ajar. Rays of sunlight are playing on the ceiling. Scroll books closed with ivory needles and jade pins fill the library. There is a magnificent cabinet containing "curios" that sparkle from top to bottom. To the north stands a table. And on the table a vase containing a bouquet of pheasants' feathers. A brilliant feather fan appears in the setting sun. In the rays of the sun the shadow of the fan, the shadow of the vase, the shadow of the table – all perfectly rendered. On the wall we see scrolls and calligraphic paintings hung in pairs in a decorative manner... If you cross the room towards the east, you come to the northern part of a large courtyard. There is a long corridor that seems to continue indefinitely and a succession of columns. The stone paving has a fine, even lustre.

'If you move to the east, you will see something like a house whose door seems not yet to have been opened. If you lower your head to look beyond the window you will see two dogs playing together on the ground... If you stand at the foot of the east wall again and look at the west wall, you will again see the three rooms of the outside building. Close to the window, the sun casts the shadow of three three-footed vases. Three tables are arranged in an arc. Gold flashes. High up on the pillars three large mirrors are suspended.

'To the north-east of this vestibule stand screens; to the east and west two tables covered with rich brocade. On one of them, a pendulum clock that strikes automatically; on the other, an astronomical instrument. Between the two tables stand two chairs. Four oil lamps and candlesticks that seem to be silver are attached to the pillar. Looking at the ceiling, you will see flowers carved in wood; in the centre, you can distinguish the stamens and pistils in relief. These flowers appear upside down. If you look at the ground, it seems as shiny as a mirror and you can count every tile.

'Step forward: you will see the two storeys of bedrooms. The curtains of the entrance door are motionless; everything is profondly calm. Seen from afar, the table in the room is in perfect order.

'You are tempted to enter... You stretch out your hand and suddenly realize that you are facing a wall. The artists of ancient times knew nothing of perspective. Before such a lifelike representation as this, how one regrets that they were ignorant of it!'[4]

According to Father Amiot and letters written by Castiglione to Father Parennin, Castiglione painted religious pictures for certain Chinese Christians living in Peking. The chapel of Prince Paul, a member of the Imperial family, was 'the most beautiful in all China'. It contained oil paintings executed by Chinese but worked over by Castiglione.[5] A Christ painted by Castiglione is said to have been sent to the Queen of Portugal, who piously reproduced it in embroidery with the ladies of the Court. No one knows what has become of these paintings.

Finally, George Loehr refers to an *Archangel Michael* painted in colours on paper. This work, done in China, was presented to Monseigneur Celso Costantini when he became apostolic legate in China. In the *Dictionnaire des artistes*, von Heinecken also lists a *Salvator mundi* and a *Mater amabilis*.

The Portrait Painter

The Genre Painter

The Portrait Painter

K'ang-hsi particularly appreciated the European paint-
ers, if we are to believe the memoirs of a mandarin
named Kao Shih-ch'i. 'In portraiture', he wrote, 'the
Westerners achieve the supernatural perfection of Ku
K'ai-chih [the famous fourth-century Chinese painter].
One day the Emperor said to me: "I have here pictures
of two of my concubines, painted to rival nature by one
of these foreign painters. To you, who are old and have
been long in my service, I can show them without
danger." ' K'ang-hsi presented him with the portraits
of the two young women, one of whom was a Manchu,
the other Chinese. [1] Castiglione cannot have been the
author of these scrolls, since the story goes back to 1703,
prior to his arrival in Peking. It is very probable that
Castiglione, whose influence in the Imperial Office of
Painting was very considerable, painted portraits for
K'ang-hsi later. But there is no reference to this to be
found either in Chinese or European works.

The catalogue of secular paintings in the Imperial
collections, the *Shih-ch'ü pao-chi*, mentions no portraits
of the Emperors K'ang-hsi or Yung-cheng, but only
one of Ch'ien-lung, *shao nien*, an ambigous term which
makes it impossible to tell whether it showed the
Emperor as a child or an adolescent. Ferguson, in his
list of Lang Shih-ning's works, states that this painting
was in Peking in the Palace Museum. [2] In the *Lang
Shih-ning hua chi*, published in Peking in 1931, there is
indeed a portrait of the Emperor as a young man,
signed by Castiglione, on which Ch'ien-lung wrote the
following poem:

Welcoming the Arrival of Spring. Painting on silk depicting the
Emperor Ch'ien-lung as a young man. 0.77 × 0.45 m. Cat. 70.
Former Imperial Palace Collection, Peking.

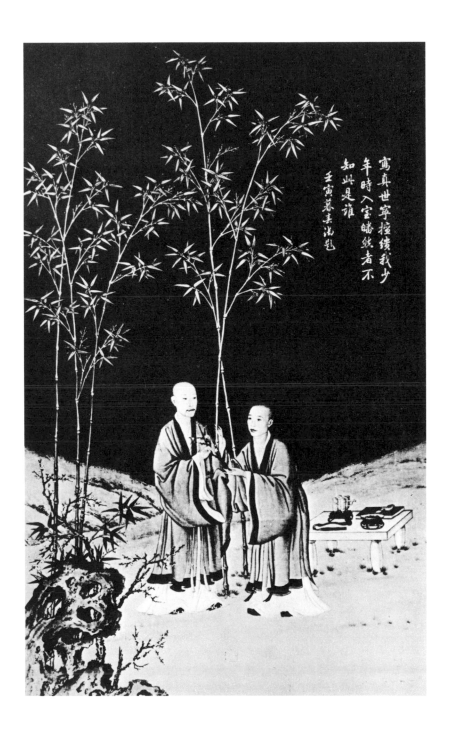

97

In my Heart there is the Power to Reign Peaceably. Painting on silk depicting the Emperor Ch'ien-lung and his concubines. 0.53 × 7.79 m. Cat. 81. Cleveland Museum of Art, Cleveland, Ohio.

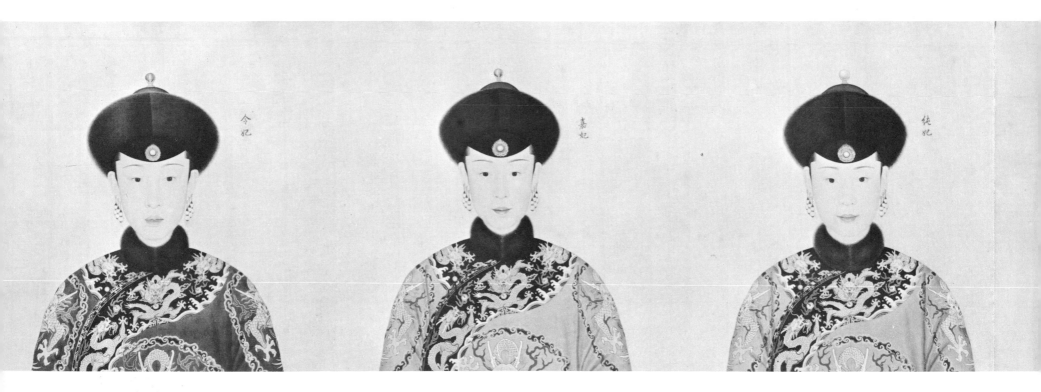

'Shih-ning has no rival in the art of portraiture... He painted me in my young years. When I enter this room today with my white hair I no longer know who this persons is.' This poem figures in the book *The Ceremonies for the Eighty Years of Emperor Ch'ien-lung* (Vol. I, folio 18).

Hu Ching, author of the *Kuo-ch'ao yuan-hua-lu*, says that this portrait was not mentioned in the *Shih-ch'ü pao-chi*, and it was not the only omission.

According to Amiot, Castiglione painted 'more than two hundred portraits of people of different ages and different nationalities'. Father Attiret is even more precise. 'The portraits of the Emperor and the Empress

Red incised lacquer box decorated with the five-clawed Imperial dragon containing the famous scroll depicting the Emperor Ch'ien-lung and his concubines. On the lid the inscription 'In my Heart there is the Power to Reign Peaceably'. Cat. 81.

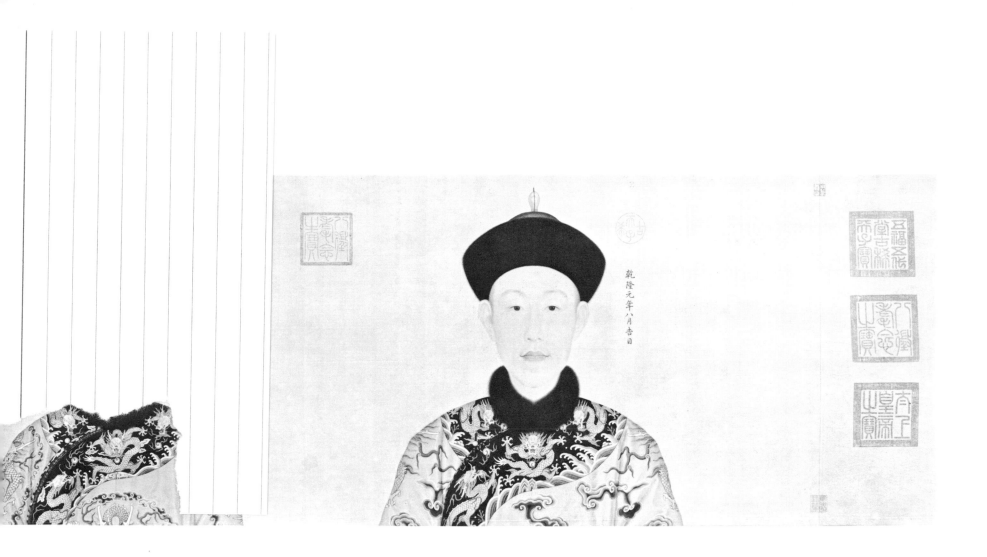

had been painted before my arrival [1738] by one of our Brothers named Castiglione, a skilful Italian painter with whom I am every day.'[3]

A portrait of Ch'ien-lung and his eleven concubines, signed Lang Shih-ning, (originating from the Summer Palace and found by Mr Spink of London) is now in Cleveland Museum. It is an exceptionally interesting painting on silk dated 1737 – hence prior to Father Attiret's arrival in Peking. It depicts the Emperor Ch'ien-lung, aged twenty-one, with the Empress and eleven of his concubines: Noble, Joyful, Sensitive, Worthy of Praise, Excellent, Pleasant, Happy, Distinguished, Honest, Obedient. The three last, portraying women of a mature age, are executed more carelessly. The Emperor, the Empress and the first concubine are wearing the yellow Imperial robe; the others are dressed in red or maroon robes with a little fur collar and a jewel in their hair. This scroll is contained in a red lacquer box ornamented with a dragon and bearing the following inscription: 'In my heart there is the power to reign peaceably'.

The Emperor only looked at this work three times in his life: when the painting was finished, on his seventieth birthday and on the occasion of his abdication. Then he finally sealed the box and declared that anyone who tried to look at the picture would be cut into a

thousand pieces. [4] Curiously, the catalogue of the Imperial collection does not mention any portrait of a woman. However, certain authors attribute to Castiglione three charming paintings, all three of which depict the famous Perfumed Concubine, Hsiang Fei, also known as the Model Beauty. In one of these portraits, today in the National Palace Museum in Taiwan, the young woman is wearing a European style cuirass and helmet; in the second, which belongs to M^{me} Chiang Kai-shek, she is dressed in a red tunic; in the third (reproduced in M. Adam's work *Yuen-ming-yuen*), she appears disguised as a European shepherdess in a hooped dress with a crook and a large hood. Despite the charm and quality of these paintings and their evident European workmanship, it would be audacious to claim that they are Castiglione's work, and more audacious still to claim that this is definitely Hsiang Fei. Let us note also the portrait of a young Italian woman with a dog at her feet which J. C. Ferguson saw in China.

To paint the portrait of the Emperor or any other important personage was no sinecure. 'A European painter', writes Father de Ventavon in a letter dated 1769, 'is in real difficulties from the outset. He has to renounce his own taste and his ideas on many points, in order to adapt himself to those of the country. There is

no way of avoiding this. Skilful as he may be, in some respects he has to become an apprentice again. Here they want no shadow in a picture, or as good as none; almost all paintings are done in water-colour, very few in oil. The first of this kind shown to the Emperor are said to have been done on badly prepared canvases and with badly prepared paints. Shortly afterwards they turned black in a manner that displeased the Emperor, who wants almost no more of them. Finally, the colours have to be unbroken and the lines as delicate as in a miniature.' [5]

At a pinch, the Emperor permitted the use of oils in portraiture, but he did not like their glossy appear-ance. 'Tempera paint', he said, 'is more graceful; it strikes the eye pleasantly from whatever side one looks at it.' In a message addressed to the Imperial Office of Painting, he notes that 'painting in water-colour has a profound significance; it is delectable in every point. Although Attiret paints well in oils, we do not like his water-colours. If he studied water-colour painting he would surely become a great artist. Therefore cause him to study this technique. When he paints a portrait he may employ oil painting. Let him understand our wishes.'

Every portrait had to be painted full face, not at an angle, and the eyes had to be looking at the spectator.

Portrait possibly of Princess Hsiang Fei, a concubine of the Emperor Ch'ien-lung. Oil painting attributed to Castiglione. Cat. 83. Said to be in the collection of Mme Chiang Kai-shek, Taipei, Taiwan.

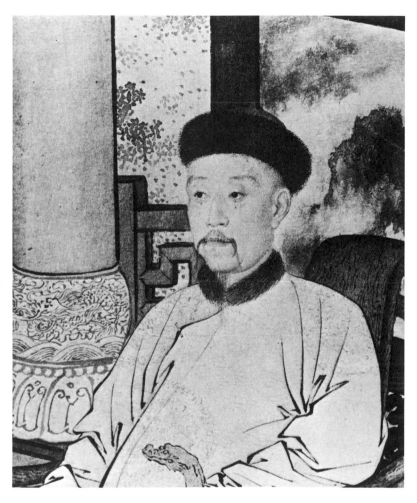

Portrait of the Emperor Ch'ien-lung. Detail of a painting on paper called *Kazaks Presenting Horses in Tribute*. 0.45 × 2.67 m. Cat. 23. Musée Guimet, Paris.

Shadows had to be avoided; they looked to the Chinese like smudges on the face. The Emperor attached great importance to likeness. He demanded that he should be painted with all the lines and imperfections of his face, not forgetting the tuft of hairs just above one eye – a small defect which a European painter would not have failed to conceal. When, as a good courtier, Father Benoist remarked that one did not notice it, the Emperor replied with a smile: 'Right, then tell him to paint this fault in such a way that one does not

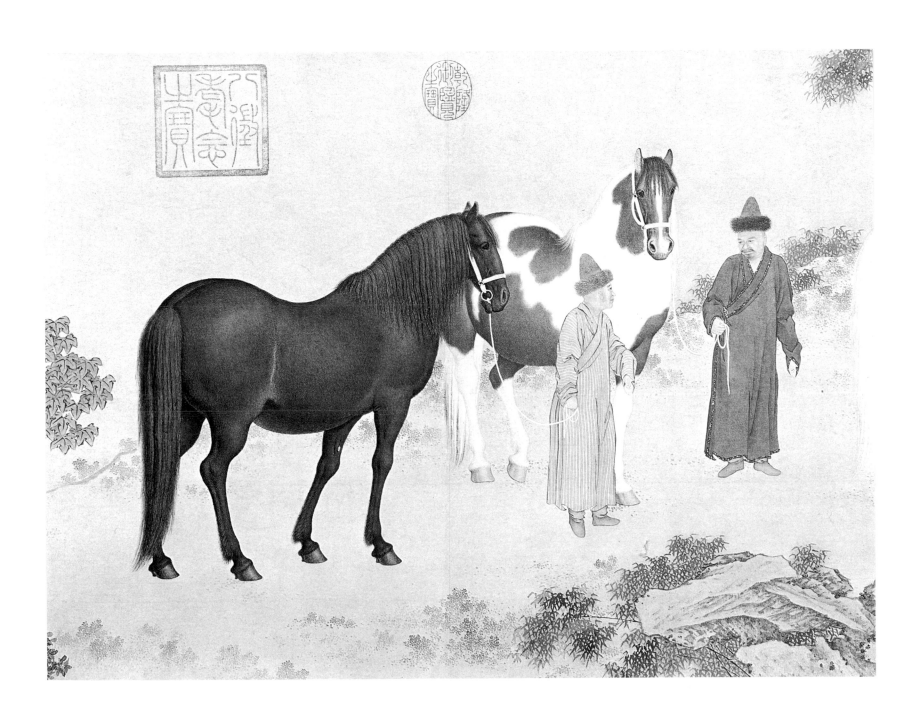

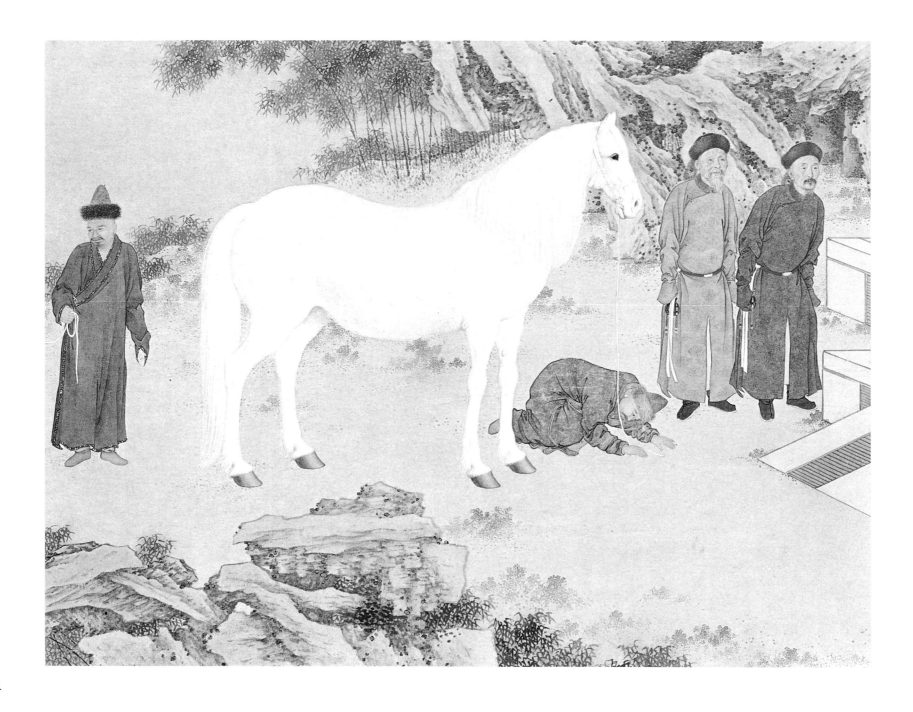

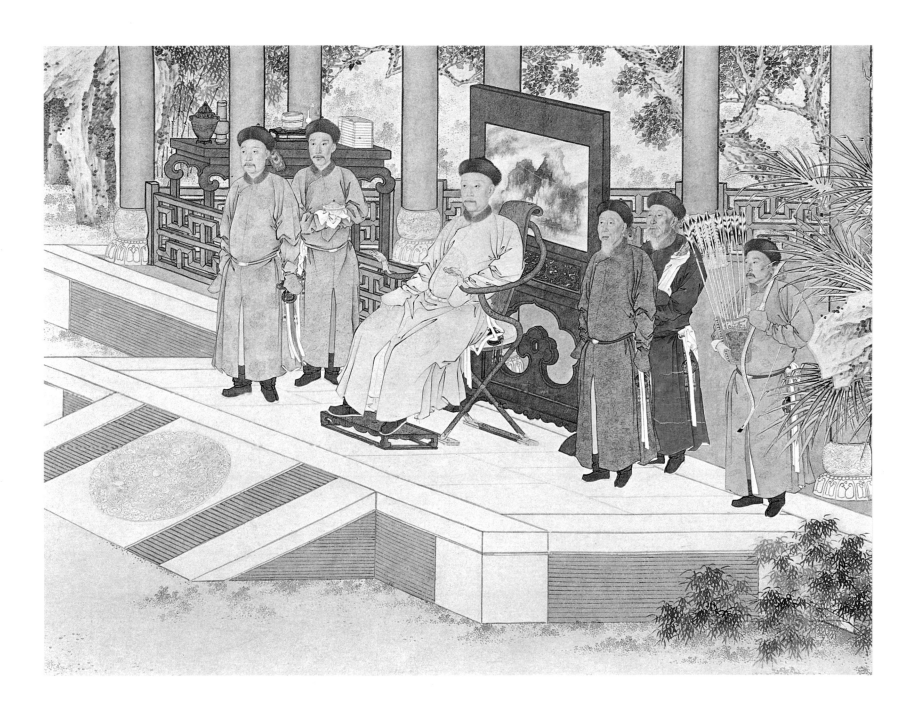

see it if one has not been forewarned. It is my portrait he is painting: he must not flatter me.'[6]

The Emperor himself chose the pose. An affable man, he did his best to make the artist's task easier. Since with the best will in the world, he could not spare the time for many sittings, a eunuch put on his robe so that the missionary could reproduce the details and the embroidery at leisure. The design of the fabric was more important to the Emperor than the rendering of the drapery.

Ch'ien-lung sometimes made demands that surprised the Europeans. He wished to be depicted larger than life and always considered that the missionaries made his head too small. 'Even while Father Attiret was picking up his palette and brushes, a eunuch, who was standing opposite him, put both hands to his head, moved them quite far apart and then pointed with his finger at the Emperor, who could not see him, as though to tell the Father that his Majesty's intention was that he should paint his head "very large". Another eunuch said it out loud and the Emperor expressed his approval. The Emperor's command was categorical, and if the painter proved incapable of correcting his picture himself, someone else would do it for him.'[7]

In order to paint portraits of women, the artist had to have acquired some knowledge of Chinese customs and tastes. The Chinese wished to distinguish the subject's rank at the first glance. Lively, shining eyes and a bold expression were suitable only for young women 'of mediocre virtue' or those 'under the influence of wine'. For the missionary newly arrived in China, to paint a concubine was such a delicate undertaking that he was advised to begin by painting the portrait of a young Tartar girl still ignorant of Chinese customs. Father Attiret learnt this to his cost. Soon after landing in China he had painted young girls playing in a garden of the palace. Ch'ien-lung, perplexed, studied the picture and asked him: 'Are these Chinese or European girls?' 'They are Chinese', replied the Father. 'Oh', exclaimed the Emperor, 'they don't look like it.' The interpreter explained to the painter that he had not distinguished the servants from their mistresses, that he had omitted to paint the red hands and the artificial nail of gold or silver attached to the little finger. [8]

The scroll painted on paper in the Musée Guimet, depicting Ch'ien-lung receiving the horses presented in tribute by the Kazaks, enables us to appreciate Castiglione's talents as a portraitist. This work painted in 1757 is probably the one mentioned in the *Kuo-ch'ao yuan-hua-lu* (Histories of the Imperial Paintings) written in 1815. The Emperor's face is painted with the fineness and precision of a miniature. The artist has not been content with absolute fidelity to the model; he has tried to capture on the face the expression, full of nobility but a little weary, of the Emperor in the exercise of his official functions. In my view it is one of Castiglione's best works and it justifies the great esteem in which the Chinese held his talent as a portraitist.

The Genre Painter

At Jehol, Castiglione had a hard task to paint the portraits of the barbarian chiefs and the Chinese generals. Working in the midst of a noisy crowd of Manchu courtiers and eunuchs who always had something to say was exhausting. He had literally to dash off the paintings, and it seems that Lang Shih-ning excelled at this. [9] In fact, he may have felt more at ease catching an attitude or a gesture instantaneously than painting with minute attention to detail the Emperor sitting rigidly in his State robe. When he is depicting *Ayusi Assailing the Rebels with a*

Lance or *Ma Ch'ang Attacking the Enemy's Camp*, his hand runs freely, taking advantage of the animation of the subject, and his drawing is full of life.

The Musée Guimet possesses a series of four scrolls painted on silk, of exceptional quality, bearing the title *Mu-lan*, the name of a district to the north of Jehol where every year, at the beginning of autumn, Ch'ien-lung organized what must have been spectacular hunts, since one thousand two hundred and fifty Mongols were mobilized as beaters. Lang Shih-ning, in collaboration with some Chinese artists, has faithfully repro-

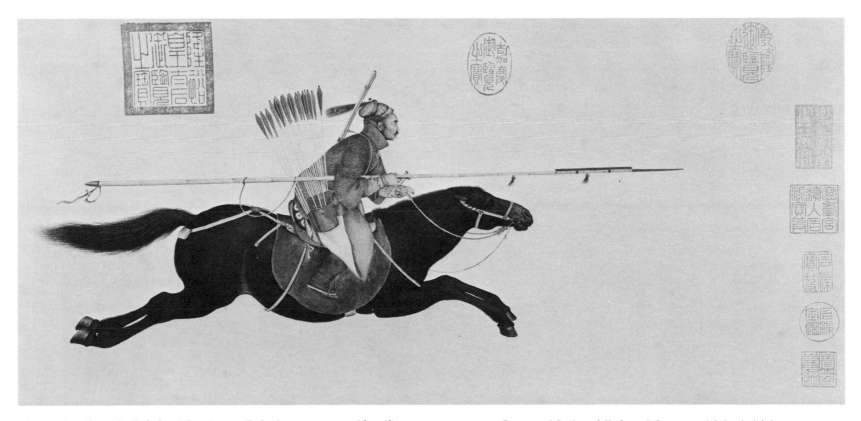

Ayusi Assailing the Rebels with a Lance. Painting on paper (detail). 0.27 × 1.04 m. Cat. 24. National Palace Museum, Taipei, Taiwan.

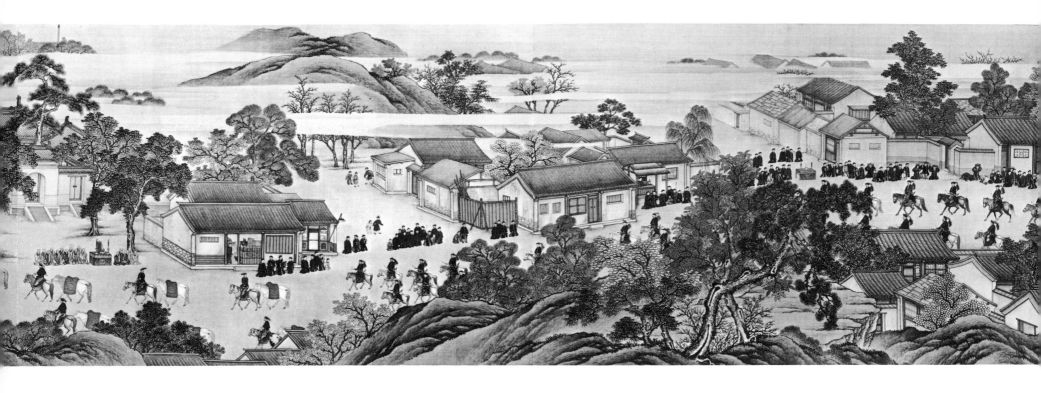

duced various episodes and all the festivities arranged on this occasion. On the first scroll, which bears the signatures of Lang Shih-ning, Ting Kuan-p'eng, Ch'eng Liang and Ting Kuan-ho, we see Ch'ien-lung entering a town with his retinue. The action takes place as in a film: the eye follows the illustrious traveller's odyssey across mountains and valleys up to his arrival before the fortified encircling wall. Inside, the notables are grouped in the main avenue, the merchants are busy in their shops. Altars mark the route followed by the cortège of the Emperor, who makes his way towards the tent set up in the market place for the ceremony. On the second scroll, signed by Lang Shih-ning, Chin K'un, Ting Kuan-p'eng, Ch'eng Chih-tao and Li Hui-lin,

Mu-lan I. The Emperor Ch'ien-lung followed by his troops enters a town. Painting on silk (detail). *Ca.* 0.77 × 27 m. Cat. 49. Musée Guimet, Paris.

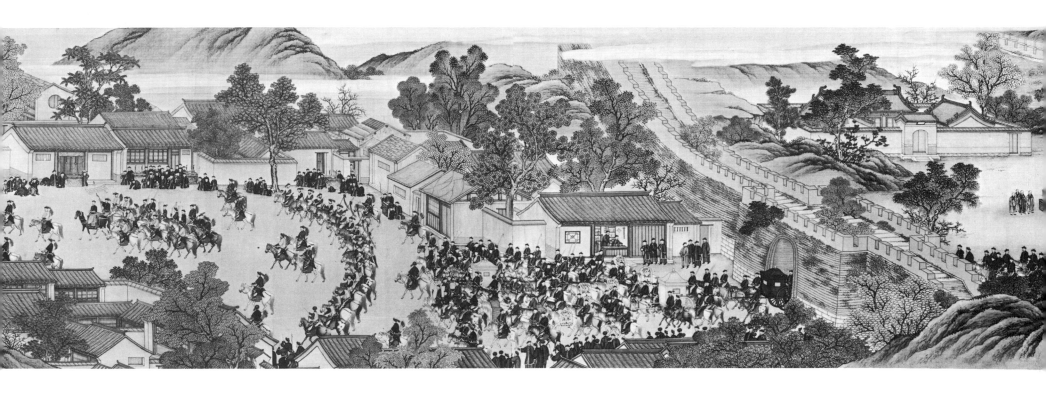

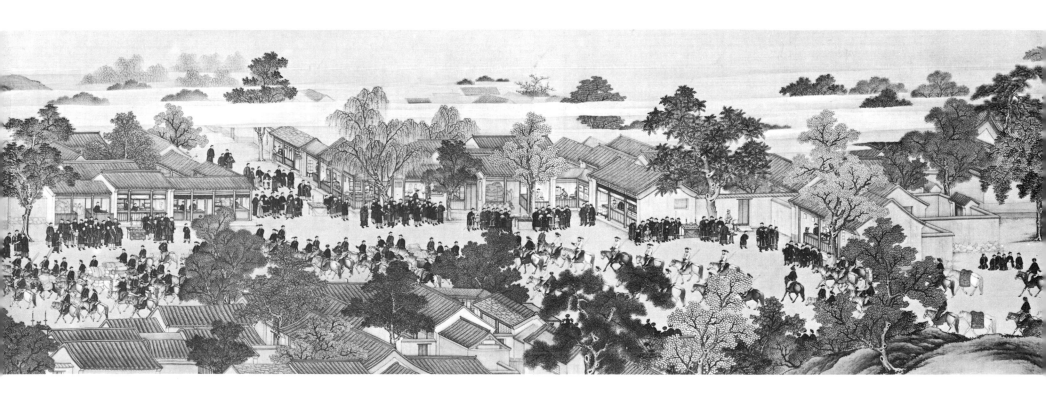

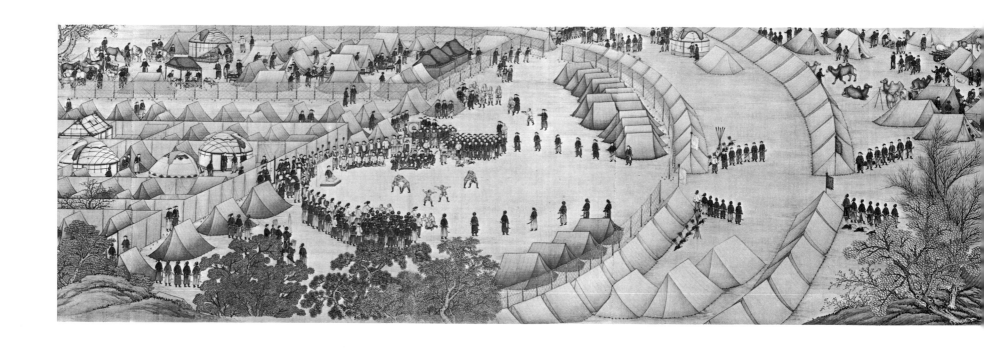

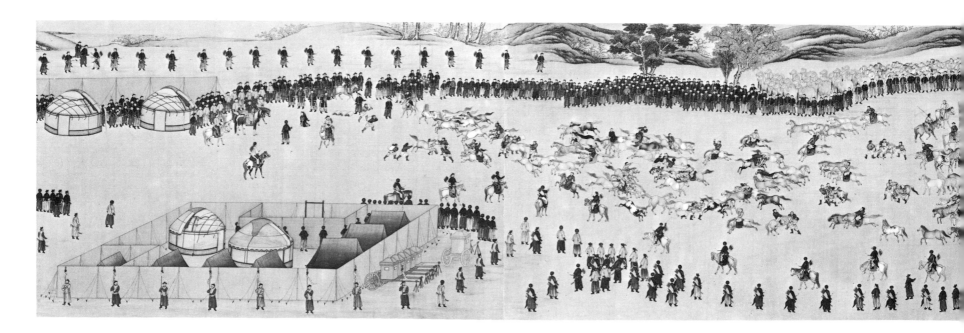

Mu-lan II. The Emperor Ch'ien-lung seated in front of his tent watching acrobats. Painting on silk (detail). *Ca.* 0.77 × 27 m. Cat. 49. Musée Guimet, Paris.

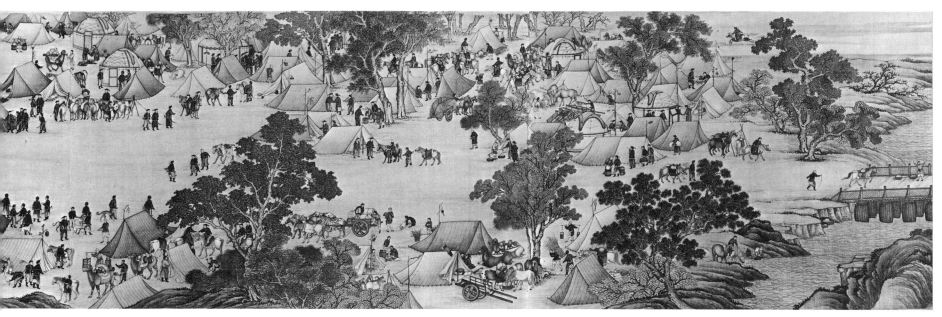

Mu-lan III. The Emperor Ch'ien-lung's soldiers capturing horses with a lasso. Painting on silk (detail). *Ca.* 0.77 × 27 m. Cat. 49. Musée Guimet, Paris.

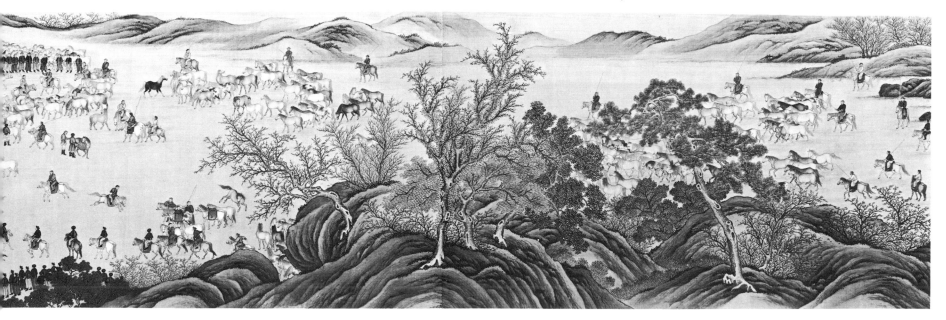

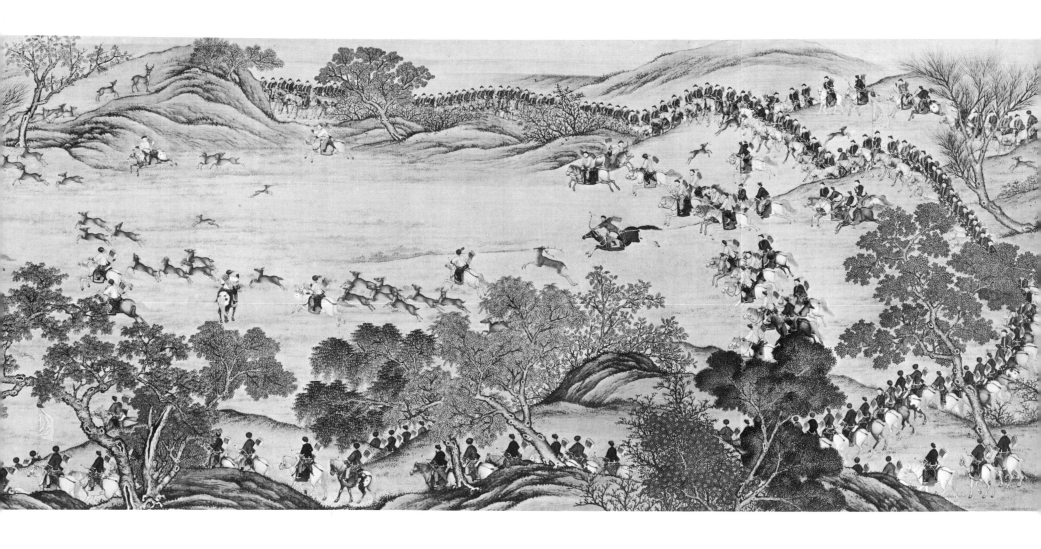

the troops are bivouacking in a plain; some soldiers are watering the buffaloes and the horses, others are unloading the camels and setting out the provisions, while the Emperor is being entertained by acrobats. The third scroll, which bears the same signatures as the first, is devoted to the lassoing of wild horses, and the fourth, signed by Lang Shih-ning, Chin K'un, Ting

Kuan-p'eng and Ch'en Yung-chieh, shows us the Emperor and the princes of his retinue shooting stags and deer with the bow. The headlong flight of the animals in a mountainous landscape to the plain where they are surrounded by the beaters covers a length of twenty feet. Whether it is galloping animals, the animation of the encampments, or chariots laden with

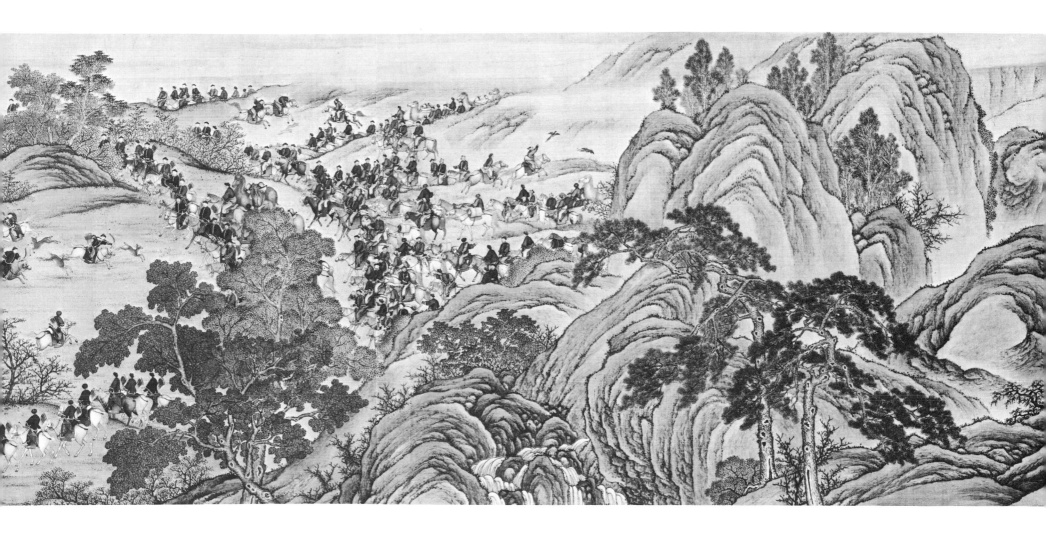

provisions, each scene, framed by a decor of mountains or trees with knotted trunks, abounds in picturesque details treated with *brio* and finely delineated.

Probably the landscapes are not by Castiglione's hand. Given the length of the scroll, he must have contented himself with painting the figures and the important scenes, leaving all the rest, landscape and details, to his Chinese colleagues.

These four *Mu-lan* scrolls, mounted on *kosseu* ornamented with dragons, bear Imperial seals. They are devoid of inscriptions and figure in the *Shih-ch'ü pao-chi*.

The National Palace Museum in Taiwan possesses a painting on paper signed by Castiglione which is not listed in the *Shih-ch'ü pao-chi* but is reproduced in the *Lang Shih-ning hua chi* (Vol. V.), a catalogue of Castiglione's work published in 1931. Emperor Ch'ien-lung

113

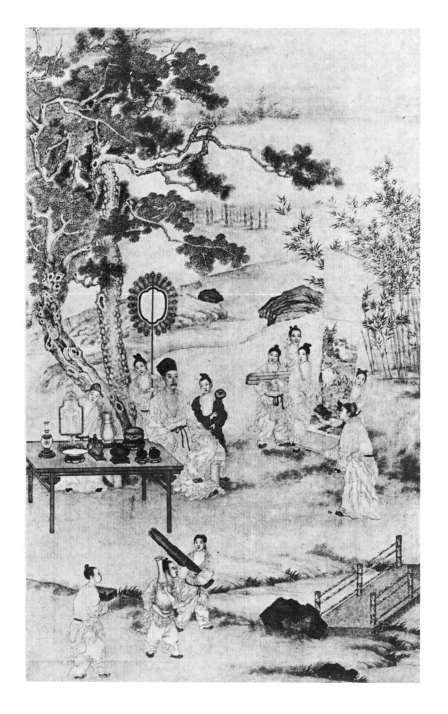

is portrayed sitting in a garden under a pine contemplating works of art. Round him young serving-men are busy. Some are unrolling a painting, *The Washing of the White Elephant*; others are bringing pottery vases or carrying musical instruments. The work seems to be taking up one of the favourite themes of Chinese painters since the famous painting of Li Kung-lin (1040–1106), *The Poetic Reunion in a Garden of the West*: a man of letters surrounded by pretty servant girls and young ephebes, 'freed from the cares of this vulgar world', is admiring works of art. The feebleness of the drawing coupled with lack of skill in the rendering of the drapery give reason to believe that this work is not by Castiglione or at least not entirely by his hand.

John Barrow, in his account *Voyage to China*, which completes *The Voyages of Lord Macartney*, mentions paintings by Castiglione discovered at Yuan-ming-yuan thanks to the helpfulness of an old eunuch. This series devoted to the Chinese in the exercise of various trades may have inspired the coloured illustrations in the volume *La Chine, moeurs, usages, costumes, arts et métiers* with explanatory notes by Malpière. Although in this work Castiglione's signature does not appear under a single engraving, the author affirms in the sub-title that the book has been illustrated after original drawings by Castiglione, the Chinese painter Pu Qua, W. Alexander Chambers, etc.

There is every likelihood that the paintings Barrow admired at Yuan-ming-yuan were dispersed or destroyed

The Emperor Kao-tsung (Ch'ien-lung) Contemplating Works of Art. Painting on paper. 1.56 × 0.71 m. Cat. 72. National Palace Museum, Taipei, Taiwan.

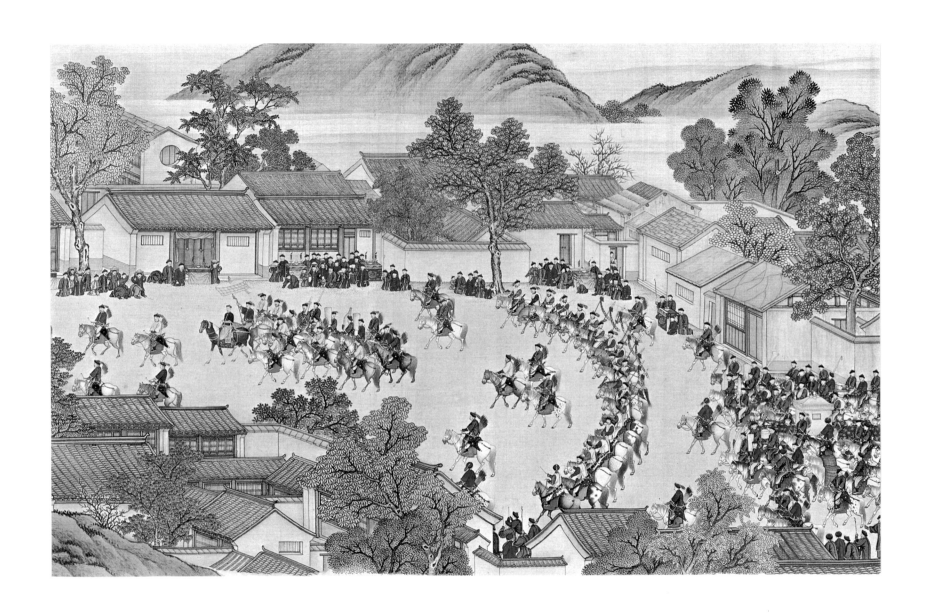

Mu-lan I. The Emperor Ch'ien-lung entering a town on horseback. Painting on silk (detail). *Ca.* 0.77 × 27 m. Cat. 49. Musée Guimet, Paris.

in 1860 during the sacking of the Summer Palace. Let the traveller describe his discovery himself:

'... The eunuch took me into a corner of the apartment, opened a coffer resting on a support and, with a meaningful glance, told me he was about to show me something that would astonish me. Then he took out of the coffer several large volumes filled with figures drawn in a superior manner and painted with watercolours. These figures depicted the various trades and occupations of the Chinese. They looked as if they were glued to the paper, since there was neither shadow, nor projection, nor distance to give relief. The page opposite each figure contained an explanation of it in Chinese and Manchu characters. When I had leafed right through one volume of these figures I saw on the last page the name of Castiglione, which gave me the key to the mystery.' [11]

But the eunuch was much annoyed when he realized that these drawings, in which he took so much pride, were the work of a European artist!

Albums of engravings and drawings representing Chinese figures – mandarins, soldiers, artisans, courtesans, etc., or else foreigners of various nationalities – bearing the signature of Lang Shih-ning sometimes come up for public sale both in London and Paris. The careless workmanship, the awkwardness of the drawing, prove that these are only clumsy copies, perhaps the work of pupils of the Jesuit painters.

The Painter of Animals

The Painter of Flowers

The Painter of Landscapes

The Painter of Animals

If the portraits that can be attributed to Castiglione are few, numerous scrolls bear witness to his talent as an animal painter. The Manchu emperors, great hunters and good horsemen, liked to have portraits painted of their favourite horses, of their dogs, of monkeys, falcons and the rare birds which they received as tribute. Ever since the T'ang, the Chinese had excelled at animal art. Han Kan (eighth century), Li Kung-lin (1040–1106), Ma Fen (twelfth century) and Jen Jen-fa (fourteenth century) were especially distinguished in this domain. These artists often depicted on the same scroll animals as diverse as the horse, the goose, and the monkey, painted from life in the most varied attitudes.

Emperor Yung-cheng requested Castiglione, who had proved his talents as a painter, to execute in his turn a scroll depicting a hundred horses. Castiglione, who was well acquainted with Chinese tastes, represented the animals rolling on the ground, gambolling and frolicking two by two in the fresh, calm atmosphere of the countryside, just as he had seen them in the paintings suggested to him as models. The countryside itself, on the other hand, is treated with a low horizon according to the rules of perspective still in force in the West. In imitation of the Chinese, he has portrayed the horses in a 'flying gallop', something never done before by a European painter.

We can only admire the ease with which Castiglione employed the difficult art of tempera on silk. It is very likely that he entrusted the preparation of the silk to Chinese more experienced than himself in this procedure. The silk was coated with a solution of liquid glue and alum until the surface was completely smooth. It had to appear as 'clean as the snow', as 'pure as river water'. The colours employed were either pigments reduced to powder or colouring matter dissolved in water, which were mixed with glue to obtain good keying of the colour to the fabric.

As William Willets comments in his remarkable work *Foundations of Chinese Art*: 'The materials used in Western oil painting are such as to encourage the artist to paint step by step.'[1] The painter can obliterate and correct his drawing, as is proved by x-ray examinations that enable us to see the artist's hesitations, and the modifications of the work in the course of its execution. By contrast, painting in tempera does not permit the artist to venture on the surface to be painted until the vision of the work is clear and final. Brush-strokes on silk are almost impossible to obliterate; moreover, the absorptive capacity of the fabric demands a light and very certain hand, which, to use a phrase of Ingres, must have 'the delicacy of the fly wandering over a window-pane'. In the *A Hundred Horses* scroll, considered one of Castiglione's finest works, the virtuosity of execution has astounded Chinese art lovers.

Portraits of some famous horses from Ch'ien-lung's stable bear witness to Castiglione's mastery as an animal painter. Limited by the use of the cold colours of tempera, Castiglione has devoted all his attention to the rendering of volumes and contours. The composition is harmonious, calm and of a rare simplicity. Each animal is depicted standing, full-face, three-quarter face or in profile, with its more or less fine bone structure, its thick or thin hooves, in a characteristic attitude. The painter has observed and stressed the peculiarities of each animal. The wash-tint that brings out the highlights on the horses' coat retains all its original

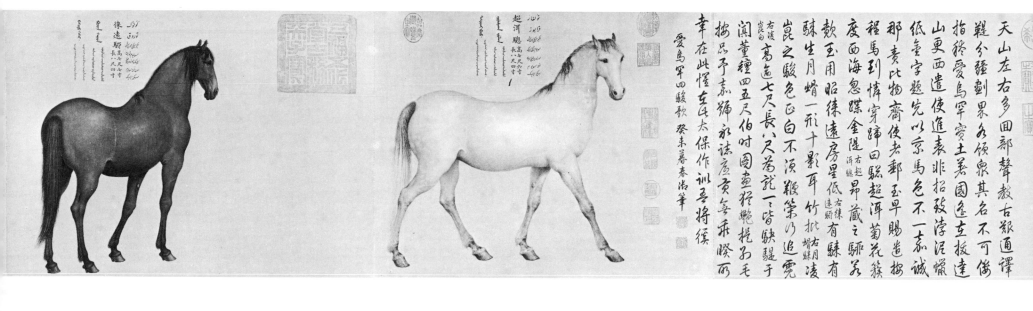

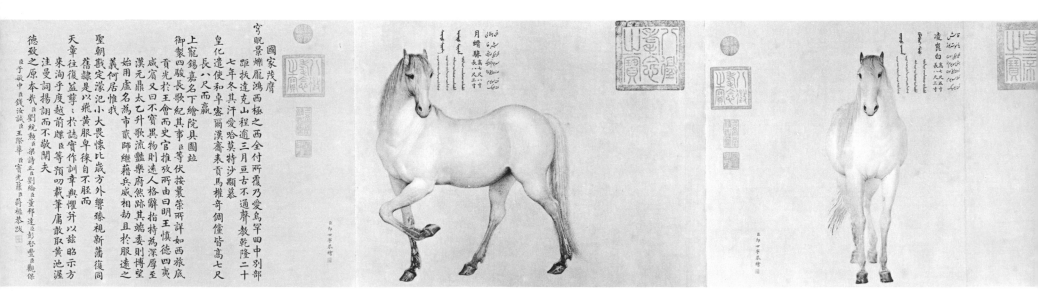

120 *Four Steeds of Ai-wu-han*. Painting on paper. These four Afghan horses: 'Superior Horse', 'Distant Horse', 'Moon Horse', and 'White Horse' rank among Castiglione's masterworks. 0.40 × 2.97 m. Cat. 27. National Palace Museum, Taiwan, Taipei.

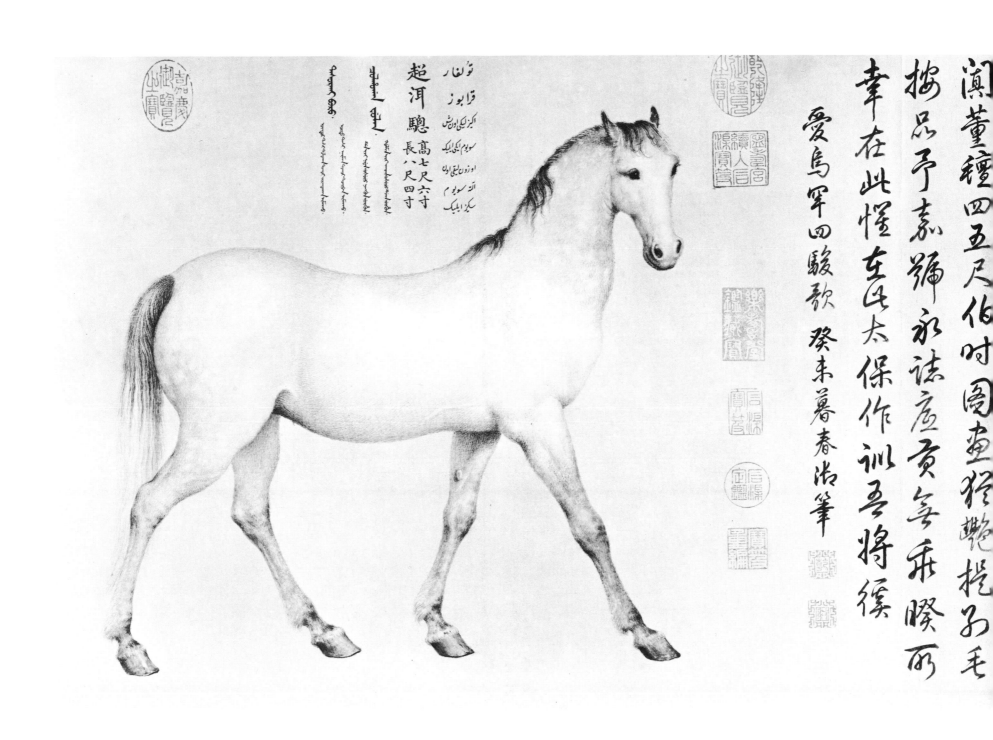

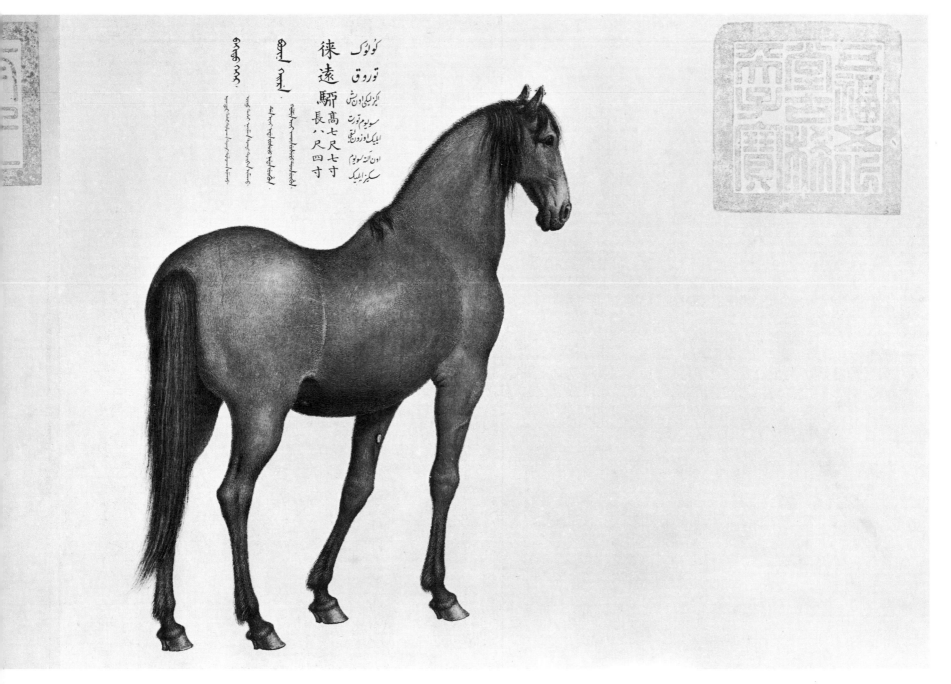

Four Steeds of Ai-wu-han (detail). 'Distant Horse'. Cat. 27.

freshness – which proves the quality of the materials used by Castiglione. The study, though very searching and exact, is not a 'photographic' reproduction. If the eye has observed the slightest detail in nature, the brush only translates the essential. In these portraits of horses there is an understanding of the subject, a skill in the utilization of Chinese technical formulas that compel admiration.

Castiglione also painted numerous portraits of dogs, monkeys, eagles and falcons. Some of these have great charm, such as *The Monkey from Cochin-China* or *Dog under Flowering Branches*, which are reproduced on pages 125 and 143. These are always patient and scrupulous studies, but they are sometimes a little too academic.

Presenting of Superior Horses like Clouds in the Embroidered Sky (Eight Horses). Painting on silk. 0.59 × 0.35 m. Cat. 51. National Palace Museum, Taipei, Taiwan.

Dog 'Striped Like a Tiger'. Painting on silk from the series Nine Dogs. 2.48 × 1.64 m. Cat. 61. National Palace Museum, Taipei, Taiwan.

'Yellow-Leopard' Dog. Painting on silk from the series Nine Dogs. 2.48 × 1.64 m. Cat. 62. National Palace Museum, Taipei, Taiwan.

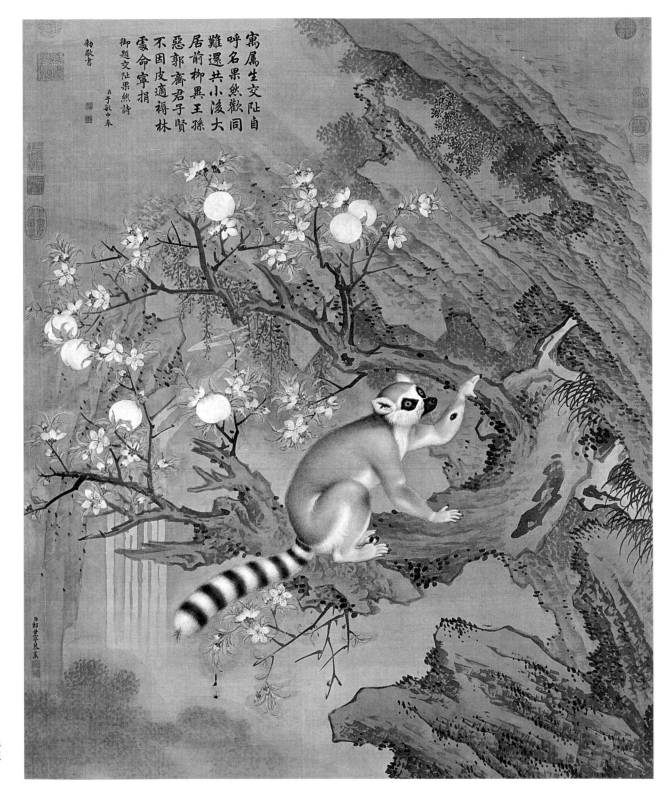

寓屬生交阯自
呼名果然歡同
難還共小陵大
居前柳異王孫
惡郭齋君子賢
不因皮適褥林
愛命寧捐
御題交阯果然詩
勑敬書　良于敏中奉

The Monkey of Cochin-China. Painting on silk. 1.09 × 0.84 m. Cat. 39. National Palace Museum, Taipei, Taiwan.

The Painter of Flowers

Mi Fei (1052–1107), in his treatise on painting, the *Hua-chi*, writes that in his opinion portraits of men and women 'serve only for the entertainment of officials', whereas Buddhist paintings, landscapes, paintings of flowers and plants, belong to the category of 'treasures of pure art'. In fact, since the tenth century, the theme of flowers and birds, *hua-niao*, has possessed in Chinese painting the importance which the portrait and the nude have in the West.

Since the end of the Ming there existed a multitude of albums of flower and bird paintings which we should call still-lifes. Some of these are intended to demonstrate how the brush should be held to paint a tree, a peony or a blade of grass. The most famous of these treatises

Four leaves from an album of Sketches of Flowers containing 16 illustrations. Painting on silk. 0.33 × 0.27 m. Cat. 1-16 (14, 16, 4, 2). National Palace Museum, Taipei, Taiwan.

on painting is the *Garden as large as a Mustard Seed* (1685). A few wood engravings from this book were brought to Germany in 1692 by a physician named Kaempfer, who had accompanied a Dutch embassy to Peking.

To the Chinese, permeated by Taoist teachings, the term still-life (or more emphatically *nature morte* in French) has no meaning. To them there are no inanimate objects; everything has its own vitality, its spirit, the *ch'i-yün*, which must be made to 'resound'. The brush is the vehicle for this *ch'i-yün*. The chief concern of the Chinese artist is to communicate with nature, to identify himself with it, not to dominate it. A mystic feeling is born from the contemplation of a flower, an insect; it

127

is with deep emotion, with attentive tenderness, that the painter of 'flowers and birds' represents the fragility of a petal, of a feather, or the trembling of a dragonfly's wing. Because *hua-niao* also includes paintings of insects, shells, water plants, of 'a thousand little living things', to use a Chinese expression.

To observe nature, to reproduce minutely the slightest detail, was within the scope of many artists. But only a few masters such as Chao Ch'ang (beginning of the Sung), Hsü Hsi (961–975) and Pa-ta Shan-jen (1626–1705), were capable of expressing a flower's *ch'i-yün*. As Kuo Jo-hsü (1626–1705) wrote: 'For those who do not succeed in attaining the marvellous, there remains delicacy.'

In general the Europeans admired the preciosity and the colouring of Chinese paintings of flowers and birds, but the poetic feeling that is always manifest in the most minutely detailed of these representations escaped them. They saw in the fine rendering of detail only a wretched concern for exactitude. 'The Chinese', writes Feuillet de Conches, 'is subtle and refined. He excels at cutting a hair in four, in embroidering on a spider's web. A true hero of patience, he is great in the small.' [2] Father Attiret suffered at not being allowed to paint great historical scenes or portraits in oils. When a Chinese pointed out to him that his tree and its leaves were not

Flower vase showing in its decoration obvious European influence. Painting on silk. 1.45 × 0.56 m. Cat. 94. Collection Mrs J. Riddell, London.

Blue-and-white vase with facets and the mark of Siuan-te. Percival David Foundation of Chinese Art, London.

Flowers in a Vase. Painting on silk. 1.13 × 0.59 m. Cat. 52. National Palace Museum, Taipei, Taiwan.

'like nature', he replied in exasperation: 'I am not a botanist.' However, Castiglione had explained to Father Attiret on his arrival in China: 'A good European painter would find your flower perfect; but there is not one apprentice painter here who would not tell you at first glance that your flower does not have in its outline the number of leaves it ought to have.' [3] And the painter Attiret was forced to note that in fact the Chinese painters did not think much of his flowers. The more patient Castiglione strove to reproduce plants and birds with the delicacy of a natural history painter. These paintings have the freshness and elegance of a water-colour by Redouté.

Castiglione did not choose his subjects himself: they were set him by the Emperor, who also liked to write his impressions on the scroll or to have a poem of his composition written on it by a skilled calligrapher. Thus the Jesuit Father Pierre Chéron d'Incarville in 1753 presented Ch'ien-lung with a variety of mimosa whose flowers retract when touched. Delighted with this gift, Ch'ien-lung requested Castiglione to paint the plant and added the little poem it had inspired. In all likelihood, the arrangement of the flowers was not left to Castiglione. They were not assembled in such a way as to combine into a harmony or provoke a contrast, but according to the subtle rules of a symbolic language. Their message was generally one of good omen: wishes for happiness, wealth and success.

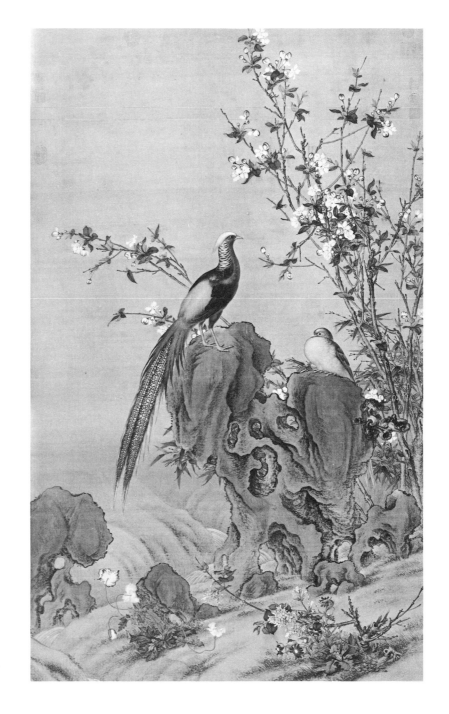

Gorgeous Spring. Painting on silk. 1.69 × 0.95 m. Cat. 43. National Palace Museum, Taipei, Taiwan.

Orchids expressed a tender and reserved friendship; a butterfly fluttering over chrysanthemums, wishes for a long life; goldfish and wisteria, the symbol of high distinctions accorded to an official; pomegranates, the hope of bringing into the world fine boys. The choice of flowers was also linked with the cycle of the seasons. A flowering branch carrying birds aroused in the soul the emotion of spring; the chrysanthemum evoked autumn; the pine tree, winter.

Castiglione was doubtless unaware of these subtleties. He contented himself with avoiding entanglement of the stalks and confusion of the drawing, so that the message of the flowers should remain legible. He will not have had the audacity of a Pa-ta Shan-jen who allows a bud to dangle carelessly on the neck of a vase, nor the swift brushstroke of the eccentric masters of Yang-chow 'who only painted for their pleasure and as their imagination took them'. His compositions are conventional, elaborated according to the academic taste then prevalent at Ch'ien-lung's Court.

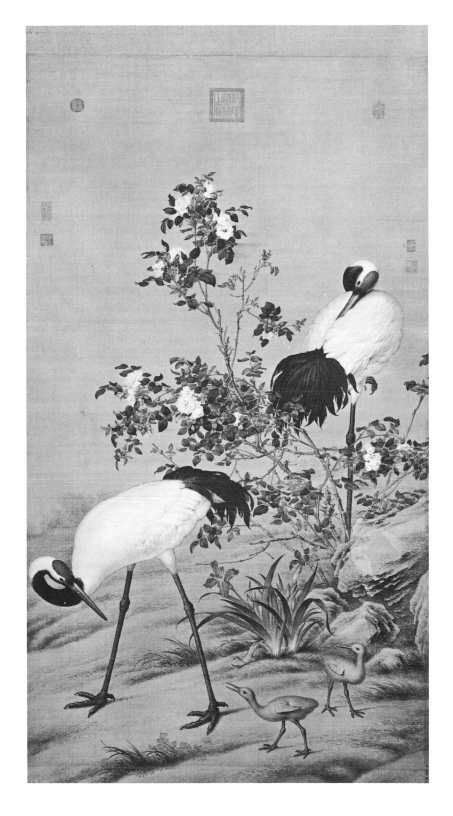

Cranes and Flowers. Painting on silk. 1.70 × 0.93 m. Cat. 46. National Palace Museum, Taipei, Taiwan.

131

The Painter of Landscapes

Several of Castiglione's works, as we have seen, were painted in collaboration with talented Chinese painters who belonged, like himself, to the Imperial Office of Painting. Such is the case with the scroll, now in Tokyo, showing the Emperor riding in the country in the company of an officer. If the horses and the figures are clearly by the hand of Castiglione, the landscape is the work of T'ang Tai, a painter of Manchu origin very much appreciated at Court. By contrast, the landscapes in *The Conquests of the Emperor Ch'ien-lung*, *A Hundred Horses* and *Horses Presented in Tribute by the Ta-wan* have been executed by Castiglione himself in accordance with the rules of European perspective.

John Barrow relates that in 1793, when he visited Yuan-ming-yuan, he saw 'two large landscapes painted in great detail'. The touch was passable, the details 'well finished', but the whole thing lacked those contrasts of light and shade that give vigour to a painting and create an effect. The most elementary rules of perspective had been neglected. 'In spite of this', adds Barrow, 'I could not help recognizing the hand of a European.'[4] In fact, a more attentive examination enabled him to find Castiglione's signature on both pictures. Unfortunately, the two landscapes probably disappeared during the destruction of Yuan-ming-yuan by Franco-British troops in 1860.

In the National Palace Museum in Taiwan there is a mountainous landscape signed Lang Shih-ning that is treated 'in the Chinese manner'. The brushwork in this painting is flat and so impersonal that Mikinosuke

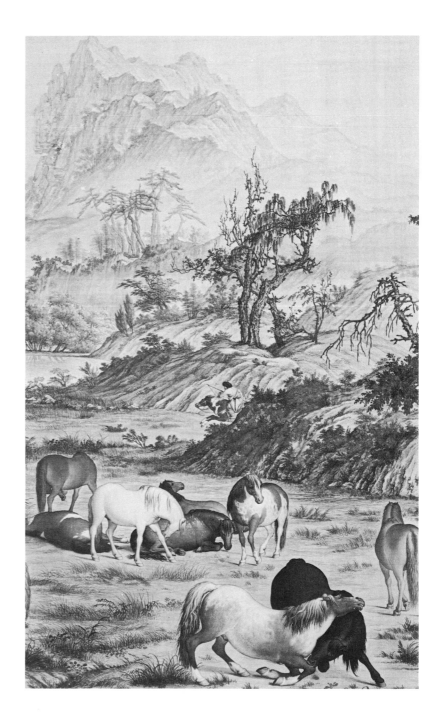

A Hundred Horses. Painting on silk, dated 1728 (detail). 0.94 × 7.76 m. Cat. 17. National Palace Museum, Taipei, Taiwan.

132

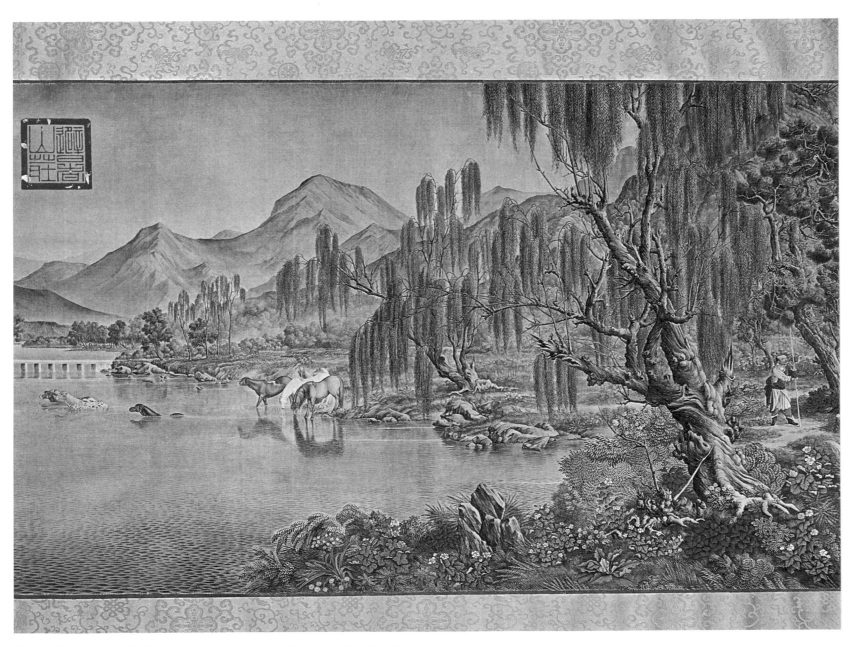

Horses Presented in Tribute by the Ta-wan. Painting on silk (detail).
0.66 × 6.58 m. Cat. 104. Collection Cheng Te-k'un, Cambridge.

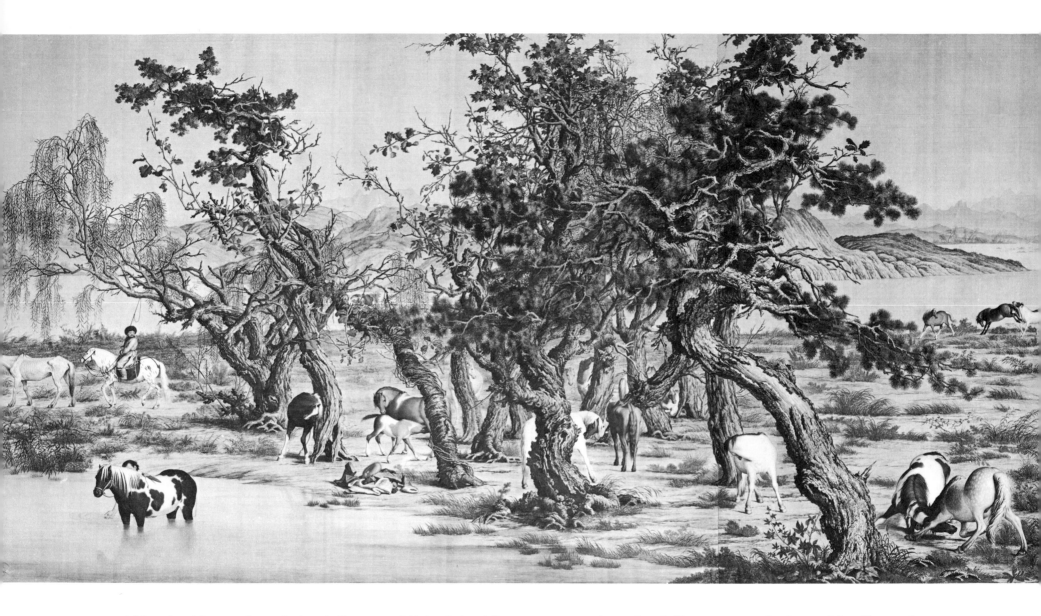

Ishida, in his study of Castiglione published in *The Memoirs of the Research Department of the Toyo Bunko*, 1960, expresses doubt as to the authenticity of the painting. Trained in the strict discipline of European perspective, Castiglione can only have felt discomfort and incomprehension when confronted by the Chinese pictorial idiom. We can imagine that if he adopted it, it was with reluctance.

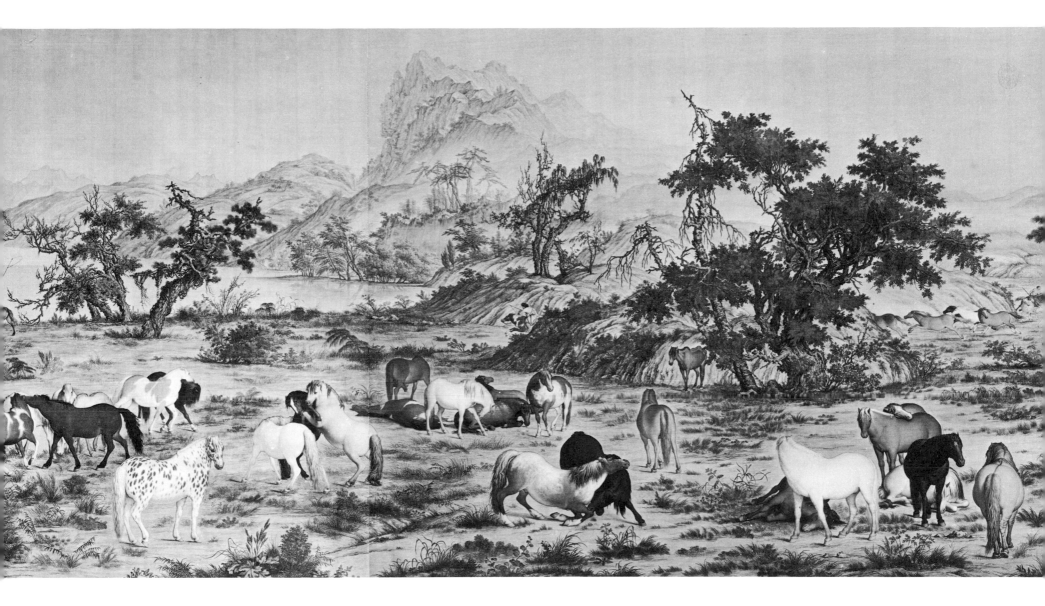

In eighteenth-century Peking artists painted according to the principles laid down by Kuo Hsi. 'In landscape, the first thing is to paint mountains in tens of feet, trees in feet, horses in inches and humans in tenths of an inch.' To render the effect of aerial perspective, they applied the rules of so-called *chin-yuan* (near and far). 'Mountains have three dimensions. When you look from the foot of the mountain towards

the summit, that is height. When you look from the front of the mountain towards the back, that is depth. When you look from a mountain that is close towards one that is far away, that is flat (horizontal) distance. The tone of the dimension in height is light and luminous. The tone of the dimension in depth is heavy and dark. But that of the horizontal dimension is sometimes light and sometimes dark. Height is bold and resolute. Depth is obtained layer by layer. The effect of distance is obtained by adding vaporous lines that are shaded off as they move further away.' [5]

Thanks to these very simple rules, Chinese artists excelled in creating the impression of depth — so true is it that one conventional means judiciously employed is worth another. To them, parallel lines do not converge towards a vanishing point, they remain truly parallel. As their system is not based on a study of the phenomena of vision, they know nothing of the art of foreshortening. There is not one point of view, but several. The position of the eye is not fixed, which enables them to show various aspects of a landscape or a courtyard in one and the same painting. This misreading of the elementary laws of perspective appeared to the eyes of an eighteenth-century European painter as a gross error.

In order to rectify this ignorance, Castiglione suggested to the Emperor the opening of a school of painting. The project was not approved and he had to content himself with publishing a book entitled *Shih-hsueh* (Visual Instruction). This work, based on Andrea Pozzo's *Perspectiva Pictorum et Architectorum*, was written in Chinese (in 1729) by Nien Hsi-yao, superintendent of customs of the porcelain factory, to whom

Landscape. Painting on silk attributed to Castiglione. 1.43 × 0.89 m. Cat. 59. National Palace Museum, Taipei, Taiwan.

Castiglione gave painting lessons. In the preface, the author says that he has studied with Lang Shih-ning the 'subtleties' of Western painting and in particular the art of creating the illusion of three dimensions by depicting shadows. A new edition, published in 1735, is accompanied by diagrams supporting the text. A copy of this edition is in the Bodleian Library, having been presented to the Royal Society by the Jesuit

137

Antoine Gaubil. The Bibliothèque Nationale in Paris possesses an incomplete copy of the work.

This problem was not new. In 1629 some Jesuits had tackled the subject in a treatise entitled *Réponses sur la peinture*. Shortly afterwards, Father Buglio had presented the Emperor with three pictures illustrating the European theories on perspective, which he took the trouble to explain in a short booklet. In 1696 Chiao Ping-cheng drew inspiration from these works when engraving plates for the new edition of the *Keng-chih t'u*, a work on agriculture and weaving published in the eleventh century and reissued under the Ch'ing with poems by K'ang-hsi and Ch'ien-lung.

The Manchu emperors and a number of Court painters admired the Europeans' skill in creating the illusion of space. The *trompe-l'œil* colonnades in the murals of the Pei-t'ang and Nan-t'ang churches impressed them deeply. However, if artists like T'ang Tai, Leng Mei, Shen Yüan and Chiao Ping-cheng, who worked at the Office of Painting, were interested in these methods, in general such innovations were received rather coldly.

The construction of space according to geometric perspective, the only one accepted by Europeans, seemed to many Chinese very learned, but mendacious and inartistic. To compel belief in reality where there is only a flat surface was contrary to nature. The Emperor said that 'the imperfections of the eye were no reason to represent the objects of nature as imperfect.'[6] The Chinese *literati* thought, like André Lhote today, that painting ought to remain faithful to its own structure, its two basic dimensions. In their eyes, there was no sense in the arithmetical relationships between the various parts of the body, the 'divine proportions' of the head, the typology based on Dürer's system of measurement. These preoccupations, they thought, had nothing to do with art.

Today a new system is in the process of replacing that of geometrical perspective which, since the fourteenth century, has formed part of the language of Western art. But in Castiglione's time this was the only one a European painter could understand. It is typical of the Western attitude towards nature. The painter takes his 'distance', his 'point of view' and defines it with absolute rigour, with triumphant realism. For the Chinese artist, man is not the measure of all things. He integrates himself into the landscape, which is the supreme subject. According to a very Taoist viewpoint, it is nature that expresses itself through the artist. A text by Lao-tze states: 'My birth is interdependent with that of the universe. I am one with the infinity of beings.' And the painter Shih-t'ao (1630–1717) writes in his treatise on painting: 'The mountains and the rivers undertake to speak for themselves. They are born in me and I in them.'[7]

Castiglione and the Chinese Painters of his Day

When Castiglione arrived in Peking, at the end of the year 1715, the great orthodox painters of the beginning of the Ch'ing period – Wang Shih-min (1582–1680), Wang Chien (1598–1677), Wang Yuan-ch'i (1642–1715) and Yün Shou-p'ing (1633–1690) – were dead. Wang Hui (1632–1717), already very old, was to die two years later and Wu Li (1632–1718), converted to Catholicism and entirely taken up by his priestly duties, had painted almost nothing for several years. He died in Shanghai in 1718 without, it seems, ever meeting Castiglione.

The majority of the artists belonged to the families of high officials of the Ming dynasty, and in spite of all the efforts of the Manchu emperors to attract them to Court, they most often preferred to remain outside public life. Wang Yuan-ch'i, grandson of Wang Shih-min and youngest of the 'Four Wangs', alone agreed to live at K'ang-hsi's Court. He was heaped with honours, became chancellor of the Han-lin Academy, and the Emperor entrusted to him the education of the young Manchu lords.

In the course of its history, Chinese art has followed two antagonistic trends linked with the philosophical doctrines that dominate Chinese thought: one academic and very Confucian, the other anti-conformist and Taoist in spirit. The act of painting was inseparable from a certain intellectual and moral attitude: without virtue one could not attain the inner purity necessary to the 'spiritual breath'. The *Book of Rites* affirms: 'That which is accomplished by virtue is superior to that which is accomplished by professional skill.' Thus the Court painters despised the negligence and lack of good citizenship of certain Individualist artists, while the latter thought little of the Court artists, considering them to be 'professionals' – to their minds a pejorative term.

A number of painters preferred to live in the provinces, in the country and sometimes as hermits, far from politics and worldly life. Chang Jui (1704–1729), a pupil of Wang Hui, on being invited by the Emperor to come to Peking, pleaded illness and retired to the temple of Tung-ch'ang. These Individualist painters were sometimes protesters before the word was thought of, indulging in all sorts of eccentricities. There were many of them at Yang-chow, a town in which a seditious spirit reigned, and where their extravagances delighted wealthy art lovers.

It is clear that Castiglione, who only lived at Court – in Peking, Yuan-ming-yuan and Jehol – knew nothing of these strange masters and their antecedents: Pa-ta Shan-jen (1626–1705), Shih-ch'i (1612–1680) and Shi-t'ao (1630–1717). He knew only the official artists, those who, not having experienced the war and the horrors of the end of the Ming, considered it a great favour to be admitted to the Imperial Office of Painting. Most of them had studied under the direction of one of the Four Wangs; they defended orthodoxy in matters of art and called themselves disciples of Huang Kung-wang (1269–1354) and Tung Ch'i-ch'ang (1555–1636).

Thanks to his talent, Castiglione had acquired real celebrity at the Court of Ch'ien-lung. He was on friendly terms with high officials, such as Nien Hsi-yao, minister of the Imperial house in 1728, superintendent of customs and director of the Ching-te-chen porcelain factory. A great man of letters, Nien Hsi-yao published several works on trigonometry and was even a painter

in his leisure moments. From 1726 to 1736 he directed the Ching-te-chen porcelain factory with the assistance of T'ang Yin, who later succeeded him in the post. He personally supervised the porcelains intended for the Court in Peking. It was at his instigation that the factory began to manufacture porcelain whose decorations, although still Chinese in overall effect, showed distinct signs of European influence.

Nien Hsi-yao, who was particularly interested in the work of the Europeans, made frequent visits to the Fathers. He asked Castiglione to give him painting lessons and with his help undertook to write a treatise on perspective, the *Shih-hsüeh*, a work which, as we have seen, appeared in 1729 and was reissued in 1735. In the preface Nien Hsi-yao wrote: 'Thanks to Lang Shih-ning, I am now capable of drawing a Chinese subject in the style of the Westerners.'

Dortours de Mairan, permanent secretary of the Académie Royale des Sciences, member of the Royal Society, London, and the Royal Society, St Petersburg, states that he received from Father Parennin one of those works 'of which Nien Hsi-yao was the author, after drawings by the reverend Jesuit Fathers who are in Peking. Whereupon I remembered that Father Parennin had informed me in one of his letters that this Chinese had always shown himself extremely curious about European matters. From which we may infer notwithstanding that this Nien Hsi-yao was not a man without discernment.'[1]

Learned as he was, Nien Hsi-yao was not a *chin-shih*, that is to say an 'accomplished man of letters' who had passed the difficult examination that was held every three years in Peking and opened the doors of the

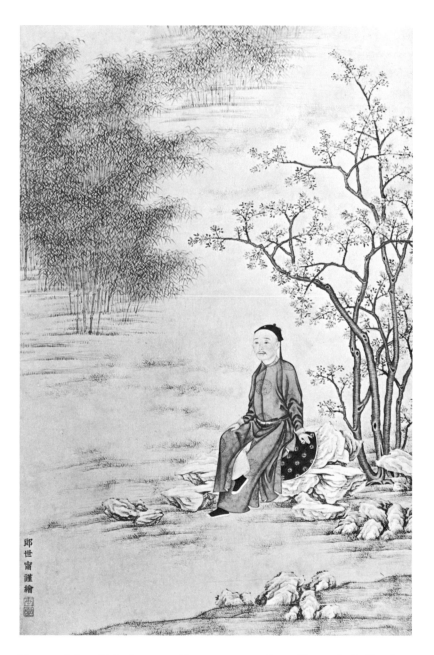

Young scholar. Painting on silk. 0.44 × 0.28 m. Cat. 96. Collection Jean-Pierre Dubosc, Paris.

famous Han-lin Academy. This examination enabled the successful candidate to attain to the highest offices, no matter how modest his origins. From the *chin-shih* were recruited not merely prefects, magistrates and ministers but also engineers capable of building a road or a dam. These 'managers before the term was invented', as Etienne Balazs has called them, possessed an encyclopaedic culture that excluded any specialization. [2] It was not rare for a minister to be at once a scholar, a poet, a musician, a painter and a skilled calligrapher. Thus the Emperor never hesitated to ask him to compose a poem and transcribe it on some painting of his choice belonging to the palace collections. At times the Emperor, particularly inspired, would undertake this operation himself or else dictate a poem to his minister and order him to write it out for him. Thus we can find on Castiglione's works the names of the most famous *chin-shih* of the Court, such as Chang Chao, Liang Shih-cheng, Shen Te-ch'ien, Yu Min-chung, Ch'ien Tsai and Ch'ien Ch'en-ch'un.

There was constant contact between the *literati* and the Italian painter. Each had a very high idea of his own culture. Nevertheless, the Jesuit forced himself to greater humility and patience in a real desire to integrate himself in Chinese society with the secret hope of converting it to Christianity. Everyone took a passionate interest in art in general and painting in particular. An extremely promising dialogue was established between these intellectuals who, with their

Dog under Flowering Branches. Painting on silk. 1.23 × 0.61 m. Cat. 45. National Palace Museum, Taipei, Taiwan.

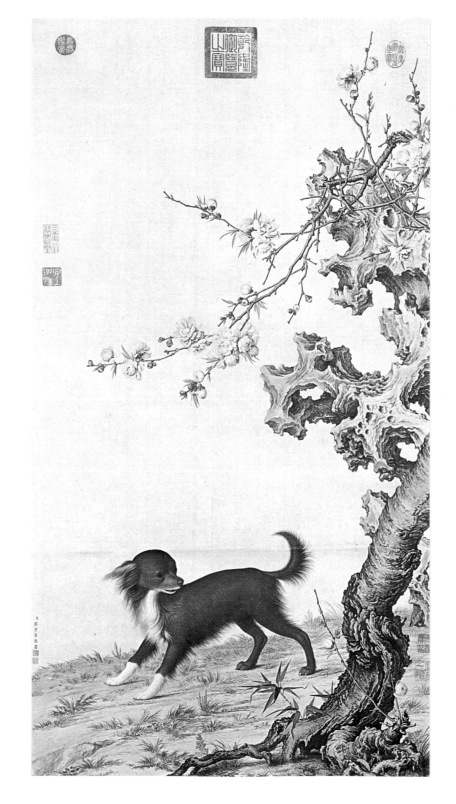

The White Hawk. Painting on silk. 1.88 × 0.97 m. Cat. 30. National Palace Museum, Taipei, Taiwan.

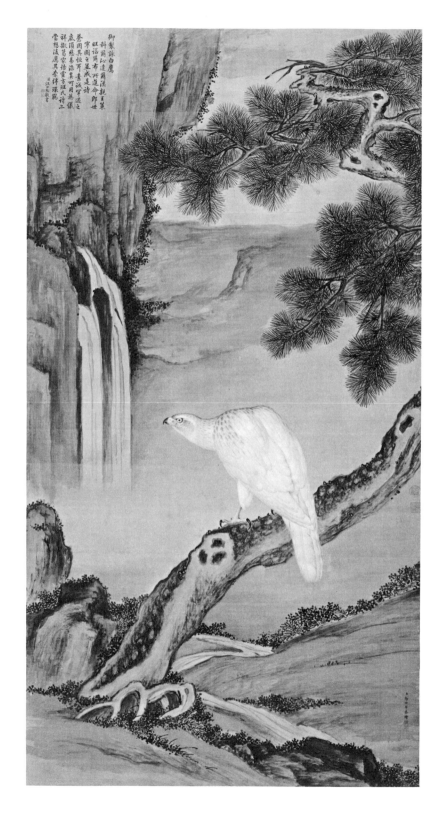

widely differing personalities, were all representative of the society of their time.

Chang Chao (1691–1745) was a *chin shih* and a member of the Han-lin Academy. While a high official, he was charged with the difficult mission of pacifying the Miao. Having failed, he was condemned to death but reprieved on account of his talent as a calligrapher. He continued his career as director of the Institute of Music, while writing operas and plays in his spare time. He also excelled in painting plum blossoms. In 1743 he composed a series of poems on the ten horses presented to the Emperor by the princes of the commandery of the K'a-erh-k'a, which Castiglione had painted. Ch'ien-lung himself did not disdain to compose a few small poems on this occasion which he had calligraphed by Liang Shih-cheng (1697–1763), teacher of the Manchu princes at the Imperial Palace and tutor of the heir apparent. In addition to their administrative and artistic functions Liang and Chang, great experts on antiquities, had been charged with cataloguing the bronzes in the Imperial Palace and the *objets-d'art* in the palace at Mukden.

Likewise a *chin-shih* and a member of the Han-lin Academy, Yu Min-chung (1714–1780) was also charged with transcribing and editing the poems which the indefatigable Emperor would sometimes compose between two audiences. The minister did not always have a brush ready to hand, but his memory was exceptional. The Emperor felt real affection for this unscrupulous individual, who was later accused of corruption. Yu Min-chung's name appears on several Castiglione's paintings: *The Monkey from Cochin-China, The Bird from Tsu-yueh, Presenting of Superior Horses like*

Clouds in the Embroidered Sky. Father Panzi painted a portrait of this high official and sent it to Bertin, then general controller of the finances and director of the Compagnie des Indes, who, as we have seen, had adroitly reserved for his collection a series of engravings from *The Conquests of the Emperor Ch'ien-lung*.

Three other *chin-shih* – Shen Te-ch'ien, Ch'ien Ch'en-ch'un and Ch'ien Tsai – also calligraphed poems on the painting entitled *Horses Presented in Tribute by the Ta-wan* (today in the Cheng Te-k'un Collection in Cambridge).

Ch'ien Ch'en-ch'un (1686–1774) belonged to a family of *literati*. His mother, Ch'ien Shu, was famed for her flower paintings. In 1714 he had the privilege of being received by the famous salt merchant and Maecenas An Ch'i (1683–1744) and allowed to study his admirable collection of paintings. The Emperor particularly appreciated Ch'ien's literary talent and exchanged poems with him.

Ch'ien Tsai (1708–1793), of far more modest origins, had been a tutor in Ch'ien Ch'en-ch'un's house and had studied painting with his mother. After becoming a member of the Han-lin Academy, he was charged with editing the Emperor's journal. Poet, calligrapher and art lover, he felt great admiration for Castiglione's painting.

In fact the poems calligraphed on Castiglione's paintings, although composed by men illustrious in their day, abound in literary clichés and bear witness

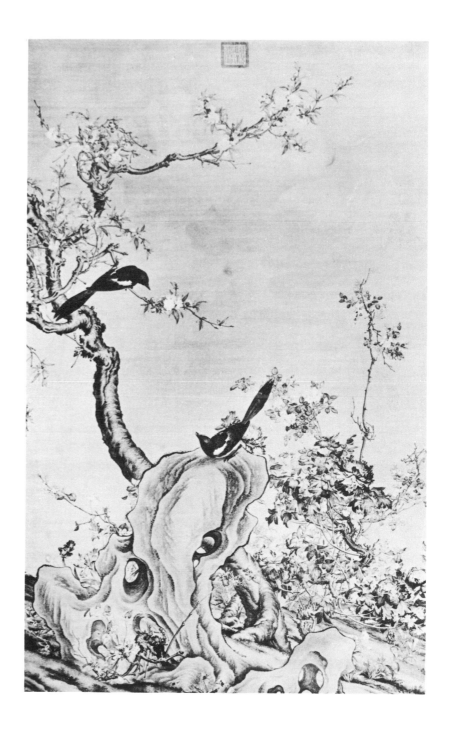

Magpies and Peach Blossom. Painting on silk signed by Castiglione and T'ang Tai. Cat. 90. Former collection of Prince Yi, destroyed by fire in 1923.

145

to the conventional taste that reigned at Court. As for Ch'ien-lung's poems, they are generally very mediocre, since the Emperor lacked the literary gifts of his grandfather K'ang-hsi.

In the Imperial Palace, Castiglione had an opportunity of working not only with the *literati* and high officials, but also with the Court painters, some of whom, such as T'ang Tai (1680–1749) were talented artists and are still greatly admired today. The son of a Manchu general, trained in the school of Wang Yuan-ch'i, T'ang Tai excelled in landscape painting. Both K'ang-hsi and Ch'ien-lung esteemed him highly, not only because he was a Manchu like themselves, but because they considered him an indisputable genius. As a result of this admiration, no doubt, most of T'ang Tai's works are in the Imperial collections and very few in private hands. T'ang Tai used to deliver lectures on art at Court. He is the author of a treatise on art, the *Hui-shih fa-wei* (The Mystery of Painting), which is mentioned among others in the *Mei-shu ts'ung-shu*. At the Emperor's request, T'ang Tai executed several works in collaboration with Castiglione: one of them, *Driving a Horse in a Spring Field*, a scroll painted in 1744, is now in the Yurin-kan Museum, Kyoto. T'ang Tai was at this time a very old man. He painted the landscapes and Castiglione painted the horses and figures. In another painting (undated), representing *Magpies and Peach Blossom*, T'ang Tai painted the rocks and Castiglione the flowers and birds.

Roger Goepper, author of an essay on T'ang Tai, emphasizes the curious nature of this collaboration. The Chinese artist's rocks, outlined in Chinese ink, entirely academic in their severity, contrast with Castiglione's flowering branches marked by a luxuriant exuberance which the painter has difficulty in holding in check. If T'ang Tai does not seem to have been greatly inspired by this collaboration, Castiglione, by contrast, – especially in the scroll in the Yurin-kan Museum – appears totally at ease.

This kind of collective work was prevalent in Peking. T'ang Tai, Castiglione and another painter named Sh'en Yüan, a specialist in Buddhist subjects, illustrated a popular song of the Pin country from the *Shih-ching*. The calligraphy was executed by Chang Chao (1691–1745). This scroll, referred to by J. C. Ferguson and the *Shih-ch'ü pao chi*, was at Yuan-ming-yuan in the Cheng-ta kuang-ming (Pavilion of Uprightness, Greatness and Brightness). It is now in the National Palace Museum in Taiwan.

Chiao Ping-cheng (between 1622 and 1722) and his disciple Leng Mei had studied the principles of perspective, but they most often preferred to keep to the Chinese tradition. In his *Hui-shih fa-wei* T'ang Tai does not speak of Western painting. However, by the end of the eighteenth century Chinese painters were increasingly disposed towards the use of colour and we can see in this the influence of the Europeans working in China.

Castiglione was distinguished from the members of the Office of Painting and the *literati* of the Han-lin Academy by his skill in portraiture and the brilliance of his colours. In their eyes, however, he was nothing but a 'professional', an artisan, gifted certainly, but superficial. The Emperor, on the other hand, considered Castiglione an excellent painter of horses and admired him as much as the greatest Chinese painters

of the past. Ferguson relates that Ch'ien-lung had Li Kung-lin's *Five Horses* copied by a palace painter, compared this painting with the one by Castiglione representing a horse 'By my wish' and stated that Castiglione's work was superior. [3]

Very few *literati* of the period shared the Emperor's enthusiasm for Castiglione's work. We will nevertheless quote the praise of Ch'ien Tsai who, as has already been said, was a great expert on painting. Concerning a scroll of Castiglione's *Horses Presented in Tribute by the Ta-wan*, he wrote: 'Lang Shih-ning employs a new method of painting. He is an official. His method opens up new horizons. The use of colour is particularly noteworthy, for it enables relief to be represented in a satisfactory manner. Mountains, rivers, plants and trees are admirably rendered and absolutely realistic. Furthermore, in this painting *shen* (spirit) is present.'

Europe questioned the traditional method of portraying space in painting; it brought new images; oil painting aroused amused curiosity; but Chinese artists remained faithful to the pictorial language of the past, the only one they could understand. Lang Shih-ning was appreciated only to the extent to which he had adopted it.

The majority of the artists working in the Office of Painting shared the opinion of Tsou-i-kuei (1686–1772), a painter of flowers highly valued by Ch'ien-lung. He expounded his viewpoint in his treatise on painting, the *Hsiao-shan hua-p'u*: 'The Europeans, when they paint, know how to represent light and shade, distance and proximity. They paint their figures and the trees by introducing shadows. Their paints and their brushes differ from ours. They paint palaces and rooms on walls, imitating reality so closely that you imagine you are confronted by a true palace and are about to enter it. There are good elements in this painting and it would be profitable to absorb one or two. But Europeans use their brushes without style and although well executed their paintings are nothing but skilled craftsmanship.'

The painter Wu Li who, it seems, did not know Castiglione but as a Jesuit priest had no prejudices against Europeans, did not appreciate Western painting. He wrote:

'Our painting does not seek a formal resemblance. It does not restrict itself to the beaten paths of tradition. It is inspired and untrammelled. The Europeans work according to certain rules concerning light and shade in order to represent what is near or far. They strive by painstaking labour to obtain a formal resemblance. They do not utilize the brush in the same manner as we do.' [4]

Not to be 'inspired', to work laboriously, to have no style in the use of the brush – these were the reproaches levelled by the Chinese painters against the Europeans. The latter, incidentally, displayed no less incomprehension with regard to their Chinese colleagues. Ricci deplores the fact that they do not know how to paint in oils or introduce shadows. Barrow considers them wretched daubers because they are incapable of creating perspective or painting the nude. Gherardini wrote in his journal: 'Long live Italy for the Fine Arts! The Chinese know as much about architecture and painting as I know of Greek and Hebrew.' More moderate, the Jesuits endeavour in their *Mémoires* to be more objective. 'Our European painters who judge this painting not by the daubs of Canton but by

what they have seen in the Palace agree that it has a good deal to teach our painting as to the way to treat a landscape, to paint flowers, to render a dream palpable, to express passions, etc. In China, they laugh at figures that get lost under the frame, princes barehcaded and naked on a charger, princesses with their breasts uncovered and dressed in ermine in the face of a garden that clearly speaks of summer, or Christian virgins dressed up like actresses.' Modest themselves, the Fathers were delighted to find that the Chinese were shocked by the portrayal of the naked body. [5]

Nevertheless, it is curious to note that the missionaries did not translate any of the many treatises on painting published in China. Works on history, literature, music, porcelain and architecture alone seemed to them worth being communicated to Europeans. The time was not ripe for the pictorial language of the Far East to be understood and to enrich our own.

Castiglione's signature in Chinese characters.

Castiglione Seen by Chinese Critics

Castiglione's Correspondence

Castiglione Seen by Chinese Critics

'Giuseppe Castiglione strikes a happy balance between the Western and the Chinese methods of painting. He excels in the representation of horses.'

Chung-kuo mei-shu-shih
(History of the Fine Arts in China) Ch'en Pin-he
Commercial Press, Shanghai 1930, p. 230

'Giuseppe Castiglione's painting combines the Western and the Chinese method. The objects which he reproduces are strikingly lifelike in both form and spirit. His work is refined, well finished, subtle. He excels in painting birds and beasts, flowers, and plants, figures and horses, archery and hunting. Above all, he is a specialist in painting horses.'

Chung-kuo huei-hua-shih
(History of Chinese Painting)
Commercial Press Taipei, 1960, pp. 255 f.

'Among the foreign painters who have combined the style of Western painting with that of Chinese painting, Giuseppe Castiglione is without equal. He excels in painting figures, but above all horses and flowers. This combination of the two styles does not prevent his method from being founded on the Western tradition while drawing inspiration from the Chinese manner. His picture *A Hundred Horses* bears witness to his hard work and success; it also testifies to a feeling that is more Western than Chinese. If we compare the horses painted by Giuseppe Castiglione with those of Han Kan, Li Kung-lin and Chao Meng-fu we immediately observe that Giuseppe Castiglione lacks *hsi-lien* [purity and training] and that he is ignorant of the specific procedure of Chinese tradition. Neither the line nor the colour are

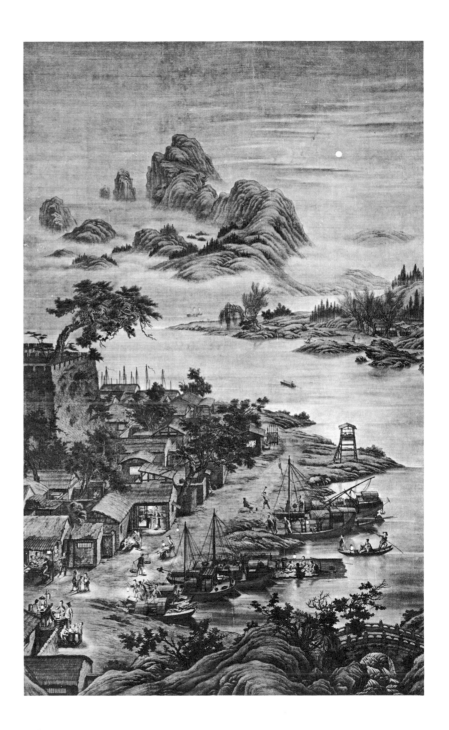

Night Market at Yang-ch'eng (Canton). Painting on silk. 2.60 × 1.55 m. Cat. 82. The Stanford University Museum of Art, Stanford, California.

151

sufficiently powerful. But we ought not to deny either Giuseppe Castiglione's success in the domain of creativity or his influence on Chinese painting.'

Chung-kuo mei-shu shih-kang
(Summary of the History of Chinese Fine Arts)
Li Yü, Peking 1957, pp. 294 f.

'Giuseppe Castiglione excels only in resemblance in the form of things *(hsing-ssu)*. His masterpieces are few.'

Ming-ch'ing shih
(History of the Ming and the Ch'ing)
Li Hsün, Peking 1957, p. 240.

'Giuseppe Castiglione's painting has not succeeded in seizing the spirit of Chinese painting. His method is Western, even though he employs the instruments of Chinese painting. The horses and flowers painted by Giuseppe Castiglione are exactly like what they are in reality: it is a photograph and that is all; there is neither the spirit nor the rhythm of Chinese painting. Giuseppe Castiglione was a famous painter in Italy and Portugal before he came to China. If he studied Chinese painting it was to facilitate the propagation of his religion and that is praiseworthy. Although he remained in Peking for fifty years, he never learned to write Chinese. That is why the images of the saints which he painted for the churches of Peking and its suburbs are not signed by him. The signatures they bear in Chinese characters are not by his hand. His painting has not influenced Chinese painting.'

Lecture by Archbishop Lo Kuang of Taipei on the occasion of the exhibition of Giuseppe Castiglione's paintings. *Chung-yang jih-pao* (Central Daily) 16 May 1969.

Castiglione's Correspondence

Castiglione's correspondence is not very plentiful. We give below a list of the letters we have been able to consult and extracts from some of those which seem to us of particular interest.

In the Archives Nationales in Paris: a letter from Castiglione dated 1766 translated into French, but it is not the original.

In the Biblioteca Corsiniana in Rome: a letter dated November 1732 addressed to the missionaries exiled to Macao and signed by G. Castiglione, Th. Pedrini, D. Parennin and I. Kögler.

Father Lamalle has informed us of the presence of several letters in the Archivum Romanum Societatis Iesu in Rome.

1. Letter of 22 February 1714 addressed to Father Michele Tamburini.
2. Letter of 7 November 1725 addressed to Father Niccolò Giampriano.
3. Letter of 1 December 1726 addressed to Father Michele Tamburini.
4. Letter of 14 October 1729 (to the same).
5. Letter of November 1731 addressed to the missionaries exiled to Macao and signed by Fathers Pedrini, Parennin, Kögler, Pereira and Castiglione.
6. Letter of 31 October 1733 addressed to Father de Retz.
7. Letter of 27 November 1733 (to the same).
8. Letter of 23 November 1733 from Father Tamburini to Castiglione.
9. Letter of 18 December 1755 from Father Centurione to Castiglione.

Father Mauricio Domingos of Lisbon possesses a copy of a letter of obedience to the decree of Innocent III written in 1724 and signed by the brothers coadjutor of Peking: Stadlin, da Costa, Moggi and Castiglione.

Below are the names of the Fathers General with whom Castiglione corresponded. These Generals were appointed for life.

Father Michele Tamburini, General from 30 January 1706 to 28 February 1730.

Father François de Retz, General from 30 November 1730 to 19 November 1750.

Father Ignazio Visconti, General from 4 July 1751 to 4 May 1755.

Father Luigi Centurione, General from 30 November 1755 to 2 October 1757.

Father Laurent de Ricci, General from 21 Mai 1758 to the dissolution of the Society in 1773.

Letter by Castiglione, addressed to Father François de Retz, General of the Society of Jesus, of 31 October 1733 (see translation on p. 155). Archivum Romanum Societatis Iesu, Rome.

118

Extracts

From a letter dated Lisbon, 22 February 1714, addressed to Father Tamburini, General of the Jesuits in Rome.

'... Having received instructions from the Venerable Father Provincial to leave without fail this year for the mission which I requested in China. I greatly wish to go, but I must first satisfy the desire of the Queen, who wishes me to paint the portraits of her two small children. But I hope in the Lord that everything will be finished in the required time and that I shall be able to embark. The works in the chapel of Coïmbra have been completed to everyone's satisfaction, thanks be to God! I have nothing else to say except very humbly to ask Your Paternity's blessing.

Your very humble and unworthy Son,
Giuseppe Castiglione.

(*Note*: The Queen of Portugal at this time was Maria Anna of Austria. Her two children were Maria Barbara, born in 1711, and Peter, born in 1712.)

From a letter dated Peking, 14 November 1729.
'...and so I make Your Paternity the following proposal: in the course of several years I have made various paintings (certainly of little value) of which I still have the preliminary drawings. It seems to me that it would be possible to make copper-plate engravings from these drawings and to print from them pictures for the use of this mission. From these prints a book could then be made which could be used in Europe as an aid to beginners in the art of painting with the addition (if this seems to me useful) of some pieces of advice and documentary material on this art.

As the hand of a good copper-plate engraver will be required for this work, I have put the idea to Brother Ferdinando Moggi (who is at present living in this residence), who most affectionately offered his services for the execution of this work, on condition that this was authorized by the Superiors. Truly, it would be a great comfort if no stranger were to be involved in this little undertaking, but only two brothers of the Society. In my opinion, it would be edifying for the laymen of Europe, who would note that we do not remain idle and that we dedicate all our time to the glory of God. This, incidentally, can be explained in the book.

If it pleases God Our Lord, and with the consent of Your Paternity, that I may complete this little work and that it achieves some success, as I hope in the Lord, and that it is well received, I believe that it would be a very useful and entertaining thing or at least a work of piety and of some novelty in Europe. I say then that our ambition would be to use the profits from this enterprise in pious works for the benefit of the mission and to divide the profits in two halves so that each of us may be able (with Your Paternity's permission) to employ the said half to whatever purpose will most benefit our mission. As for the cost of producing the said book, I shall make use of the alms which I collect, although I think that this will not be sufficient, on account of other necessities, but in that case I should have recourse to the Superiors or others among our people and I hope that, if necessary, Our Lord will give me the courage to appeal to Your Paternity, since I have the good fortune to have such a Father and to be the unworthy son of such a mother (the Society).

I have already communicated the above idea to the Venerable Father Ignatius Kögler and the Venerable Father Gio Duarte, to his successor Father Tomás Pereira and also to the Father Superior Domenico Pinheiro, who, with a paternal love, have acceded to this request and encouraged me.'

From a letter dated Peking, 31 October 1733, and addressed to Father François de Retz, General of the Society of Jesus.

'Last year I did not reply to Your Paternity in order not to importune you further. That is why I now come respectfully to ask news of Your Paternity's health. I happen to have in my possession a rather bizarre stone showing in its centre veins which describe a kind of pyramid with different arcs of a circle. This stone, it seems to me, might be pleasing to Your Paternity. You could place it either in your gallery or wherever it may please Your Paternity. I take leave to present this thing of little value to Your Paternity, judging that I could not put it to better use. May Your Paternity pardon my simplicity! The Chinese make use of such stones and set them in a frame with two legs and place them on a table, so that they may be seen from both sides...'

(*Note*: It is clear from this letter that in China Castiglione had acquired the taste for curious stones so widespread among the *literati*).

From a letter from the Father General Luigi Centurione to Brother Castiglione dated 18 December 1755.

'...I have not forgotten the clockmaker brother whom the Father Vice Principal desires nor the painter whom you have asked for so that you may instruct him during your life and leave him as your successor in the art which so aids the progress of the mission and the Society.

Our reverend Father knows how delicate is your brush and that is why he rightly considers that the excellent copies of your paintings which you have transmitted should be engraved on copper. The copies have all been preserved in my residence. The pictures will serve to propagate in Europe devotion towards the Saints venerated in our Church and by the Christian community of Peking.'

(*Note*: See the catalogue for two of these engravings, Cat. 119 and 120).

Castiglione's signature on a letter addressed to Father Tamburini, of 22 February 1714 (see translation on p. 154). Archivum Romanum Societatis Iesu, Rome.

Bibliographical Notes

THE LIFE OF CASTIGLIONE

[1] HUBRECHT, A., *Grandeur et suprématie de Pékin*, p. 230.

[2] Letter written by Castiglione on 22 February 1714 (Archives of the Society of Jesus, Rome), see extracts, p. 154; Franco, A., *Imagen do secundo seculo... Fundo geral* 750, fol. 163 and 178. National Library, Lisbon.

[3] *Lettres édifiantes*, vol. 17, p. 13 (de Tartre, 1701).

[4] *Lettres édifiantes*, vol. 17, p. 14 ff. (de Tartre, 1701).

[5] HUBRECHT, A., *Grandeur et suprématie de Pékin*, p. 179.

[6] *Lettres édifiantes*, vol. 17, p. 348 (Fontaney, 1704).

[7] LOEHR, G., 'Missionary Artists at the Manchu Court' in *Transactions of the Oriental Ceramic Society*, vol. 34. 1962–1963, p. 55.

[8] *Lettres édifiantes*, vol. 17, p. 60 (de Tartre, 1701).

[9] *Lettres édifiantes*, vol. 23, p. 129 (Amiot, 1752).

[10] *Lettres édifiantes*, vol. 22, p. 393 (Attiret, 1743).

[11] *Lettres édifiantes*, vol. 22, p. 415 (Attiret, 1743).

[12] *Memoirs of Father Ripa*, p. 89.

[12a] *Memoirs of Father Ripa*, p. 48.

[13] Decree in Favour of the Christian Religion, 1692.

[14] LECOMTE, H.L., *Nouveaux Mémoires sur l'état présent de la Chine*, p. 398.

[15] FEUILLET DE CONCHES, M.F., 'Les Peintres européens en Chine' in *Revue contemporaine*, vol. XXV, pp. 228 ff.

[16] *Journal des Savants*, June 1771, p. 408 (Amiot, 1769).

[17] *Journal des Savants*, June 1771, p. 407 (Amiot, 1769).

[18] LOEHR, G., 'Missionary Artists at the Manchu Court' in *Transactions of the Oriental Ceramic Society*, vol. 34. 1962–1963, p. 55.

[19] MOYRIA DE MAILLAC, J. A.-M. de, vol. XI, p. 354.

[20] CORDIER, H., *Histoire générale de la Chine* vol. III. 1920–1921, p. 338 f.

[21] *Lettres édifiantes*, vol. 18, p. 6 (Jartoux, 1704).

[22] *Lettres édifiantes*, vol. 24, p. 396 (Un missionnaire, 1778).

[23] Letters I. Kögler to M. Tamburini, Peking 17 October and 22 November 1723. Quoted after G. Loehr, 'Missionary Artists at the Manchu Court' in *Transactions of the Oriental Ceramic Society*, vol. 34, 1962–63, p. 58.

[24] *Lettres édifiantes*, vol. 20, pp. 287 ff. (Parennin, 1736).

[25] *Lettres édifiantes*, vol. 22, p. 216 (Etat de la religion en 1738).

[26] *Lettres édifiantes*, vol. 22, pp. 219 f. (Etat de la religion en 1738).

[27] *Lettres édifiantes*, vol. 23, p. 225 (Un missionnaire, 1750).

[28] *Lettres édifiantes*, vol 23, p. 86 (Chanseaume, 1746).

[29] *Lettres édifiantes*, vol. 23, p. 88 (Chanseaume, 1746).

[30] PELLIOT, P., *Les influences européennes sur l'art chinois*, 1927, p. 10, and M. F. FEUILLET DE CONCHES, 'Les Peintres européens en Chine' in *Revue Contemporaine*, vol. XXV, pp. 228 f.

[31] *Lettres édifiantes*, vol. 23, p. 294 (Amiot, 1754).

[32] *Lettres édifiantes*, vol. 23, p. 292 (Amiot, 1754).

[33] LOEHR, G., 'Missionary Artists at the Manchu Court' in *Transactions of the Oriental Ceramic Society*, vol. 34. 1962–1963, p. 57.

[34] *Tao Ya*, p. 72.

[35] *Lettres édifiantes*, vol. 22, p. 415 (Attiret, 1742).

[36] *Lettres édifiantes*, vol. 22, p. 412 ff. (Attiret, 1742).

[37] *Lettres édifiantes*, vol. 23, p. 275 (Amiot, 1754).

[38] *Lettres édifiantes*, vol. 23, p. 132 (Amiot, 1752).

[39] *Lettres édifiantes*, vol. 23, p. 142 f. (Amiot, 1752).

[40] *Lettres édifiantes*, vol. 23, p. 262 ff. (Amiot, 1754).

[41] *Lettres édifiantes*, vol. 23, p. 266 (Amiot, 1754).

[42] *Lettres édifiantes*, vol. 24, p. 393 (Un missionnaire, 1778).

[43] *Lettres édifiantes*, vol. 17, p. 199 (Fontaney: *Obsèques de Verbiest*, 1703).

[44] HUBRECHT, A., *Grandeur et suprématie de Pékin*, p. 230.

CASTIGLIONE THE ARCHITECT

[1] LOEHR, G., *Giuseppe Castiglione*, p. 78.

[2] *Lettres édifiantes*, vol. 24, p. 325 (Un missionnaire, 1775).

[3] *Lettres édifiantes*, vol. 24, p. 336 (Un missionnaire, 1775).

[4] ADAM, M., *Yuen-ming-yuen*, p. 19.

[5] *Lettres édifiantes*, vol. 22, p. 407 (Attiret, 1743).

[6] HÉRISSON, comte Maurice d'Irisson d', *Journal d'un interprète en Chine*, p. 349.

[7] SIRÉN, O., *Les Palais Impériaux de Pékin*, vol. III, pl. 207 ff.

[8] Lettres du Père Bourgeois à Delatour, in Delatour. J. F., *Essai sur l'architecture des Chinois*, pp. 170–172.

CASTIGLIONE AND THE CONQUESTS OF THE EMPEROR OF CHINA

[1] Archives nationales, Paris, o¹, 1924.

[2] PELLIOT, P., 'Les Conquêtes de l'Empereur de la Chine' in *T'oung Pao*, série 11, vol. XX, p. 182.

[3] PRAY, P., *Imposturae CCXVIII...* (Epistola VI, Hallerstein) pp. 43 f.
[4] CORDIER, H., *La Chine en France au XVIII^e siècle*, pp. 57 f.
[5] Archives Nationales, Paris, o¹, 1924.
[6] PELLIOT, P., 'Les Conquêtes de l'Empereur de la Chine' in *T'oung Pao*, série 11, vol. XX, p. 203.
[7] PIRAZZOLI - t'SERSTEVENS, M., *Gravures des conquêtes de l'Empereur de Chine K'ien-long au Musée Guimet* (1969).

CASTIGLIONE AND RELIGIOUS PAINTING

[1] LOEHR, G., *Giuseppe Castiglione*, p. 7.
[2] Letter written by Castiglione on 3 February 1714 (Archives of the Society of Jesus, Rome).
[3] HUC, R.-E., *Le Christianisme en Chine*, vol. IV, pp. 71 f.
[4] Mikinosuke Ishida, 'A Biographical Study of Giuseppe Castiglione' in *The Memoirs of the Toyo Bunko*, No. 19, 1960.
[5] *Lettres édifiantes*, vol. 19, p. 376 (Amiot, 000).

THE PORTRAIT PAINTER / THE GENRE PAINTER

[1] PELLIOT, P., *Les Influences européennes sur l'art chinois*, p. 6.
[2] FERGUSON, J. C., *China Journal*, vol. XII (1930).
[3] *Lettres édifiantes*, vol. 22, p. 414 (Attiret, 1743).
[4] *Illustrated London News* (8 June 1968).
[5] *Lettres édifiantes*, vol. 23, p. 457 (Ventavon, 1769).
[6] *Lettres édifiantes*, vol. 24, p. 251 (Benoist, 1773).
[7] *Lettres édifiantes*, vol. 23, p. 274 (Amiot, 1794).
[8] *Journal des Savants*, June 1771, pp. 408 ff. (Amiot, 1769).
[9] *Lettres édifiantes*, vol. 23, p. 267 (Amiot, 1754).
[10] BARROW, Sir John, *Voyage en Chine...*, vol. 11, p. 71.

THE PAINTER OF ANIMALS / THE PAINTER OF FLOWERS / THE PAINTER OF LANDSCAPES

[1] WILLETS, W., *Foundations of Chinese Art*, vol. II, p. 552.
[2] FEUILLET DE CONCHES, M. F., 'Les Peintres européens en Chine' in *Revue contemporaine*, vol. XXV, p. 24.
[3] *Lettres édifiantes*, vol. 24, p. 260 (Benoist, 1773).
[4] BARROW, Sir John, *Voyage en Chine...*, vol. 11, p. 71.

[5] SIRÉN, O., *History of Chinese Painting*, vol. II, p. 24.
[6] BARROW, Sir John, *Voyage en Chine...*, vol. 11, p. 73.
[7] RYCHMANS, P., 'Les propos sur la peinture de Shi Tao' in *Arts Asiatiques*, vol. XIV, 1966.

CASTIGLIONE AND THE CHINESE PAINTERS OF HIS DAY

[1] PARENNIN, D., *Lettres* (1770), p. 56.
[2] BALAZS, E., *La bureaucratie céleste*, p. 36.
[3] FERGUSON, J. C., *Chinese Painting*, p. 179.
[4] LIPPE, prince de, 'A Christian Chinese Painter' in *Bulletin of the Metropolitan Museum of Art*, 1952.
[5] *Mémoires concernant l'Histoire...*, vol. 9, p. 363.

Catalogue

The *Shih-ch'ü pao-chi*, the catalogue of secular paintings in the Imperial Palaces, comprizes three series.

The first was composed between 1743 and 1744. Of this series there exists a lithographic edition published in 1918. The second, written between 1791 and 1793, was never published. The third, dating from 1815, was published in Shanghai by Lo Chen-yü in 1917. These three series contain references to fifty-five works by Lang Shih-ning. In 1816 Hu Ching, a member of the commission charged with drawing up the third series of the *Shih-ch'ü pao-chi*, wrote a work entitled *Kuo-ch'ao yüan-hua lu*, or 'History of the Paintings of the Office of the Reigning Dynasty', in which he lists forty-seven paintings by Lang Shih-ning. In 1934 J. Ferguson published the *Li-tai chu-lu hua-mu*, a catalogue of the Imperial Collections established on the basis of the *Shih-ch'ü pao-chi*, and a list of the paintings identified as being in the various palaces and libraries. In 1931 the *Lang Shih-ning hua-chi* was published under the aegis of the Chinese Government, in five volumes reproducing fifty of Castiglione's paintings and an album of flower sketches.

Our catalogue of Castiglione's paintings is based on these works. It cannot be complete, since the commissioners charged with editing the *Shih-ch'ü pao-chi* are said by Hu Ching to have forgotten to mention some of the paintings. Furthermore, although we visited Peking, the palaces, libraries and museums were closed, so that we were unable to complete our documentation. To mitigate these shortcomings we have had recourse to other publications and to private collections.

Castiglione's signature frequently appears on paintings of doubtful authenticity. We have eliminated manifest forgeries, but since we were unable to examine personally all the works reproduced in this book we have confined ourselves to indicating our sources of information and, where appropriate, expressing our doubts.

We have employed the following code for the various references: *Shih* 1, 2, 3 refers to the three series of the *Shih-ch'ü pao-chi*; *Kuo* to the *Kuo-ch'ao yüan-hua lu*; *Lang* to the *Lang Shih-ning hua-chi*; *Li* to the *Li-tai chu-lu hua-mu*.

On pages 192 and 193 we have reproduced the seals that appear most frequently on Lang Shih-ning's paintings. In the captions catalogue we refer the reader to the relevant page, indicating the number relating to each seal. Finally, the dimensions of the paintings taken from the old catalogues are approximate. The Chinese 'foot'—about 35 cm—was a measurement that varied in the course of the centuries and from province to province. Measurements are given in metres; the first dimension is always the height.

We would remind our readers that Chinese paintings are scrolls to be read from right to left.

PAINTINGS LISTED IN
THE CATALOGUE OF THE
IMPERIAL COLLECTIONS
The *Shih-ch'ü pao-chi* (series one)

石渠寶笈

Seal no. 16

1-16 SKETCHES OF FLOWERS

寫生花卉

(*see also* illus pp. 126-7)
Sixteen paintings on silk
0.33 × 0.27 m.
Signed on the 8th leaf
Seals: 4th leaf, no. 2a
 8th leaf, nos. 27, 14, 13
 16th leaf, nos. 2, 26, 19, 18.
Cf. *Shih* 1 (vol. IV, p. 38); *Li*; *Lang*
vol. IV; *Kuo* p. 14.
National Palace Museum, Taipei,
Taiwan.

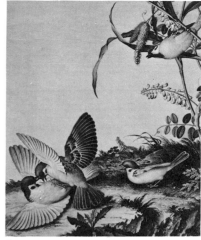

1

2

3

4

5

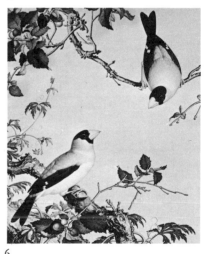

6

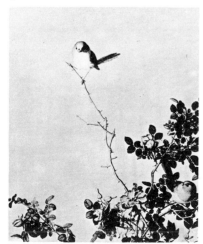

7

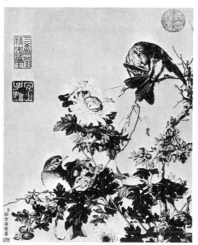

8

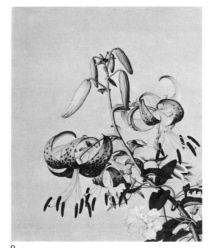

9

10

11

12

13

14

15

16

17 A HUNDRED HORSES

白駿

(*see also* illus pp. 34-5, 132, 134-5)
Painting on silk
0.94 × 7.76 m.
Signed, dated: 6th year of Yung-cheng (1728)
Seals: nos. 2, 26, 11.
Painting belonging to the Yü-shu-fang (Imperial Library).
Cf. *Shih* 1 (vol. XXXV, p. 29); *Li*; *Lang* vol. III; *Kuo* p. 15.
National Palace Museum, Taipei, Taiwan.
A copy of this painting is in the collection of Mrs Takeuchi Yoneko, Kanagawa, Japan (Exhibition of

Chinese Art of the Ming and Ch'ing periods), Tokyo, National Museum, 1963; another copy is in the collection of Prince Moritz von Hessen, Lütjenburg, Germany.

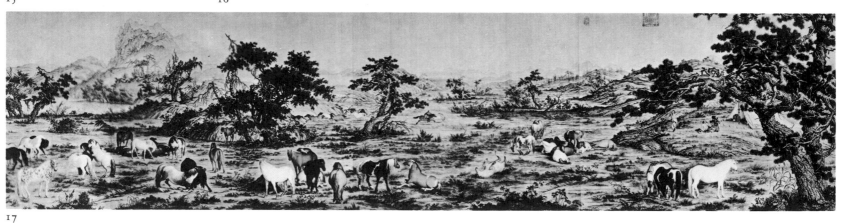

17

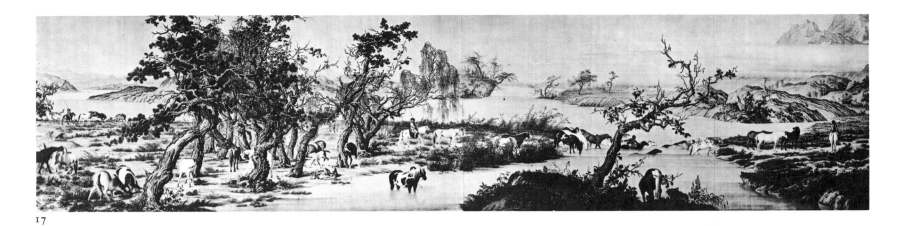

17

18-22 TEN HORSES 十駿

Series of ten paintings on silk
Each 2.40 × 2.71 m.

Signed: Respectfully painted by Lang Shih-ning who comes from the west of the seas. There follow two of the painter's seals (see p. 193). Dated: 1st month of the year 1743. Horses presented by the princes of the commanderies of Ko-erh-ka and Ko-erh-hsien. Names and sizes of the horses inscribed in Chinese, Manchu and Mongol characters.

Seals: each painting carries seals; see nos. 2, 4, 5, 3.

a) Horse named 'Ten Thousand Happinesses' (not reproduced)

萬吉驢

Poem by Chang Chao (1691-1745) (see p. 144). Summary: 'This horse can fly to the sky and gallop in the clouds. It is the symbol of peace and happiness.'

b) Horse named 'As Brave as a Tiger' (not reproduced) 鬭虎驢

Poem by Liang Shih-cheng (1697-1763) (see p. 144). Summary: 'This horse is a dragon of heaven capable of crossing mountains and valleys. Nothing can stop it. Its anger is to be feared. What happiness to possess such an exceptional animal!'

c) Horse named 'As Brave as a Lion' (not reproduced) 獅子玉

Poem by Chang Chao. Summary: 'This steed, the friend of dragons, can travel 10,000 li. Its hair is the colour of jade. Its strength is that of a lion. It has no equal.'

d) Horse named 'Swift as Lightning' (18) 霹靂驤

Poem by Emperor Ch'ien-lung. Summary: 'This horse is the most precious in my stables. All it lacks is speech.'

Second poem written by Liang Shih-cheng. Summary: 'This horse is out of the ordinary. Like a cyclone it scatters the peach blossoms.'

e) Horse named 'Vulture Spotted with Snow' (19) 雪點鵰

Poem by Emperor Ch'ien-lung. Summary: 'The Emperor asked Lang Shih-ning to paint for him this horse like a dragon. Henceforth it can no longer be said that no one can equal Ts'ao and Han.' (Two painters famous for their paintings of horses.)

Second poem by Chang Chao comparing this horse to a vulture.

f) Horse named 'Carefree' (not reproduced) 自在驈

Poem by Liang Shih-cheng. Summary: 'The horse of the Son of Heaven must be virtuous and docile that the ride may be pleasant.'

g) Horse named 'Galloping in the Clouds' (20) 奔霄驄

Poem by Emperor Ch'ien-lung. Summary: 'For two years the Emperor raised this docile horse on which he hunts. Before 120 riders it killed a fox.'

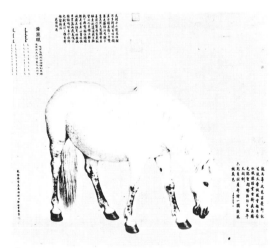

18

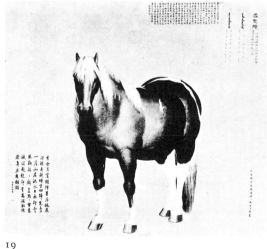

19

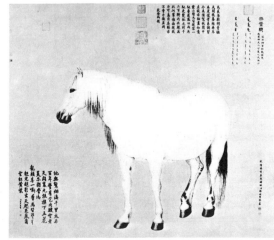

20

Second poem by Chang Chao. Summary: 'The world is at peace and this horse is an auspicious symbol. It is as swift as lightning.'

h) Horse named 'Eagle with Red Flowers' (21)

Poem by Emperor Ch'ien-lung. Summary: 'Connoisseurs of horses are rare. This horse is capable of rising to the clouds.'

Second poem by Liang Shih-cheng extolling the pleasures of the chase in autumn in the Imperial park, where the Emperor is hunting birds and beasts with the bow.

i) Horse named 'Heroic' (not reproduced)

Poem by Chang Chao. Summary: 'This exceptional horse braves the winds of autumn and dances across the black clouds. How happy it is to have met a benevolent sovereign.'

j) Horse named 'Walking in the Clouds' (22)

Poem by Emperor Ch'ien-lung. Summary: 'Each year in autumn my ministers accompany me to places where the neighing of horses echoes and the grass is like brocade. Those escorting me are dazzled by all this

splendour and I ask the princes' tutor to write a poem.' Second poem by Liang Shih-cheng. Summary: 'This celestial horse can rise into the clouds. Ten thousand *li* are nothing to him.' We have been able to obtain photographs of only five horses belonging to this series.

According to these documents each painting bears two poems, one of them by the Emperor. However, the *Shih-ch'ü pao-chi* vol. XL, p. 19, which describes each painting, does not mention the Emperor's poems. Could they have been added later? On the other hand, if the catalogue of paintings in the National Palace Museum,

Taiwan refers to the portrait of the horse named 'Walking in the Clouds' as 'one of the eight prize steeds', this is because the Museum possesses eight paintings of horses of which five are in this series. No doubt the rest remained in Peking.

Cf. *Shih* 1 (vol. XL, p. 19); *Li*; *Lang* vol. II, pp. 2, 3, 4, 14, 15; *Kuo* p. 14. National Palace Museum, Taipei, Taiwan.

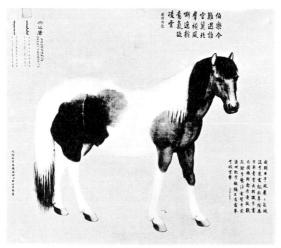

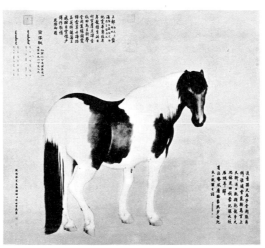

21

22

Seals: nos. 6, 5, 3, 9, 16, 17, 10, 15, 1, 12, 14, 13, 16, 20.
Poem by Emperor Ch'ien-lung. Summary: 'This people, for long at war with China, now present him with horses in tribute. Swift as lightning, these horses are veritable dragons and the Emperor asks Lang Shih-ning to paint them.' (The Kazaks were Turkish Moslem nomads living in the region between Lake Balkhash and the Urals. They acknowledged the sovereignty of the Dzungars.)
Cf. *Shih* 2; *Li*; *Kuo* p. 15.
Scroll presented in 1925 to the Musée Guimet by General Frey who fought the Pei chih-li campaign in 1900.
Musée Guimet, Paris.

The *Shih-ch'ü pao-chi* (series two)

Seal no. 10

At the 'NING-SHOU-KUNG' (Palace of Tranquillity and Longevity)

23 KAZAKS PRESENTING HORSES IN TRIBUTE 哈薩克貢馬

(*see also* illus pp. 102, 103-5)
Painting on paper
0.45 × 2.67 m.
Signed, dated: year ting-ch'ou of Ch'ien-lung (1757)

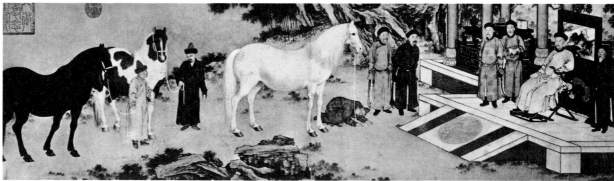

23

24 AYUSI ASSAILING THE REBELS WITH A LANCE 阿玉錫持矛蕩寇

(*see also* illus p. 107)
Painting on paper
0.27 × 1.04 m.
Dated: year yi-hai of Ch'ien-lung (1755)
Seals: nos. 11, 20, 10, 16, 19, 17, 29, 2a.
Poem by Emperor Ch'ien-lung. Summary: 'Tawachi had gathered together ten thousand soldiers. Ch'ien-lung sent Ayusi with only twenty-five warriors to take them by surprise. Ayusi brandished his lance, whipped his horse and cried: «All Chinese hearts united! Let the rebels flee like foxes and rats.»'
Commentary: 'Ayusi was a Dzungar. Having committed a crime he fled and came to serve in the Imperial Guard. His gallantry is incomparable.'
Cf. *Shih* 2; *Li*; *Lang* vol. II, p. 25; *Kuo*, p. 15.
National Palace Museum, Taipei, Taiwan.

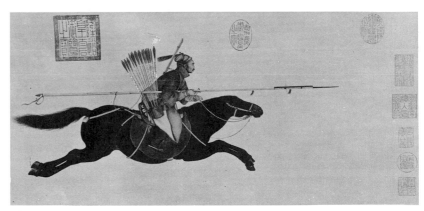

24

25 MA CH'ANG ATTACKING THE ENEMY'S CAMP 瑪瑺斫陣

(*see also* illus pp. 54-5)
Painting on paper
0.38 × 2.85 m.
Signed, dated: year chi-mao of Ch'ien-lung (1759)
Seals: nos. 6, 7, 12, 14, 13, 2a.
A long poem by Emperor Ch'ien-lung praising this general, extolling his courage, his success and his reputation in Yi-li.
Cf. *Shih* 2; *Li*; *Lang* vol. II, pp. 12-13; *Kuo* p. 16.
National Palace Museum, Taipei, Taiwan. A copy of this painting is in the Ehem. Staatliche Museen, Preussischer Kulturbesitz, Berlin.

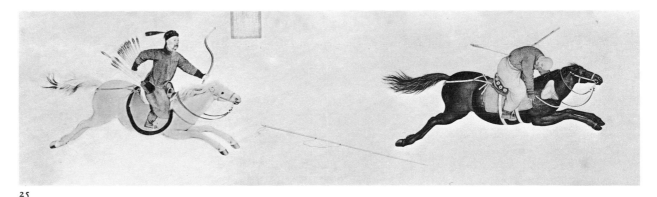

25

26 THE WHITE HAWK 白海青

Painting on paper
1.41 × 0.88 m.
Signed, dated: spring, year wu-yin of Ch'ien-lung (1758)
Seals: nos. 11, 16, 19, 17, 20, 12, 14, 13, 10.
Poem by Emperor Ch'ien-lung. Summary: 'This bird with flaming eyes and plumage as white as pear blossom comes from the eastern seas. It possesses power. But is not virtue the primordial quality?'
Cf. *Shih* 2; *Li*; *Lang* vol. I, p. 17.
National Palace Museum, Taipei, Taiwan.

26

27 THE FOUR STEEDS OF AI-WU-HAN (Afghan horses) 愛烏罕四駿

(*see also* illus p. 120)
Painting on paper
0.40 × 2.97 m.
Signed, dated: 27th year of Ch'ien-lung (1762)
Seals: nos. 11, 10, 20, 16, 19, 17, 1, 29, 9, 6, 5, 3, 12, 5, 14, 13.

a) 'Superior' Horse (*see also* illus p. 121)
b) 'Distant' Horse (*see also* illus p. 122)
c) 'Moon' Horse (*see also* illus p. 26 and jacket)
d) 'White' Horse

Poem by Emperor Ch'ien-lung. Summary: 'These horses have been presented in tribute. Their ears are straight as bamboos. They cross mountains like dragons.'

Commentary: 'These horses were presented by Ai-ha-mo-to. The Emperor ordered Lang Shih-ning to paint these horses.' There follow the names of eleven officials.

Cf. *Shih* 2; *Li*; *Lang* vol. II, pp. 22-4; *Kuo* p. 16.

National Palace Museum, Taipei, Taiwan.

▶

167

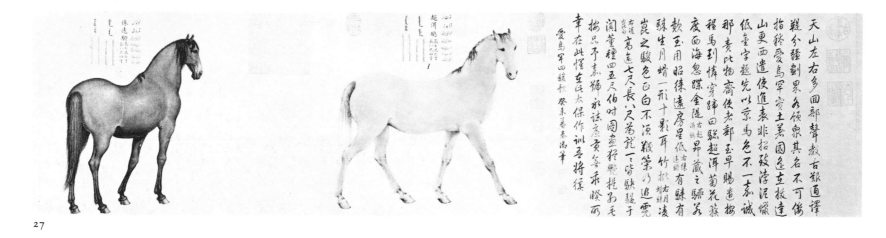

27

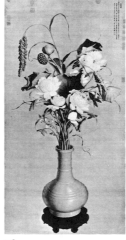

27

At the 'CH'IEN-CH'ING KUNG
(Palace of Celestial Purity) 乾清宮

Seal no. 8

28 AUSPICIOUS OBJECT 象瑞

(*see also* illus p. 37)
Painting on silk
1.73 × 0.86 m.
Signed, dated: 1st year of Yung-cheng, 9th month, 15th day (1723)
Seals: nos. 16, 19, 17, 8, 11, 29, 12, 14, 13.
Inscription: '1st year of Yung-cheng, 9th month, 15th day (1723). Two-

eared grain grows in the fields, double lotuses flower in the pond and I, Lang Shih-ning, paint these auspicious signs.'
Cf. *Shih* 2; *Li*; *Lang* vol. I, p. 18; *Kuo* p. 16.
A copy of this painting is reproduced in the *So gen min shin meiga daikan*, p. 326.
National Palace Museum, Taipei, Taiwan.

28

29 THE WHITE HAWK 白鶻

(*see also* illus p. 42)
Painting on silk 1.23 × 0.65m.
Signed, dated: 16th year of Ch'ien-lung, 5th month, 10th day (1751)
Seals: nos. 8, 12, 11, 16, 19, 17, 29, 14, 13.
Inscription: 'A white eagle presented by Fu Heng, the loyal and gallant duke.'
Poem by Emperor Ch'ien-lung calligraphed by Chi Huang. Summary: 'This white hawk is a bird powerful among all birds and of extreme rarity. It can be compared to a general.'
Cf. *Shih* 2; *Li*; *Lang* vol. I, p. 23; *Kuo* p. 17. National Palace Museum, Taipei, Taiwan.

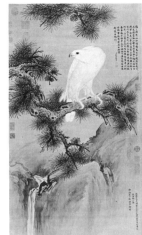

29

At the 'YANG-HSIN-TIEN' (Palace for Cultivating Hearts) 養心殿

 Seal no. 28

31 THE WHITE HAWK 白鷹

Painting on silk
1.79 × 0.99 m.
Signed, dated: 30th year of Ch'ien-lung (1765)
Seals: nos. 16, 19, 17, 11, 12, 14, 13, 28.
Poem by Ch'ien-lung. Summary: 'A rapacious bird captured and presented by a minister as an auspicious gift.'
Cf. *Shih* 2; *Li*; *Lang* vol. I, p. 20; *Kuo* p. 17.

31

At the 'CHUNG-HUA-KUNG' (Palace of Double Flowers) 重華宮

Seal no. 26

33 THE WHITE MONKEY 白猿

(*see also* frontispiece)
Painting on silk
1.69 × 0.99 m.
Signed
Seals: nos. 16, 19, 17, 29, 11, 12, 14, 13, 26.
Cf. *Shih* 2; *Li*; *Lang* vol. I, p. 16.
National Palace Museum, Taipei, Taiwan.

33

30 THE WHITE HAWK 白海青

(*see also* illus p. 144)
Painting on silk
1.88 × 0.97 m.
Signed
Seals: nos. 29, 11, 12, 14, 13, 8, 19, 17.
Inscription indicating the name of the donator followed by the calligraphy of Wang Yu-tun.
Cf. *Shih* 2; *Li*; *Lang* vol. I, p. 15.
National Palace Museum, Taipei, Taiwan.

30

At the 'CH'UN-HUA-HSÜAN' (Palace of Probity and Simplicity) 淳化軒

32 LOTUS FLOWERS

Painting on silk
Vertical scroll
Signed
Seals: nos. 29, 18, 2.
Cf. *Shih* 2; *Li*; *Kuo* p. 17.
Collection Mme Chiang Kai-shek, Taipei, Taiwan.

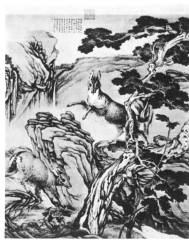

32

34 GOATS 青羊

Painting on silk
2.43 × 2.14 m.
Signed
Seals: nos. 6, 26.
Inscription: 'Poem by Emperor Ch'ien-lung calligraphed by Liang Shih-cheng' (1697-1763) (*see* p. 144). Summary: 'The goat may escape the lions and tigers. But if it stays eating too long it risks being devoured. One must not be greedy.'
Cf. *Shih* 2; *Li*; *Lang* vol. I, p. 6.
National Palace Museum, Taipei, Taiwan.

34

35 THE WHITE HAWK

Painting on silk
1.88 × 0.97 m.
Signed, dated : year chia-shen of Ch'ien-lung (1764)
Seals: nos. 12, 14, 13, 16, 19, 26.
Poem by Emperor Ch'ien-lung. Summary: 'I asked Lang Shih-ning to paint the portrait of this bird whose plumage can change colour and which was presented to me by the tribe of Ho-Han (Sin-Kiang). I have had an aviary made for it, because it is an auspicious symbol.'
Cf. *Shih* 2; *Li*; *Lang* vol. I, p. 7; *Kuo* p. 17.
National Palace Museum, Taipei, Taiwan.

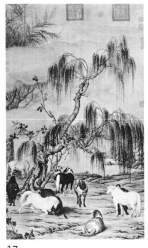

37

39 THE MONKEY OF COCHIN-CHINA 交趾果然

(*see also* illus p. 125)
Painting on silk
1.09 × 0.84 m.
Signed
Seals: nos. 12, 11, 29, 14, 13, 27.
Inscription: 'Poem by the Emperor calligraphed by Yu Min-chung describing this little monkey from Cochin-China.'
Cf. *Shih* 2; *Li*; *Lang* vol. V, p. 2; *Kuo* p. 17.
National Palace Museum, Taipei, Taiwan.

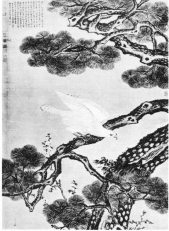

35

At the 'YÜ-SHU-FANG' (Imperial Library) 御書房

 Seal no. 27

38 TSU-YUEH BIRD (Phoenix) 鸑鷟雨

Painting on silk
1.80 × 1.05 m.
Signed
Seals: nos. 11, 29, 6, 3, 5, 14, 27.
Inscription: 'Poem by Emperor Ch'ien-lung calligraphed by Yü Min-chung (1714-1789) (*see* p. 144). Summary: 'The Emperor does not know this bird whose name does not appear in the dictionary. It is black speckled

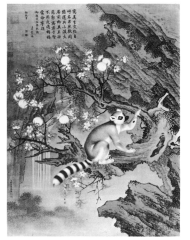

39

36 FISH AND PLANTS 魚藻

Painting on silk
0.68 × 1.22 m.
Signed
Seals: nos. 19, 17, 5, 6, 29, 26.
Cf. *Shih* 2; *Li*; *Lang* vol. I, p. 19; *Kuo* p. 17.
National Palace Museum, Taipei, Taiwan.

36

with white. Its eyes are red circled with yellow. The Emperor asked Lang Shih-ning to paint this bird that comes from a distant country and was presented by the minister A Kuei.'
Cf. *Shih* 2; *Li*; *Lang* vol. I, p. 24; *Kuo* p. 7.
Former Imperial Palace Collection, Peking.

40 'FLOWER OF JADE' HAWK 玉花鷹

Painting on silk
1.43 × 0.78 m.
Signed
Seals: nos. 29, 16, 19, 17, 2, 12, 14, 13, 27.
Inscription in *li* script: '*Flower of Jade*, eagle presented by a prince of Ko-erh-hsien.'
Cf. *Shih* 2; *Li*; *Lang* vol. I, p. 10; *Kuo* p. 17.
National Palace Museum, Taipei, Taiwan.

37 EIGHT HORSES 八駿

Painting on silk
1.39 × 0.80 m.
Signed
Seals: nos. 12, 26, 14, 6, 11, 19, 26.
Cf. *Shih* 2; *Li*; *Lang* vol. I, p.3.
There are in the *Shih-ch'ü pao-chi* and in the *Li-tai chu-lu hua-mu* three paintings entitled *Eight Horses*. The present one, a second, horizontal, which is said to belong to the Ning-shou-kung, and a third, identical with Cat. 51: *Presenting of Superior Horses like Clouds in the Embroidered Sky*.
National Palace Museum, Taipei, Taiwan.

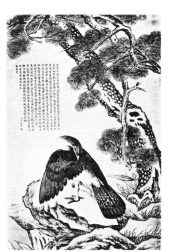

38

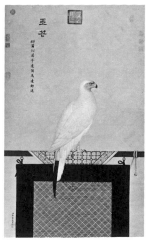

40

41 AN OCCIDENTAL PLANT
SAID TO TELL THE TIME
(*Mimosa Pudica*)　海西知時
Painting on　　　paper 1.36 × 0.88 m.
Signed, dated: year kuei-yu (1753)
Seals: nos. 16, 19, 17, 1, 23, 11, 29,
12, 14, 13, 27.
Inscription: 'Poem by Emperor
Ch'ien-lung.' Summary: 'This yellow
flower with the green leaf tells the
time. It was presented by the Western-
ers. When touched it goes to sleep,
then it wakes up. Rare things ought
not to be praised, but it is strange and
deserves a poem.'
Cf. *Shih* 2; *Li*; *Lang* vol. I, p. 9;
Kuo p. 16. National Palace Museum,
Taipei, Taiwan.

41

43 GORGEOUS SPRING 錦春

(Pheasant on a rock)
(*see also* illus p. 130)
Painting on silk
1.69 × 0.95 m.
Signed
Seals: nos. 5, 6, 3, 27.
Cf. *Shih* 2; *Lang* vol. V, p. 2; *Kuo*
p. 17.
National Palace Museum, Taipei,
Taiwan.

43

44 PEACOCK OPENING
ITS TAIL　　　孔雀開屏

Painting on silk
3.28 × 2.82 m.
Signed, dated: year wu-yin of Ch'ien-
lung, 6th month, 16th day (1758)
Seals: nos. 16, 18, 4.
Poem by Emperor Ch'ien-lung de-
scribing the animal.
Cf. *Shih* 3; *Li*; *Lang* vol. I, p. 14;
Kuo p. 18.
National Palace Museum, Taipei,
Taiwan.

44

42 CHRYSANTHEMUMS
OF THE WEST　　　洋菊
Painting on paper
0.60 × 0.47 m.
Signed
Seals: nos. 29, 14, 13, 27, 11, 12, 16,
19, 17.
Cf. *Shih* 2; *Li*; *Lang* vol. I, p. 11;
Kuo p. 17.
National Palace Museum, Taipei,
Taiwan.

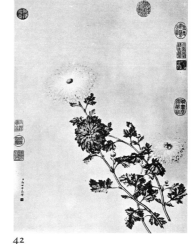

42

The *Shih-ch'ü pao-chi* (series three)

　Seal no. 18

At the 'NING-SHOU-KUNG'

　Seal no. 10

45 DOG UNDER　　　花底仙尨
FLOWERING BRANCHES

(*see also* illus p. 143)
Painting on silk
1.23 × 0.61 m.
Signed
Seals: nos. 29, 16, 18, 2, 30, 14, 13.
Cf. *Shih* 3; *Li*; *Lang* vol. I, p. 4;
Kuo p. 18.
National Palace Museum, Taipei,
Taiwan.

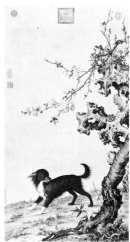

45

46 CRANES AND FLOWERS 花陰雙鶴

(*see also* illus p. 131)
Painting on silk
1.70 × 0.93 m.
Signed
Seals: nos. 29, 16, 18, 2, 30, 14, 13.
Cf. *Shih* 3; *Li*; *Lang* vol. I, p. 12;
Kuo p. 18.
National Palace Museum, Taipei,
Taiwan.

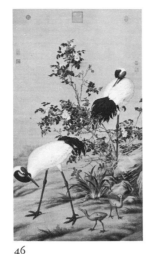

46

47 BLUE-BLACK DOG 蒼猊犬

Painting on silk
2.97 × 2.25 m.
Signed
Seals: nos. 16, 18, 29, 2, 30, 14, 13.
Inscription in Chinese, Manchu and
Mongol characters: 'Presented by
Fu-ch'ing, Commander in Tibet'.
Cf. *Shih* 3; *Li*; *Lang* vol. I, p. 8;
Kuo p. 18.
National Palace Museum, Taipei,
Taiwan.

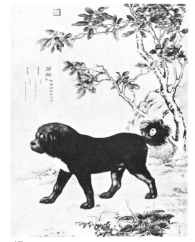

47

48 SNOW FALCON 蒼雪鷹

Painting on silk, vertical scroll
Signed
Seals: nos. 29, 16, 18, 2, 30, 14, 13.
Inscription: 'Presented in tribute by
Ta-erh-tang-a, general of the capital
of prosperity.' (Sheng-king, today
Shen-yang or Mukden.)
Cf. *Shih* 3; *Li*; *Kuo* p. 18.
Collection Mme Chiang Kai-shek,
Taipei, Taiwan.

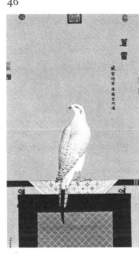

48

49 MU-LAN 木蘭

(*see also* illus pp. 53, 85, 108-13, 115)
Painting on silk; 4 scrolls
Each *ca.* 0.77 × 27 m.

A district in the vicinity of Jehol
where the Emperor hunted every
autumn.

First scroll: showing Emperor Ch'ien-
lung entering a town followed by
his troops.
Signed: Lang Shih-ning, Chin K'un,
Ting Kuan-p'eng, Ch'eng Liang,
Ting Kuan-ho—brother of the pre-
ceding.
Seals: nos. 7, 4, 5, 16, 18.

Second scroll: showing the Emperor
seated outside his tent watching
acrobats.

Signed: Lang Shih-ning, Chin K'un,
Ch'eng Chih-tao, Li Hui-lin.
Seals: nos. 7, 4, 5, 16, 18.

Third scroll: showing the Emperor's
troops catching horses with lassos.

Signed: Lang Shih-ning, Ting Kuan-
p'eng, Ch'eng Liang, Ting Kuan-ho.
Seals: nos. 7, 4, 5, 16, 18.

Fourth scroll: showing a stag hunt.
Signed: Lang Shih-ning, Chin K'un,
Ting Kuan-p'eng, Ch'en Yung-
chieh.
Seals: nos. 7, 4, 5, 16, 18.

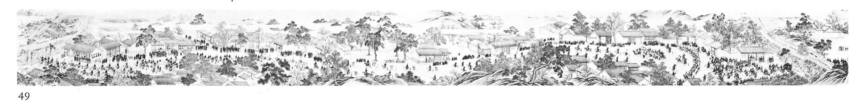

49

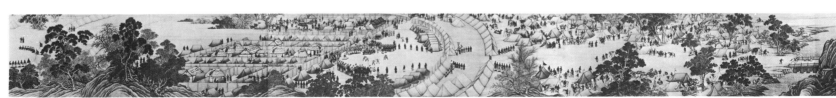

49

These four scrolls, depicting the diversions of the Emperor at Mu-lan, were presented to the Musée Guimet by General Frey in 1931.
Cf. *Shih* 3.
Musée Guimet, Paris.

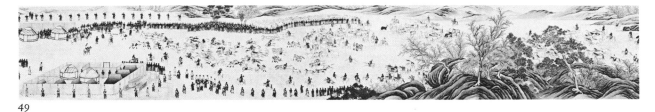

49

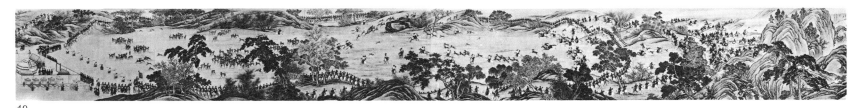

49

At the 'YEN-CH'UN-KO' (Pavilion of Prolonged Spring) 延春閣

Cf. In the *Shih-ch'ü pao-chi* this scroll is entitled *Eight Horses* and in the catalogue of the National Palace Museum, Taiwan, *Eight Horses under a Weeping-Willow*.
Cf. *Shih* 3; *Li*; *Lang* vol. I, p. 22; *Kuo* p. 18.
National Palace Museum, Taipei, Taiwan.

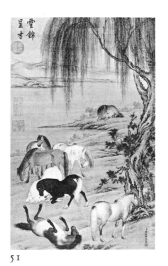

51

50 AUSPICIOUS STAG 瑞麀

Painting on silk
2.41 × 1.61 m.
Signed, dated: year hsin-wei of Ch'ien-lung in autumn (1751)
Seals: nos. 29, 16, 18, 30, 21, 14, 13.
Inscription: 'This animal with golden hair and red eyes was presented to the Empress-Mother on the occasion of her sixtieth anniversary and it is an auspicious stag.'
Cf. *Shih* 3; *Li*; *Lang* vol. I, p. 21; *Kuo* p. 18.
National Palace Museum, Taipei, Taiwan.

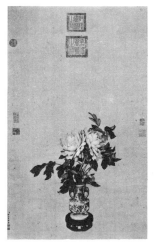

50

52 FLOWERS IN A VASE 瓶花

(*see also* illus p. 129)
Painting on silk
1.13 × 0.59 m.
Signed
Seals: nos. 16, 18, 2, 29, 30, 14, 13.
A similar vase, from the Ming period (15th century), is in the Percival David Foundation of Chinese Art, London (A.633) and a copy from the Ch'ien-lung period is in the National Palace Museum, Taiwan.

Cf. *Shih* 3; *Li*; *Lang* vol. I, p. 5; *Kuo* p. 18.
National Palace Museum, Taipei, Taiwan.

51 PRESENTING OF SUPERIOR HORSES LIKE CLOUDS IN THE EMBROIDERED SKY 雲錦呈才

(Eight Horses)
(*see also* illus p. 123)
Painting on silk
0.59 × 0.35 m.
Signed
Seals: nos. 29, 11, 3, 30, 14, 13, 18.
Inscription in four characters: 'Presenting of superior horses like clouds in the embroidered sky.' Poem by Ch'ien-lung, written by Yu Min-chung (*see* p. 144). Summary: 'Horses from Ha-sa (Ta-wan) presented to the Emperor. The latter will make a present in return.'

52

53 BEGINNING OF A PEACEFUL ERA 開泰

Painting on paper
2.57 × 1.53 m.
Signed
Seals: nos. 5, 18, 6, 14, 13.
Inscription in two characters 'Beginning of a peaceful era'.
Cf. *Shih* 3; *Li*; *Lang* vol. V, p. 3; *Kuo* p. 18.
National Palace Museum, Taipei, Taiwan.

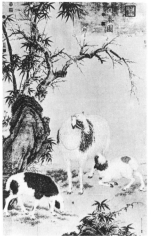

53

55 HAWK, PINE AND MUSHROOM 嵩獻英芝

Painting on silk
2.71 × 1.74 m.
Signed, dated: 2nd year of Yung-cheng, 10th month (1724)
Seal: no. 2.
Inscription: 'Hawk, Pine and Mushroom'.
This painting was in the 'Sheng-ching ku-kung'.
Cf. *Li*; *Lang* vol. I, p. 13; Ferguson, *JNBRAS* LXV, 1934.
Former Imperial Palace Collection, Peking.

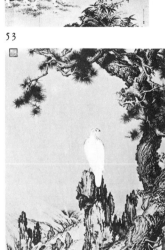

55

57 PINE AND CRANES 松鶴

Painting, vertical scroll
Signed
Seal: no. 2
This painting is said to have belonged to the 'San-ch'iu ko shu'.
Cf. *Li*; *To so gen min meiga daikan*, p. 421.
Collection Kuan Mien-chiu.

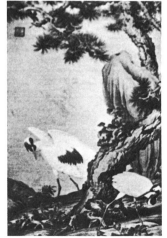

57

The *Li-tai chu-lu hua-mu* 歷代著錄畫目

(The paintings given below appear in the *Li-tai chu-lu hua-mu* but not in the *Shih-ch'ü pao-chi*.)

54 TEN THOUSAND LONGEVITIES AND ETERNAL SPRING 萬壽長春

Painting on silk, vertical scroll
Signed
Seals: nos. 14, 11.
Cf. *Li*; in the *Chung-kuo ming-hua* (vol. 25) this painting is reproduced under the title *Flowers and Plants*.

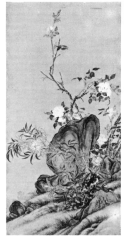

54

56 A WESTERN DOG UNDER BAMBOOS 竹陰西獷

Painting on silk, vertical scroll
Signed
Seal: Yi ch'in-wang pao 'Treasure of Prince Yi' (13th son of K'ang-hsi).
In the San-ch'iu ko shu (Library of the Palace of the Three Autumns).
Reproduced in the *Shina meiga ho-kan* (The Pageant of Chinese Paintings), p. 858, and in the *To so gen min meiga daikan*, p. 420.
Collection Kuan Mien-chiu.
A similar painting is in the Mottahedeh Collection, New York.

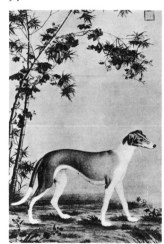

56

58 REINDEER FROM TUNG-HAI 東海馴鹿

(*see also* illus p. 51)
Painting on silk, vertical scroll
Dated: year yi-ch'ou of Ch'ien-lung (1745)
Seals: nos. 16, 18, 29, 30, 14, 13.
Poem by Emperor Ch'ien-lung. Summary: 'This animal was presented to me by a barbarian prince. It draws like an ox and can be mounted like a horse. Its food is the same as a stag's. It is a strange animal.'
Cf. *Li*; *Kuo* p. 18.
National Palace Museum, Taipei, Taiwan.

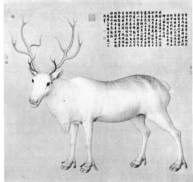

58

WORKS REPRODUCED IN THE

Lang Shih-ning hua-chi 郎世寧畫集

(The paintings listed below appear in the catalogue of Lang Shih-ning's works published in 1931, but not in the *Shih-ch'ü pao-chi*. We have doubts as to the authenticity of certain paintings reproduced in this album. We note them as being 'attributed to Castiglione'. As regards numbers 69, 70, 71, 73, 74, 75 and 76, which are not in Taipei, the quality of the reproduction does not permit us to form an opinion.)

60) dog 'Capable of Leaping into the Clouds' 騰空鵲

61) dog 'Striped like a Tiger' (*see also* illus p. 124) 斑睛虎

62) dog 'Yellow Leopard' (*see also* illus p. 124) 茹黄豹

63) dog 'Black Jade' 墨玉螭

64) dog 'With Claws of Snow' 雪爪盧

65) dog 'Sacred Wolf' 睒星狼

66) dog 'Flower of White Frost' 霜花鷂

59 LANDSCAPE 山水

Painting on silk attributed to Castiglione
(*see also* illus p. 136)
1.43 × 0.89 m.
Signed
Seal: no. 2.
Cf. *Lang* vol. I, p. 2.
National Palace Museum, Taipei'
Taiwan.

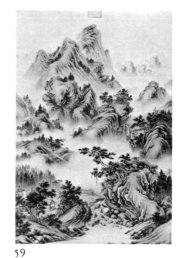

59

60-8 SERIES OF NINE DOGS

Paintings on silk
Each 2.48 × 1.64 m.
Signed
Seals: nos. 2, 29 and the seal of the 'Treasure of the Palace of Yuan-ch'ing-kung'.
Inscription in Chinese, Mongol and Manchu characters indicating the names of the dogs:

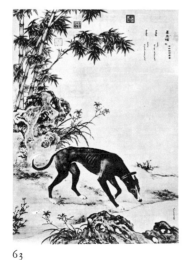

60

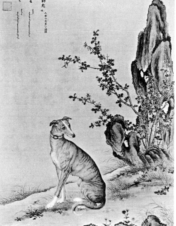

61

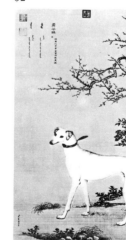

62

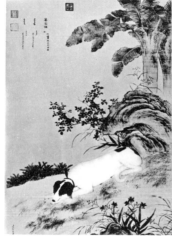

63

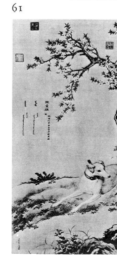

64

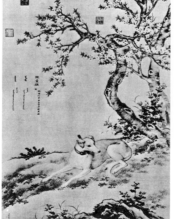

65

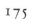

66

67) dog 'With Gilded Wings' 金翅獫

68) dog 'With Blue Bones' 蒼水虯

Cf. *Lang* vol. II, pp. 6, 10, 18-21.
National Palace Museum, Taipei,
Taiwan.

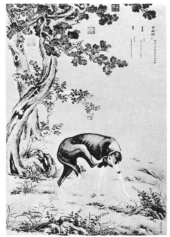

67 (Description p. 173)

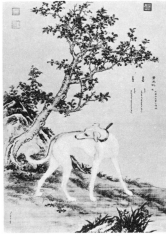

68 (Description p. 173)

70 WELCOMING THE ARRIVAL OF SPRING 安春信

(*see also* illus p. 97)
Painting on silk
0.77 × 0.45 m.
Unsigned
Seals: nos. 3, 9, 5.

Inscription dating from the year
jen-yin of Ch'ien-lung (1782). Poem
by the Emperor: 'Lang Shih-ning
excels in the art of painting. He
painted my portrait in my young
years. When I enter today into this
room with my white hair, I ask
myself who this person is.'
This poem, which is quoted in the
great official work on the *Anniversary*

Festivals of Ch'ien-lung (Vol. I, fol. 18)
did not originally appear on the
painting and was added later.
Cf. *Lang* vol. V, p. 5; *Kuo* p. 29.
Former Imperial Palace Collection,
Peking.

69 EMPEROR KAO-TSUNG (CH'IEN-LUNG) EXAMINING HORSES 高宗閱馬

Painting on paper
1.52 × 1.53 m.
Signed
Seal: no. 11.
Cf. *Lang* vol. V, p. 5.
Former Imperial Palace Collection,
Peking.

70

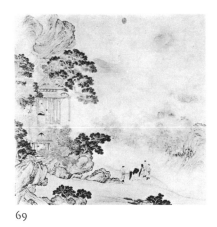

69

71 THE EMPEROR COMPOSES A POEM ON HUNTING 清高宗哨鹿賦

Painting on silk
4.90 × 2.09 m.
Signed
Poem by the Emperor.
Cf. *Lang* vol. V, p. 6.
Former Imperial Palace Collection,
Peking.

71

72 EMPEROR KAO-TSUNG (CH'IEN-LUNG) CONTEMPLAT-ING WORKS OF ART 清高宗觀畫

(*see also* illus p. 114)
Painting on paper attributed to
Castiglione
1.56 × 0.71 m.
Signed
Seal: no. 3.
Cf. *Lang* vol. V, p. 7; *Chinese Art*,
Vol. 3 (W. Speiser, R. Goepper and
J. Fribourg), 1966, p. 166.
National Palace Museum, Taipei,
Taiwan.

72

73 EMPEROR KAO-TSUNG (CH'IEN-LUNG) ADMIRING A SNOWY LANDSCAPE

高宗臨項里漢雪景

Painting on paper
0.98 × 0.55 m.
Unsigned, dated: 1763
Seals: nos, 5, 6, 1.
Poem by Emperor Ch'ien-lung. Summary: 'The snowflakes are dancing; I am happy; it is an auspicious snow and I order Lang Shih-ning to paint this landscape.'
Cf. *Lang* vol. V, p. 8.
Former Imperial Palace Collection, Peking.

73

74 EMPEROR KAO-TSUNG (CH'IEN-LUNG) HUNTING A HARE IN SPRING

高宗春苑

Painting on silk
1.35 × 2.03 m.
Signed, dated: 1755
Poem by the Emperor.
Cf. *Lang* vol. V, p. 9.
Former Imperial Palace Collection, Peking

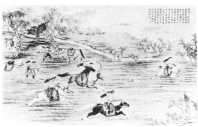

74

75 ENTERTAINMENT OF EMPEROR KAO-TSUNG (CH'IEN-LUNG)

Painting on paper
1.78 × 2.68 m.
Signed: Lang Shih-ning in collaboration with Ting Kuan-p'eng, Shen Yüan and Shou Ken.
Cf. Pelliot in *B.E.F.E.O.*, vol. 9, p. 574, mentions having seen a painting by Castiglione, depicting children's games, at the home of the Viceroy Tuan-fang. Is this the painting? *Lang* vol. V, p. 10.
Former Imperial Palace Collection, Peking.

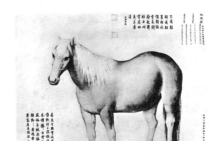

75

76 THREE FRIENDS IN WINTER

歲寒三友

(Bamboo, pine and plum blossom)
Fan. Painting on paper
0.19 × 0.54 m.
Signed
On the back of the fan, inscription with a poem by the Emperor.
Cf. *Lang* vol. V, p. 11.
Former Imperial Palace Collection, Peking.

76

77 HORSE NAMED 'RED JADE'

紅玉座

Painting on silk
2.30 × 2.78 m.
Signed, dated: year wu-ch'en of Ch'ien-lung (1748)

Seals: nos. 2, 5, 3, 6, 14, 13, 16, 19, 17, 10 and seal of the Yuan-ch'ing-kung, seals of the calligrapher Wang Yu-tun.

Inscription in Chinese, Mongol and Manchu characters giving the measurements of the horse presented by the Dzungars.

Poem by Emperor Ch'ien-lung extolling the elegance of the steed.

Poem written by Wang Yu-tun. Summary: 'This horse as agile as a red rabbit can gallop to the sky.'

Cf. *Lang* vol. II, p. 5.

National Palace Museum, Taipei, Taiwan.

77

78 HORSE NAMED 'BY MY WISH'

如意駿

Painting on silk
2.30 × 2.78 m.
Signed, dated: year wu-ch'en of Ch'ien-lung (1748)

Seals: nos. 2, 5, 3, 6, 14, 13, 16, 19, 17, 10 and seal of the Yuan-ch'ing-kung. Inscription in Chinese, Mongol and Manchu characters giving the measurements of this horse and the name of the donor.

Poem by the Emperor. Summary: 'This painting of a horse presented in tribute has been made according to the Occidental method by Lang

▶ 177

(78 continued)

Shih-ning. The Occidentals came to China in the reign of K'ang-hsi.'

Second poem by Liang Shih-cheng admiring this horse's distinction and perfect obedience.

Cf. *Lang* vol. II, p. 16.

National Palace Museum, Taipei, Taiwan.

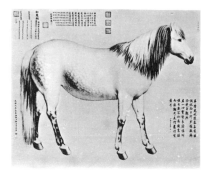

78

79 THE RED HORSE OF TA-WAN 大宛騮

Painting on silk
2.30 × 2.78 m.
Signed, dated: year wu-ch'en of Ch'ien-lung (1748)
Seals: nos. 2, 5, 3, 6 and seals of the calligrapher Wang Yu-tun.
Inscriptions in Chinese, Mongol and Manchu characters giving the measurements of this horse and its origin.
Poem by Emperor Ch'ien-lung and poem by Wang Yu-tun extolling the qualities of this horse.

Cf. *Lang* vol. II, p. 17.
National Palace Museum, Taipei, Taiwan.

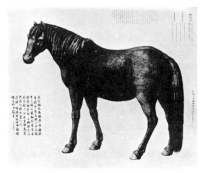

79

PAINTINGS NOT LISTED IN THE CATALOGUES OF THE IMPERIAL PALACES AND TO BE FOUND IN MUSEUMS OR PRIVATE COLLECTIONS

80 DRIVING A HORSE IN A SPRING FIELD 春郊試馬

(*see also* illus pp. 58-9)
Painting on silk, horizontal scroll
Signed: Lang Shih-ning and T'ang Tai (*see* p. 146). Dated: 1744
Seal: no. 9.
Cf. Ch'en Jen-t'ao in the *Ku kung yi-yi shu-mu chiao-chu* mentions that this painting was among the works that disappeared from the Imperial Palaces. This scroll was in the Chin-kuei-shih (Palace of the Golden Wardrobe). Painting reproduced in in the *To so gen min meiga daikan*,

p. 422.
Yurin-kan Museum, Kyoto Japan.

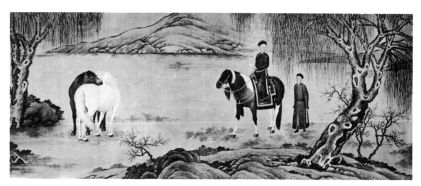

80

81

81 IN MY HEART THERE IS THE POWER TO REIGN PEACEABLY 心寫治平

(Portrait of Emperor Ch'ien-lung and his concubines)
(*see also* illus pp. 41, 43, 98-101)
Painting on silk

0.53 × 7.79 m.
Signed, dated: 1737
Seals: nos. 6, 5, 3.
The red lacquer box containing this scroll bears the following inscription: 'In my heart there is the power to reign peaceably.' The Emperor only looked at this scroll three times

in his life. In 1737 when the painting was finished; on his seventieth birthday; and on the occasion of his abdication. Each time, he had a seal attached forbidding the box to be opened on pain of death.
The Emperor and Empress are depicted with the concubines: 'Noble',

'Joyful', 'Sensitive', 'Worthy of Praise', 'Excellent', 'Pleasant', 'Happy', 'Distinguished', 'Honest' and 'Obedient'.
Cf. Spink Collection, London; *The Illustrated London News*, 8 June 1968.
Cleveland Museum of Art (John L. Severance Fund), Cleveland, Ohio.

82 NIGHT MARKET AT YANG-CH'ENG (Canton)
羊城夜市

(*see also* illus p. 151)
Painting on silk
... m.

...anghai in
...gan this
...nton in
...osta and
...esented it
...ot appre-
... style and
...In 1911 the
... Mr Kanng,
... for the Red

Cross. The painting then came into the possession of T. E. Tong of Shanghai, who sold it in 1940 to L. C. Hylbert, an American missionary. Michael Sullivan wrote a study of this painting in the review *Apollo*, November 1968, in which he points out that, if the information given by the booklet sounds unlikely, the painting may nevertheless be attributed to Castiglione.

Cf. Exhibition in Shanghai in 1916 by the Universal Learning Society; in 1929, at the First National Art Exhibition in Nanking. Reproduced in 1939 in the *South China Morning Post*, Hong Kong, and the *China Journal*, January 1939. A painting by Castiglione, entitled *Market river outside Canton*—according to Sirén—is said to have been published in the *I-shu-ts'ung pien*, but Sirén never saw this painting.

The Stanford University Museum of Art (Donation Mr and Mrs Allen D. Christiensen), Stanford, California.

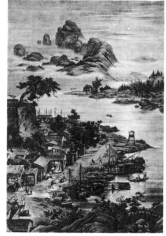

82

83 ... A YOUNG ... ED DRESS
香妃像

...ted to Castiglione
...d to depict Hsiang

... collection of Mme
..., Taipei, Taiwan.

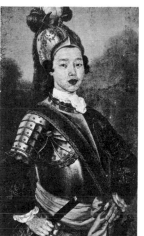

83

84 PORTRAIT OF A YOUNG WOMAN IN ARMOUR 香妃像

(*see also* illus p. 73)
Oil painting attributed to Castiglione
This painting is said to depict Hsiang Fei.

National Palace Museum, Taipei, Taiwan.

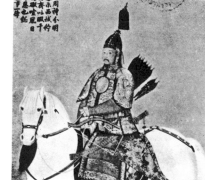

84

85 PORTRAIT OF A YOUNG WOMAN DRESSED AS A EUROPEAN SHEPHERDESS
香妃像

A painting attributed to Castiglione. In fact, all that can be said is that these three portraits were painted by a European artist in China and there is no proof that they depict Hsiang Fei. A painting attributed to Castiglione, belonging to Mr Mark Chou of Chicago, shows this young woman in the same attitude and wearing the same dress on the terrace of a palace in the company of Emperor Ch'ien-lung. This painting is entitled: *Military parade and spring festival*. Former Imperial Palace Collection, Peking.

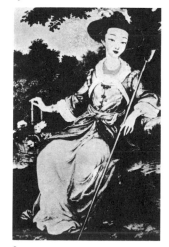

85

86 PORTRAIT OF EMPEROR CH'IEN-LUNG ON HORSEBACK

Attributed to Castiglione
Cf. Frontispiece of a book by Malone Carrol Brown, *History of the Peking Summer Palaces under the Ch'ing dynasty* (Urbana University of Illinois, 1934). Unfortunately we have no further details about this painting.
Former Imperial Palace Collection, Peking.

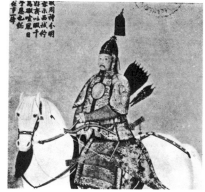

86

87 A FIERCE TIGER 猛虎

Painting on silk attributed to Castiglione
2.62 × 2 m.
Cf. Pelliot in the *B.E.F.E.O.*, no. 9, 1909, p. 574, mentions that this painting belonged to Viceroy Tuan-fang and that it bore a signature of a painter from the Sung period. Could this be the same scroll?
Collection Fusajiro Abe, Osaka.

87

88 MONKEYS 猿猴

Painting on paper attributed to Castiglione
1.20 × 0.66 m.
Signed
Cf. Mikinosuke Ishida who has examined this painting doubts its authenticity; Arthur Waley in his *Index of Chinese Artists*, p. 54, quotes this work, but he also mentions the printed or photographed reproductions in the collection of the British Museum; *Kokka*, no. 261, p. 177, January 1912.
Collection of the University of Kyoto; former collection of Professor Lo Chen-yü, Peking.

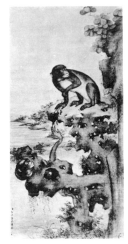

88

89 CHAMOIS 羚羊

Painting attributed to Castiglione
1.77 × 0.88 m.
Signed, dated: 1727
It is difficult to say from the reproduction whether this is really a work by Lang Shih-ning.
Cf. *So gen min shin meiga daikan*, p. 327; *Shina meiga ho kan*, p. 855.

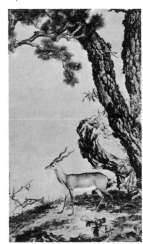

89

90 MAGPIES AND PEACH BLOSSOM 桃花喜鵲

(*see also* illus p. 145)
Painting on silk, vertical scroll
Signed: Lang Shih-ning and T'ang Tai
Seal: of Prince Yi.
This painting, originally in the collection of Keitaro Tanaka, Tokyo, was destroyed by fire in 1923.
Cf. *Kokka*, no. 357.

90

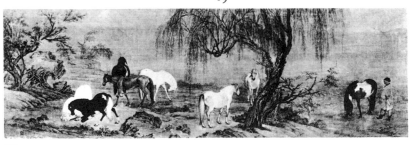

91

91 HORSES GRAZING IN A PASTURE 馬牧原郊

Painting on silk, horizontal scroll
Signed

Cf. *Shina meiga ho kan*, p. 857; *To so gen min meiga daikan*, p. 423.
Former collection of Chu Ch'i-ch'ien.

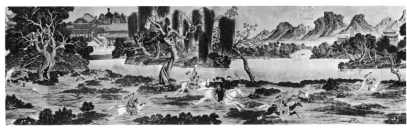

92

92 ON HIS COUNTRY ESTATE THE EMPEROR HUNTS WITH HIS CONCUBINE AND KILLS A STAG 山莊巡狩御妃鹿踝獲麟

Painting on silk, horizontal scroll
This painting attributed to Lang Shih-ning belonged to a European who sent us this photograph; but we have not been able to examine the scroll as it is no longer in his posses-

sion and its present whereabouts are unknown.

Inscription: Poem by Emperor Ch'ien-lung. Summary: 'The Emperor hunts in order to conform with the tradition of his ancestors.'

A second poem written by Shen Te-ch'ien (1673-1769) (*see* p. 145). Summary: 'In mid-autumn, the stags are particularly amorous and may be caught in dozens.'

The concubine accompanying the Emperor resembles the young woman known as Hsiang Fei, whose portrait in oil is attributed to Lang Shih-ning.

93 ALL BIRDS SALUTING THE PHOENIX 百鳥朝鳳圖

Painting attributed to Castiglione
2.14 × 3.22 m. Signed
Cf. *So gen min shin meiga daikan*, p. 328.
Former collection of Hsü Shih-ch'ang, President of the Chinese Republic from 1918 to 1922, died 1936. 徐世昌

94 FLOWER VASE

(*see also* illus p. 128)
Painting on silk
1.45 × 0.56 m.
Signed
Seal: no. 7.
European influence is obvious in the decoration of this vase of the *ku-yüeh-hsüan* style.
Cf. China Exhibition 1936, London, no. 99.
Collection Mrs J. Riddell, London.

94

95 YOUNG WOMAN CARRYING A HOE AND A BASKET OF FLOWERS

Painting on silk attributed to Castiglione
0.92 × 0.48 m.
Signed with two seals, one white, the other red.
Under a leopard skin thrown over her shoulders, the young woman wears a pink garment leaving red sleeves showing. The dark-grey skirt covers a white petticoat.
Collection Max Lochr, USA.

95

96 YOUNG SCHOLAR

(*see also* illus p. 142)
Painting on silk
0.44 × 0.28 m.
Signed
Collection Jean-Pierre Dubosc, Paris.

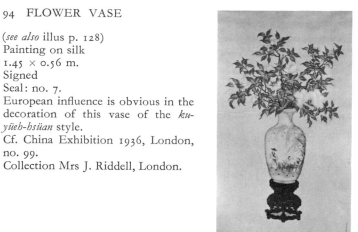

96

97 SMALL BLACK HORSE

Painting on silk. Signed
This scroll cannot be by Castiglione.
British Museum, London.

98 EIGHT HORSES

Painting on silk
0.72 × 1.42 m.
Signed
Seals: nos. 11, 29, 14, 13, 12.
We have not been able to examine this painting which seems to be by Castiglione's hand.
Collection Alice Boney, Tokyo.

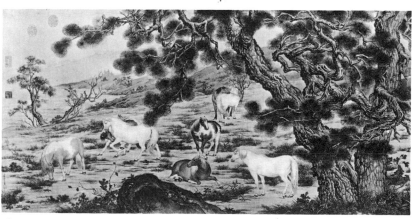

98

181

99 FAN WITH DECORATION OF PEONIES

Fan, painting on paper (back; front *see* illus p. 30)
The reverse of this fan bears a poem by Lu Yu (11th century) celebrating the beauties of nature and the charms of country life. The calligraphy is said to be by Liu and Chi Yün. On one side of the handle is engraved the following sentence: 'Near the wooden bridge there is a watercourse where it is good to meditate.'
We have not been able to examine this painting, which seems to be by Castiglione's hand.
Collection Alice Boney, Tokyo.

99

100 YOUNG WOMAN CARRYING A BASKET OF FLOWERS

Painting on silk attributed to Castiglione
0.89 × 0.33 m.
Signed
Mottahedeh Collection, New York

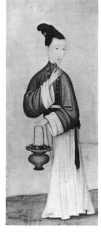

100

101 YOUNG WOMEN PLAYING DRAUGHTS

Painting on canvas attributed to Castiglione
1.08 × 0.88 m.
The woodwork portrayed in this picture bears an inscription in which we can decipher the letters L A M X ... 176 ..., which leads us to suppose that this is part of Lang Shih-ning's Portuguese name, 'Lamxinim'. This painting is the subject of an essay by P. W. Meister, *Eine Europerie des Lang Shih-ning.*
This picture was for a long time the property of a Hamburg collector, who gave it the title *Chinese painting* *in the European manner*, a description which seems to us much more likely. Hamburgisches Museum für Völkerkunde und Vorgeschichte, Hamburg.

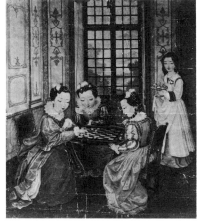

101

102 SCREEN WITH TWELVE PANELS: 'A PALACE'

Painting on paper attributed to Castiglione
This screen is reproduced in the *China Journal* of 2 June 1927. It is said to have belonged to Wu-yin-tien in the Forbidden City of Peking. According to information given by I. Mitrophanov it represents one of Emperor Ch'ien-lung's European palaces with servants preparing an audience to receive diplomats bearing tributes.
In 1927 this screen was in a private collection.

102

103 SCREEN WITH TWELVE PANELS: 'YOUNG EUROPEAN LADIES'

Four panels reproduced.
Quoted by I. Mitrophanov in the *China Journal* of 1 July 1927. Mitrophanov does not know the owners of this screen of which he merely possesses a photograph. We do not think that this screen is by Castiglione's hand.

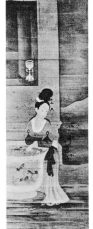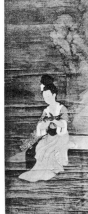

103

182

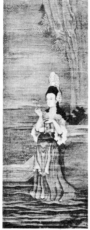

104 HORSES PRESENTED IN TRIBUTE BY THE TA-WAN
大宛貢馬圖

Painting on silk
(*see also* illus pp. 57, 133)
0.66 × 6.58 m.
Signed: Painted by Lang Shih-ning who comes from the west of the seas.
Dated: 1759.
Seals of the Emperor: nos. 9, 15, 5, 7, 12, 2, 3, 11 and seal of the 'Treasure of Ku-hsiang-chai'. At the end of the scroll a seal indicating that this painting has been remounted by Chen Pao. The yellow satin case of this picture bears a different title: 'The Emperor Kao-tsung (Ch'ien-lung) receiving

103

104

104

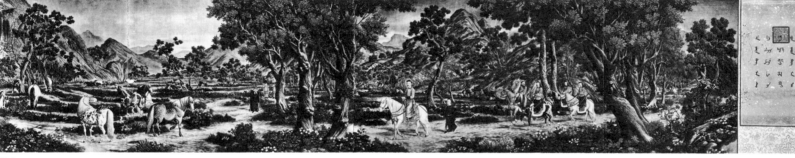

104

tributes in a plain in spring' with the following information: 'This scroll was remounted on the occasion of the Emperor's eightieth birthday.'

Poem composed and written by Ch'ien-lung saying that he is glad to accept the tribute of the Ta-wan, followed by four other poems by the

Emperor commemorating the Festival of Lanterns which took place in the evening of the 15th day of the 1st month of the year 1759.

An inscription in Manchu is signed by General A-kuei. It is followed by five inscriptions in Chinese by Ch'ien Tsai (*see* p. 145), Shen Te-ch'ien,

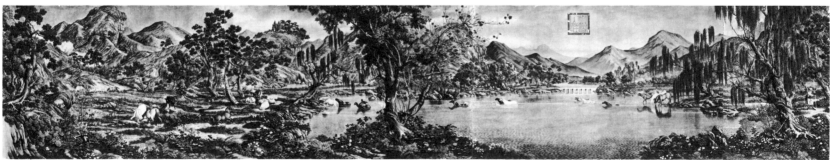

104

Kuan Pao, Wang Yu-tun and Ch'ien Ch'en-ch'un.
This painting is said to have belonged to the Imperial Collection of

Ku-hsiang-chai in Peking. It was then placed in the Summer Palace in Jehol and catalogued as No. 173 with the character 't'ien'.

Cf. 1000 Jahre Chinesische Malerei Exhibition (no. 101), Munich 1959 and Zurich 1960. Chen Te-k'un Collection, Cambridge.

▶

104 (Description p. 181)

105 IN THE GARDEN OF ETERNAL SPRING

Painting on silk attributed to Castiglione
Signed
The Emperor is at Yuan-ming-yuan in front of the belvedere with a young lady (Hsiang Fei?) dressed in European fashion.
Cf. Reproduced in *Min shin no kaiga* (Paintings of the Ming and Ch'ing dynasties).
Private collection, Tokyo. A painting bearing the same title was exhibited at the National Museum, Tokyo in 1963 (Exhibition of Chinese Art of the Ming and Ch'ing periods).

105

106 IMPERIAL ARCHERY CONTEST 御苑較射

Painting on silk
0.51 × 2.64 m.
Signed
Seals: eight Imperial seals, including nos. 9 and 11, and eight calligraphers' seals.
Inscription: Poem by Emperor Ch'ien-lung saying that this contest took place more than twenty years after his twelfth year (i.e. after 1744). Four other inscriptions indicate that this contest was held in the park of Ch'ang-ch'un-yuan. Two inscriptions are signed respectively by Liang Shih-cheng (1697-1763) and by Shen Te-ch'ien (1673-1769) (*see* pp. 143 and 145).

Some of the figures are painted with a stiffness and lack of skill which lead us to suppose that Castiglione was assisted in painting this scroll by one of his pupils.
Cf. Former collection of S. C. Wong, San Francisco; Catalogue of 12 November 1970 at the Parke Bernet Galleries, where this painting reached a price of $12,000 in the auction sale.

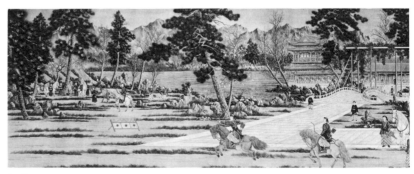

106

107 CELEBRATION OF VICTORY AT THE PALACE OF TZU-KUANG-KO

(Pavilion of Violet Light)
Painting on silk
0.52 × 6.50 m.
Signed
Seals: eight Imperial seals including nos. 11 and 9.
First inscription: Poem by Emperor Ch'ien-lung saying that he is giving this feast in honour of the victorious soldiers.
Second inscription by Liang Shih-ch'eng (1697-1763) (*see* p. 144).
Summary: 'The Emperor has ordered that the portraits of the victorious generals shall decorate the walls of the Tzu-kuang-ko and that Lang Shih-ning shall paint a scroll depicting the ceremony that took place on the banks of the lake.'
Third inscription by Shen Te-ch'ien (1673-1769) (*see* p. 145).
Fourth inscription by Ch'ien Ch'en-ch'un (1686-1774) (*see* p. 145).
This Celebration of Victory took place on 8 April 1760, which enables us to date the scroll. A certains clumsiness in the portrayal of the soldiers and some parts of the landscape lead us to believe that Castiglione called upon the assistance of one of his pupils in painting this work. It is said to have belonged to the sister of the Imperial Prince Fu-kien.
Cf. 'Giuseppe Castiglione' in *The New Catholic Encyclopaedia*, p. 192 (published by R. J. Verostko); Catalogue of 12 November 1970 at Parke Bernet Galleries, where this painting reached a price of **$**10,000 in the auction sale.

107

107

108 MAGNIFICENT VIEW OF
A LAND BEYOND THE SEA

海國勝境

Painting on silk attributed to Casti-
glione
0.66 × 6.81 m.
Signed, Imperial seals.

Inscriptions: Poem by Emperor Ch'ien-lung giving the date 1766 followed by a second poem written in 1770. (It has unfortunately been impossible to obtain photographs of the inscriptions.)
Cf. Catalogue of 12 November 1970 at Barket Bernet Galleries, where this painting reached a price of $9,000 in the auction sale.
This scroll was authenticated in 1968 by Chuang Yen, Vice-Director of the National Palace Museum, Taiwan, and by H. K. Lee of the Historical Museum of Taipei. Castiglione is said to have painted this European landscape in the year of his death in a mood of homesickness for his native land. We do not share this view. In our opinion there is nothing European about this landscape except the buildings. We believe that it is a painting executed by a Chinese imagining a European landscape 'in the manner of Lang Shih-ning'. Moreover, the fair young women moving about in groups of two or three, either in boats or on the terraces, are all dressed in the same white tunic with long hair falling down their backs, which is not a European costume of the mid-18th century.
Former collection of Minister Hsü Shin-ying, China.

108

109 PLANTS IN A STAND

Painting on paper (?) attributed to Castiglione
0.90 × 0.58 m.
Signed
Collection Dr P. W. Meister, Frank-
furt am Main.

109

CASTIGLIONE'S RELIGIOUS
PAINTINGS

110 CHRIST APPEARING TO
ST IGNATIUS
(*see also* illus p. 11)
Oil painting
Dated between 1707 and 1710
(*see* 110a)

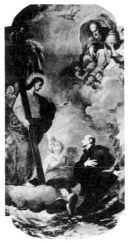

110

110 a ST IGNATIUS IN THE
CAVE OF MANRESA

(*see also* illus p. 92)
Oil painting
Dated between 1707 and 1710
These two paintings were originally
in the chapel of the novices in Genoa.
Cf. Ratti, C. G.: *Istruzione di quanto
può vedersi di piu bello in Genova in
pittura, scultura ed architettura;* Loehr,
G.: 'Missionary artists at the Manchu
Court' in *Transactions of the Oriental
Ceramic Society,* vol. 34, 1962-3.
Both paintings at Pio Ricovero
Martinez, Genoa.

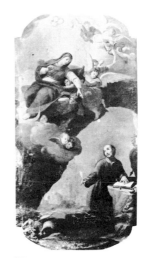

110a

111-8 EIGHT PAINTINGS IN
THE CHAPEL OF THE
HOSPITAL OF THE
UNIVERSITY OF COÏMBRA

These paintings, which are in quad-
rilobate frames, have been attributed
to Castiglione by Professors George
Loehr and Reis Santos. They are in
very bad condition and their icono-
graphy is hard to determine.
111 St Ignatius painting the *Spiritual*
Exercises (*see also* illus p. 12)
112 Birth of Stanislas Kostka (?)
113 St Ignatius at Monserrat (?)
114 A saint of the Society of Jesus
115 St Ignatius (?)
116 First appearance to
St Ignatius (?)
117 The Virgin showing St Ignatius
in his eternal glory to a young novice
(Francis Borgia?)
118 St Louis de Gonzague kneeling
before the Madonna (?) (*see also* illus
p. 91)

Neither the ceiling of this chapel, nor
the picture of *The Virgin and Child*
that is above the altar, were executed
by the same artist. On the other hand,
the style of the eight framed paintings
is very close to that of the Genoa
paintings (nos. 110 and 110a). How-
ever, it is difficult for various reasons
to assert that these paintings are by
Castiglione.
1) A letter from Castiglione ad-
dressed to Father Tamburini in 1714
states that 'work in the Coïmbra

chapel has been completed to every-
one's satisfaction'. Now, the door of
the hospital chapel housing the paint-
ings identified by G. Loehr is dated
1720, that is to say, six years later. We
believe that this letter from Casti-
glione refers to another chapel, that
of Francis Borgia, which was in the
college of the Jesuits and was destroy-
ed in the last third of the eighteenth
century, during the work of restora-
tion of the University carried out by
Pombal (1772).

111

112

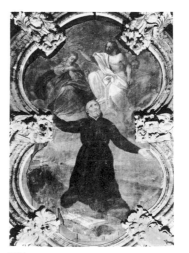

113

114

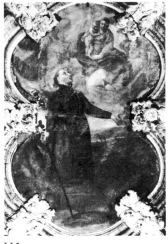

115

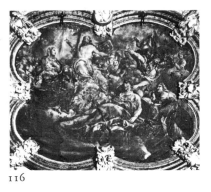

116

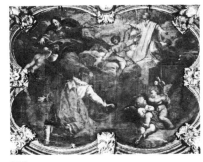

117

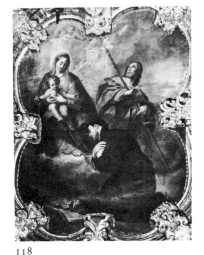

118

2) In a manuscript text *Imagen de segundo seculo da Companhia de Jhesu da Provincia de Portugal* Father Antonio Franco relates (years 1713 and 1714; fol. 163 v. and 178) that Castiglione painted the whole chapel of St Francis Borgia (fol. 178) with scenes representing the saint's life. He adds that Castiglione executed very remarkable perspectives and *trompe-l'œil* and also mentions a painting depicting the Circumcision (fol. 163).

The same Father Franco writes in another book, *Synopsis Annalium Societatis Jesu in Lusitania ab anno 1540 usque ad annum 1725*, p. 441, that all the paintings in the chapel of St Francis Borgia, including those in the galleries, were painted in only twenty months by Castiglione. Now, in the chapel of the hospital containing the paintings identified by G. Loehr there is neither *trompe-l'œil*, nor perspective, nor a painting

of the Circumcision, nor galleries . . .
3) In the aforementioned works Father Franco states that Castiglione painted episodes from the life of St Francis Borgia. But the eight paintings in the chapel of the hospital represent St Ignatius and other saints of the Society.
In conclusion, we believe that the hospital chapel is not the one decorated by Castiglione and that the paintings which he executed at

Coïmbra were in the chapel of St Francis Borgia and disappeared when this was destroyed. Nevertheless, another hypothesis is conceivable: the subsequent transfer of Castiglione's paintings to the little hospital chapel. But this is only a hypothesis for which there is no proof.

119 ST IGNATIUS FUND. S.I.

(*see also* illus p. 61)
Engraving by Klauber after a work by Castiglione made in Peking. Archivum Romanum Societatis Iesu, Rome.

119

120 S.Fr. XAVERIUS S.G. INDORUM APTIIS

(*see also* illus p. 22)
Engraving by Klauber after a work by Castiglione made in Peking. Archivum Romanum Societatis Iesu, Rome.

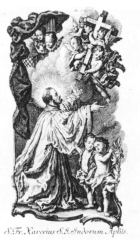

120

121-6 ENGRAVINGS OF THE CONQUESTS OF THE EMPEROR OF CHINA CH'IEN-LUNG

Series of sixteen engravings made in Paris under the supervision of C.-N. Cochin from 1767 to 1774. *See* pp. 79-88.
Each 0.52 × 0.89 m.

121 THE STORMING OF THE CAMP AT GÄDÄN-OLA

(*see also* illus p. 80)
Joseph Castilhoni Soc JESU delin 1765. C. N. Cochin direx. J.Ph. Le Bas scul 1769 Gädän-ola or Mount Gädän, about 100 *li* s.-w. of Kulja. This concerns a raid in 1755 in which the Kalmuck Ayusi, who had gone over to the Chinese with a few men, stormed the camp of Davaci set up on this mountain.
In the Helman series this engraving bears the no. V.
Print no. 2

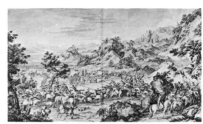
121

122 THE RAISING OF THE SIEGE AT THE BLACK RIVER

(Khara-Usu)
(*see also* illus p. 82)
Joseph Castilhoni Soc JESU delin 1765. C. N. Cochin direxit. J.P. Le Bas sculp. 1771.
In the Helman series this engraving bears the no. III.
Print no. 7

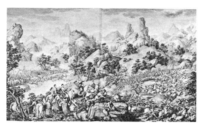
122

The drawings for the following four engravings (123-6) have been attributed to Castiglione by George Loehr.

123 THE BATTLE OF OROI-JALATU

(*see also* illus p. 81)
C. N. Cochin Filius direxit. Engraved by J. P. Le Bas, engraver of the King's Cabinet and of his Academy of Painting and Sculpture, 1770
In the Helman series this engraving bears the no. IX.
Print no. 3

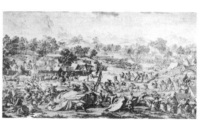
123

124 THE BATTLE OF TONGUSLUK

(*see also* illus p. 83)
C. N. Cochin direxit. Augustinus de Saint-Aubin Sculpsit. Parisiis. Anno 1773.
In the Helman series this engraving bears the no. IV
Print no. 9

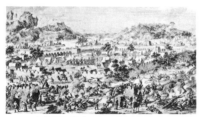
124

125 THE BATTLE OF QOS-ULAQ

C. N. Cochin Filius direxit. B. L. Prevost Sculpsit, 1774.
In the Helman series this engraving bears the no. X.
Print no. 10

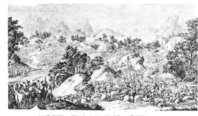
125

126 THE EMPEROR GIVING A VICTORY BANQUET TO THE OFFICERS AND SOLDIERS WHO DISTINGUISHED THEMSELVES IN THE TZU-KUANG-KO

Cochin Filius direxit. Engraved by J. P. Le Bas, engraver of the King's Cabinet, 1770.
In the Helman series this engraving bears the no. XVI.
Print no. 16
Cf. *Gravures des Conquêtes de l'Empereur de Chine K'ien-long au Musée Guimet*, by Michèle Pirazzoli-t'Serstevens, 1969.

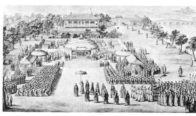
126

PAINTINGS NOT REPRODUCED

Works listed but not reproduced in this catalogue, but listed in the *Shih-ch'ü pao-chi*.

I. PIGEONS 鴿十軸

Ten vertical scrolls on silk
Cf. *Shih* 1 (vol. IX, p. 24); *Li*; *Kuo* p. 15.

II. ALBUM OF TWELVE PAINTINGS ON SILK 寫生一冊

Dated 1740, belonging to the 'Hsü Shih-ch'ang'
Cf. *Shih* 1 (vol. XVI, p. 52); *Li*; *Kuo* p. 14.

III. THE EMPEROR VANQUISHING HIS ENEMIES 天威服猛

Horizontal scroll, belonging to the 'Ning-shou-kung'
Cf. *Shih* 2; *Li*; *Kuo* p. 16.

IV. BIG STURDY HORSE 倍聞駧習

Vertical scroll, belonging to the 'Ch'ien-ch'ing-kung'
Cf. *Shih* 2; *Li*; *Kuo* p. 16.

V. TWO STAGS IN AUTUMN 莘野鳴秋

Vertical scroll, belong to the 'Ch'ien-ch'ing-kung'
Cf. *Shih* 2; *Li*; *Kuo* p. 17.

VI. HERD IN A SNOWY LANDSCAPE 雪坂牧歸

Vertical scroll, belonging to the 'Yang-hsin-tien'
Cf. *Shih* 2; *Li*; *Kuo* p. 17.

VII. GRAZING HERD 坰牧蕃滋

Vertical scroll, belonging to the 'Yang-hsin-tien'
Cf. *Shih* 2; *Li*; *Kuo* p. 17.

VIII. ORCHIDS IN A VASE 瓶蘭

Vertical scroll, belong to the 'Yang-hsin-tien'
Cf. *Shih* 2; *Li*; *Kuo* p. 17.

IX. TURKEYS 火鷄

Vertical scroll, belonging to the 'Chung-hua-kung'
Cf. *Shih* 2; *Li*; *Kuo* p. 17.

X. TEN HORSES 十駿

Series of ten paintings executed in collaboration with Ai Ch'i-mung (Father Sickelparth) and belonging to the 'Ning-shou-kung' 艾啟蒙
Cf. *Shih* 2; *Li*.

XI. THE EIGHT HORSES OF BA-DA-SHAN 拔達山八駿

Horizontal scroll painted in 1760, belonging to the 'Ch'uen-hua-hiu-en'
Each horse is described by its name: 'Congratulation', 'Vulture', 'Ocean', 'Lightning', 'Violent', 'Conquest', 'Jade', 'Happiness', 'Clouds'.
Cf. *Shih* 2; *Li*; *Kuo* p. 16.

XII. HERD OF STAGS IN AN AUTUMN FOREST 秋林群鹿

Vertical scroll, belonging to the 'Yang-hsin-tien'
Copy of a Yuan painting.
Cf. *Shih* 2; *Li*; *Kuo* p. 16.

XIII. HERD OF STAGS IN AN AUTUMN PLAIN 秋原群鹿

Vertical scroll, belonging to the 'Ning-shou-kung'
Cf. *Shih* 2; *Li*.

XIV. EIGHT HORSES

Horizontal scroll, belonging to the 'Ning-shou-kung'
Cf. *Shih* 2; *Li*.

XV. DZUNGARS PRESENTING HORSES IN TRIBUTE 準噶爾貢馬

Horizontal scroll, dated 1747, belonging to the 'Ning-shou-kung'
Inscription: Poem by Emperor Ch'ien-lung and calligraphy by Liang Shih-cheng and Shen Te-ch'ien.
Cf. *Shih* 3; *Li*; *Kuo* p. 15.

XVI. PINE, ROCKS AND CRANES 松石仙禽

Vertical scroll, belonging to the 'Yü-shu-fang'
Cf. *Shih* 3; *Li*.

XVII. LOTUS FLOWERS IN A POND 池蓮雙瑞

Vertical scroll, belonging to the 'Ning-shou-kung'
Cf. *Shih* 3; *Li*; *Kuo* p. 18.

XVIII. FLOWERS AND BIRDS 花鳥

Vertical scroll, belonging to the 'Ch'ing-ki-shan-chuang'
Cf. *Shih* 3; *Li*.

XIX. PEACH BLOSSOM AND MOUNTAIN BIRDS 桃花山鳥

Vertical scroll, belonging to the 'Ch'ing-ki-shan-chuang'
Cf. *Shih* 3; *Li*.

XX. ILLUSTRATION OF THE POEM BY PIN-FENG 豳風圖

Vertical scroll, painted in collaboration with T'ang Tai and Shen Yuan, belonging to the 'Ch'eng-ta-kuang-ming' at Yuan-ming-yuan.
Cf. *Shih* 3; *Kuo* p. 27.

XXI. ALBUM OF FLOWERS AND PLANTS 花卉

Belonging to the 'Yü-shu-fang'
Cf. *Shih* 3; *Li*.

XXII. WILD GOOSE CHASE UNDER THE AUTUMN WIND

Vertical scroll, belonging to the 'San-ch'iu ko shu'
Cf. *Li*.
The works listed above are quoted in the *Li-tai chu-lu hua-mu* by Ferguson, or in various other publications.

XXIII. A HERD OF HORSES 馬技

Horizontal scroll painted in collaboration with Chang T'ing-yen.
Cf. *Kuo* 2nd part, p. 27. 張廷彥

XXIV. SMALL HORSE WITH ONE BLACK FOOT 小黑馬尺幅

XXV. FIVE CATS PLAYING 五貓相戲

XXVI. STEEDS 駿馬

These three works (XXIV-XXVI) are quoted by Mikinosuke Ishida, 'Biographical Study of Castiglione' in *Memoirs of the Toyo Bunko*, Tokyo 1960 (no. 19). He cannot confirm that they are authentic.
Cf. Note in the preface to *Lang Shih-ning hua chi*.

XXVII. HUNTING SCENES

Horizontal scroll, belonging to the University of Kyoto.
Mikinosuke Ishida, who has examined this scroll, does not think that it is by Castiglione.

XXVIII. HUNTING SCENES WITH THE IMPERIAL PRINCE AND TARTAR HUNTERS

Dated 1763, quoted in the *Index of Chinese Paintings* by Arthur Waley. The keepers at the British Museum where this painting is preserved do not think that it is authentic.

XXIX. PORTRAIT OF BROTHER CASTIGLIONE

Self-portrait. Reproduced in *Missionary and Mandarin* by H. Rowbotham. This painting, we think, is not by Castiglione.

XXX and XXXI. ARCHANGEL MICHAEL AND GUARDIAN ANGEL

Two paintings on paper, attributed to Castiglione, belonging to Monsignor Celso Costantini, Rome.
Cf. George Loehr, *Giuseppe Castiglione*, p. 117.

XXXII. MATER AMABILIS
XXXIII. CHRIST

Works engraved by Klauber in Augsburg.
Cf. Heinecken: *Dictionnaire des artistes*, p. 702; Thieme-Becker: *Allgemeines Lexikon der bildenden Künstler*, VI (1921).

XXXIV. SEQUENCE OF EIGHT SCROLLS DEPICTING A PARK

Paintings on paper attributed to Castiglione
Each 3.98 × 0.81 m
Signed on one scroll

Cf. A painting was exhibited in 1963 at the Philadelphia Museum of Art in the exhibition 'The World of Flowers', and reproduced in *Oriental Art*, new series, Spring 1962. We have not been able to examine these scrolls which seem to be interesting. Collection Ellsworth and Goldie Ltd., New York.

XXXV. ST STANISLAS KOSTKA

with a playing child in his arms
Print 0.121 × 0.064 m.
Inscriptions: S. Stanislaus S.I.S.-C.P.S.C.M. Jos. Castiglioni S.J. inv. et del Peckini. Klauber Cath. sc. et ex. A.V.D.
Inventario da colecção de registos de Santos no. 0643 (Ernesto Soares, Lisboa 1955.)

XXXVI. ST IGNATIUS LOYOLA

Print
0.128 m.
Inscription: S. Ignatius Fund. S.J.S.-C.P.S.C.M. Jos. Castiglioni S.J. inv. et del Peckini. Klauber Cath. sc. et exc. A.V.D.
Inventario da colecção de registos de Santos no. 0961 (Ernesto Soares, Lisboa 1955)

XXXVII. ST JOSEPH

with Christ Child in his arms
Print
0.135 × 0.083 m.
Inscription: S. Josephus S.C.P.S.C.M. Jos. Castiglioni S.J. inv. et del Peckini. Klauber Cath. sc. et exc. A.V.D.
Inventario da colecção de registos de Santos no. 01259 (Ernesto Soares, Lisboa 1955)

SEAL INSCRIPTIONS

1. Ch'ien-lung 乾隆

2a. Ch'ien-lung yü-lan chih pao
Treasure having been examined by Ch'ien-lung

2b. Ch'ien-lung huang-ti yü-lan chih pao
Treasure having been examined by the Emperor Ch'ien-lung 乾隆御覽之寶

3. T'ai shang huang-ti chih pao
Seal of the Emperor Father 太上皇帝之寶

4. Ku-hsi t'ien-tzu chih pao
Seal of the Son of Heaven at seventy 古稀天子之寶

5. Pa cheng mao nien chih pao
Treasure of old age 八徵耄念之寶

6. Wu-fu-wu-tai-t'ang ku-hsi t'ien-tzu pao
Treasure of the aged Son of Heaven in the Hall of the Five Happinesses and the Five Generations 五福五代堂古稀天子寶

7. Pi-shu shang-chuang
Mountain Dwelling to Avoid the Heat (palace at Jehol) 避暑山莊

8. Ch'ien-ch'ing-kung chien ts'ang pao
Hidden treasure of the Palace of Celestial Purity 乾清宮鑑藏寶

9. Ku-hsi t'ien-tzu
Aged Son of Heaven 天子古稀

10. Ning-shou-kung hsü ju shih-ch'ü pao-chi
Palace of Tranquillity and Longevity—additional entries in the *Precious notebooks of Shih-ch'ü*
 寧壽宮續入石渠寶笈

11. Ch'ien-lung yü-lan chih pao
Treasure having been examined by Ch'ien-lung
 乾隆御覽之寶

12. Ch'ien-lung chien shang
Ch'ien-lung has appreciated 乾隆鑑賞

13. Yi tzu-sun
Happiness for posterity 宜子孫

14. San-hsi-t'ang ching-chien hsi
Seal of the Hall of the Three Rarities 三希堂精鑑璽

15. Shou
Longevity 壽

16. *Shih-ch'ü pao-chi*
Precious notebooks of Shih-ch'ü 石渠寶笈

17. *Pao-chi ch'ung pien*
Precious notebooks, second series 寶笈重編

18. *Pao-chi san pien*
Precious notebooks, third series 寶笈三編

19. Shih-ch'ü ting chien
Definitive appreciation of Shih-ch'ü 石渠定鑑

20. Lo-shou-t'ang chien ts'ang pao
Treasure hidden in the Hall of Joy and Longevity 樂壽堂鑑藏寶

21. Yi tsai pi chien
Pleasure is at the tip of the brush 意在筆尖

22. Yi-ch'in-wang pao
Treasure of Prince Yi 親王寶

23. Pi-hua ch'un yü
Picture of spring rain 筆畫春雨

24. Li tsao wei ch'un
The seaweed announces spring 滿藻為春

25. Ku-lei-chai pao
Treasure of the Studio of Ancient Thunder 古雷齋寶

26. Chung-hua-kung chien ts'ang pao 重華宮鑑藏寶
Treasure of the Palace of Double Flowers

27. Yü-shu-fang chien ts'ang pao
Treasure of the Imperial Library

 御書房鑑藏寶

28. Yang-hsin-tien chien ts'ang pao
Treasure of the Palace for Cultivating Hearts

 養心殿鑑藏寶

29. Chia-ch'ing yü-lan chih pao
Treasure having been examined by Chia-ch'ing

 嘉慶御覽之寶

30. Chia-ch'ing chien shang
Chia-ch'ing has appreciated

 嘉慶鑑賞

31. Castiglione's signature

 臣郎世寧恭畫

32. Castiglione's signature 臣郎世寧恭繪

CHRONOLOGICAL TABLE

REIGN OF K'ANG-HSI (1662-1722)

1715	Brother Castiglione's arrival in China	
1715	yi-wei	乙未
1716	ping-shen	丙申
1717	ting-yu	丁酉
1718	wu-hsü	戊戌
1719	chi-hai	己亥
1720	keng-tzu	庚子
1721	hsin-ch'ou	辛丑
1722	jen-ying	壬寅

REIGN OF CH'IEN-LUNG (1736-1795)

1723	kuei-mao	癸卯
1724	chia-ch'en	甲辰
1725	yi-ssu	乙巳
1726	ping-wu	丙午
1727	ting-wei	丁未
1728	wu-shen	戊申
1729	chi-yu	己酉
1730	keng-hsü	庚戌

1731	hsin-hai	辛亥
1732	jen-tzu	壬子
1733	kuei-ch'ou	癸丑
1734	chia-yin	甲寅
1735	yi-mao	乙卯

REIGN OF CHIEN-LUNG (1736-1795)

1736	ping ch'en	丙辰
1737	ting-ssu	丁巳
1738	wu-wu	戊午
1739	chi-wei	己未
1740	keng-shen	庚申
1741	hsin-yu	辛酉
1742	jen-hsü	壬戌
1743	kuei-hai	癸亥
1744	chia-tzu	甲子
1745	yi-ch'ou	乙丑
1746	ping-yin	丙寅
1747	ting-mao	丁卯
1748	wu-ch'en	戊辰

1749	chi-ssu	己巳
1750	keng-wu	庚午
1751	hsin-wei	辛未
1752	jen-shen	壬申
1753	kuei-yu	癸酉
1754	chia-hsü	甲戌
1755	yi-hai	乙亥
1756	ping-tzu	丙子
1757	ting-ch'ou	丁丑
1758	wu-yin	戊寅
1759	chi-mao	己卯
1760	keng-ch'en	庚辰
1761	hsin-ssu	辛巳
1762	jen-wu	壬午
1763	kuei-wei	癸未
1764	chia-shen	甲申
1765	yi-yu	乙酉
1766	ping-hsü	丙戌
1766	Brother Castiglione's death in Peking	

BIOGRAPHICAL NOTES OF SOME EUROPEAN PERSONS REFERRED TO IN THE TEXT

ALEXANDER, William (?)
English draughtsman who formed part of Lord Macartney's embassy of 1793–4. (George III's ambassador was also accompanied by another artist, the painter Hickey.)

AMIOT, Father Jean-Joseph-Marie (1718–1793)
French Jesuit born in Toulon, arrived in China in 1740. He is the author of a Manchu grammar and dictionary and various works on China, among others *Mémoires concernant l'histoire des Chinois...* (Paris 1776–91).

ANDRADE, Fernão Perez de (b. *ca.* 1490)
Portuguese navigator who reached Canton in 1517, followed soon afterwards by his brother Simão. Fernão was accompanied by an apothecary, Pires, sent by the King of Portugal. Fernão was well received in Canton; Pires left for Peking, but in the meantime Simão committed acts of piracy. Pires' mission failed; he was regarded as a spy and banished somewhere in China. He is said to have married, had children and died in China in 1543.

ATTIRET, Father Jean-Denis (1702–1768)
Born in Dole, went to Rome and entered the noviciate of the Society of Jesus. Coadjutor in 1735. Sent to China to help Castiglione. Arrived in Peking in 1739. Worked at Court as a painter. Took part in the decoration of Yuan-ming-yuan. An album of ten horses signed with his Chinese name Wang Shih-cheng was in the palace of Ning-shou-kong.

BARROW, Sir John (1764–1848)
English traveller and geographer. He was a member of Lord Macartney's embassy and its secretary. He afterwards went to the Cape and remained there until 1845.

BELLEVILLE, Brother Charles de (1656–after 1700)
Arrived in China in 1698. An architect, he built the Jesuits' residences in Canton and Peking.

BENOIST, Father Michel (1715–1774)
Arrived in China in 1774. He had studied astronomy in Paris with La Caille and Le Mennier. He constructed the hydraulic machines and the fountains at Yuan-ming-yuan and directed the work of the Chinese craftsmen charged with engraving new copies of *The Conquests of the Emperor of China*. He was also superior of the French residence in Peking. In 1761 he drew a map of the world in two hemispheres and a map of the heavens for Emperor Ch'ien-lung. These were engraved on copper in 1769. His translation of the *Shuking* remained in manuscript. He died in Peking in 1774 after learning of the suppression of the Society of Jesus.

BERTIN, Henri-Léonard (1720–1792)
Minister and secretary of state under Louis XV and XVI. Controller General of Finance. The Compagnie des Indes was under his authority. He was also concerned with the Sèvres factory and it was he who created the Cabinet des Chartes. Bertin possessed an important private collection of Chinese curiosities containing, among other things, a portrait of Ch'ien-lung by Father Panzi, a copy of *The Conquests of the Emperor of China* and engravings of the European palaces at Yuan-ming-yuan. Forced to go into exile during the Revolution, he had to sell part of his collection. He died at Spa in 1792. A sale of the remains of this collection in 1815 mentions objects 'from the Emperor's factories and even from his private collection', including a screen presented by the Emperor, which reached the price of 867 F; a *pi-t'ung* of cornelian and onyx from the Emperor's collection, 180 francs; a collection of a hundred and five plates representing the *Life of Confucius*, various manuscripts and prints.

BOUVET, Father Joachim (1660–1732)
French Jesuit mathematician, arrived in China in 1685, taught mathematics to Emperor K'ang-hsi and took part in drawing the great map of the Empire. He produced several *Relations* of his missions, an *Etat présent de la Chine*, a sequence of drawings engraved by Giffart and a *Portrait historique de l'Empereur de la Chine*, Paris 1697. In his letters to Leibniz (1646–1716) he expressed the belief that he had discovered a link between binary arithmetic and the Chinese diagrams said to be by Fu-hsi.

BUGLIO, Father Luigi (1606–1682)
Jesuit missionary of Sicilian origin sent to China in 1637. Skilled at Chinese calligraphy, he was assistant to Father Schall and shared various works with him. He was imprisoned during the persecution. Author of a booklet on the kingdoms of Europe and of a work on falcons written at the request of K'ang-hsi.

CHALIER, Father (1697–1747)
French missionary born at Briançon, entered the Society of Jesus in 1715, arrived in China in 1728. Emperor Yung-cheng sent for him in Peking. He invented the famous 'clock of vigils'. Superior general of the French mission in China from 1745 to 1747.

CHANSEAUME, Father Jean-Gaspard (1711–1756)
Born in Auvergne. He lived for a time in Macao and was then sent to Kiangsi, where he died in 1756.

CIBOT, Father Pierre-Martial (1727–1781)
French Jesuit missionary born in Limoges. Arrived in China in 1760. Mathematician at the Court. He worked with Father Amiot editing the *Mémoires concernant l'histoire des Chinois...* He is also the author of several treatises on the plants of China, the pleasure gardens, commerce, language and character of the Chinese. He worked at Yuan-ming-yuan as a fountain-builder and machine designer.

CLEMENT XIV (Lorenzo Ganganelli), Pope (1705–1774)
Entered the Franciscan order at a very early age. It was he who signed the *Dominus ac Redemptor*, the papal brief that led to the dissolution of the Order of Jesuits in China. 'Questa suppressione mi darà la morte — This suppression will cause my death,' he said on signing it.

COCHIN, Charles-Nicolas (1715–1790)
The most illustrious of a family of engravers in which his father, 'Cochin le Vieux', had already distinguished himself. As secretary and historiographer of the Académie de Peinture he was charged by the Marquis de Marigny with directing the execution of the engravings *The Conquests of the Emperor of China*.

COLBERT, Jean-Baptiste (1619–1683)
Minister of Louis XIV, Controller General of Finance and secretary of state for the Navy. He pursued a vigorous policy of economic independence for France. He encouraged the creation of the Compagnie des Indes Orientales. He was the patron of the missionaries in

China and requested them to act as correspondents of the Académie Royale des Sciences in Paris.

COSTA, Father G. (1679–1747)
Born in Calabria in 1679. After learning pharmacy and surgery he entered the Society of Jesus in 1700. He arrived in Peking in 1715 in the company of Castiglione and opened a dispensary. He died in 1747 after having bought several fields with the alms received as thanks for his ministrations. The revenues from these fields maintained the dispensary. The Emperor bestowed gifts on the occasion of the Father's funeral in 1747.

COUSIN-MONTAUBAN, General Charles (1796–1878)
Born in Paris in 1796, died at Versailles in 1878. Napoleon III placed him at the head of the French expeditionary force in 1860. After the Franco-British victory at Pa-li-kao on the Tien-tsin road on 21 September 1860, he received the title of Count of Palikao.

DAMASCÈNE, Father Jean (d. 1781)
A barefoot Augustinian sent to China by the Propaganda, originally a Roman priest by name Salusti or Sallusti. Although a mediocre painter he collaborated in the engravings *The Conquests of the Emperor of China*. He was consecrated Bishop of Peking in 1778 and died in 1781. According to Father Amiot he never succeeded in learning Chinese and was dismissed from Court because he had 'neither the manners nor the tone appropriate to the place'.

DELATOUR, Louis-François (1727–1807)
Librarian and secretary to the King who carried on a continuous correspondence with the missionaries in Peking. Author of an essay on Chinese architecture. His collection contained numerous curiosities, among them two series on *The Cries and Shops of Peking*, works on the art of cultivating rice, silkworms, etc., a copy of the *Festivals of the Sixtieth Birthday of K'ang-hsi* sold in 1810 for 170 F, and *Thirty Views of Jehol*. All these works are today in the Bibliothèque Nationale in Paris. Father Bourgeois sent Delatour twenty plates representing the palaces of Yuan-ming-yuan. In 1793 Delatour, having been imprisoned, was forced to dispose of them. The collection was sold after the collector's death, in 1808 and 1810, but partial sales had already greatly reduced its importance.

ELGIN, James Bruce, Earl of (1811–1863)
British statesman and diplomat. After the destruction of the foreign trading stations in Canton he took the city, defeated the Chinese and forced them to sign the Treaty of Tien-tsin (1858). In 1860, in agreement with the Franco-British forces commanded by Generals Cousin-Montauban and Grant, he gave the order to sack Yuan-ming-yuan. He sent Queen Victoria a selection of objects chosen with discernment and superior in quality to those received on the same occasion by Emperor Napoleon and still to be seen today at the palace of Fontainebleau.

ENTRECOLLES, Father d' (d. 1741)
Superior general of the French mission. He was distinguished above all for his decorations on porcelain.

FIORI, Brother Cristoforo (?)
A painter who arrived in Peking in 1694 but being unable to stand the missionary life returned to Europe in 1705. He left works in China, none of which have come down to us.

FRANCIS XAVIER, Saint (1504–1550)
Spanish Jesuit born in the castle of Xavier near Pampeluna in 1504. After studying in Spain he went to the Sainte-Barbe College in Paris and was then appointed professor of philosophy at Beauvais. Touched by grace, he was one of the first six Jesuits who, in 1534, took the vow at Montmartre 'to dedicate their life to the service of God and the Church.' He arrived in Goa in 1542 and evangelized India bell in hand. In 1549 he went as far as Japan and obtained numerous conversions. He died aged forty-six, before entering China, on the little island of Sancian. Pope Urban VIII canonized him in the bull of 6 August 1623.

GAUBIL, Father Antoine (1689–1759)
French Jesuit. Arrived in China in 1722, succeeded Father Parennin and directed the imperial college for Manchus destined for a diplomatic career. His profound knowledge of Chinese enabled him to translate a life of Ghengis Khan (Paris 1739), some annals of the T'ang (in *Mémoires concernant l'histoire des Chinois...*) and the *Shu-king*, and to write an historical and critical treatise on Chinese astronomy. A scientist and a scholar, he was a member of the Royal Society, London, and the Académie des Sciences, Paris. He is considered one of the most remarkable minds among the missionaries in China.

GERBILLON, Father Jean-François (1654–1707)
French Jesuit missionary, arrived in China in 1696. He built the Holy Saviour church (Pei-t'ang) in Peking and directed the Collège

Français. Among his principal works were *Traité de géométrie* (in French and Tartar) and *Observations historiques sur la Grande Tartarie*. He made eight journeys to Tartary and acted as interpreter during the Treaty of Nerchinsk (1689) between K'ang-hsi and the Russians. He was the author of a grammar of the Tartar language.

GHERARDINI, Brother Giovanni (?)
Italian painter born in Modena who worked for the Duc de Nevers. He arrived in China in 1698 with Father Bouvet on the *Amphitrite*. He carried out the decorations on the walls, the ceiling and the cupola of the French Jesuits' church in Peking. Unable to accustom himself to the missionary life, he returned to Europe in 1707.

HALLERSTEIN, Father von (1703–1774)
President of the Tribunal of Mathematics in Peking, where he lived at the Portuguese mission. His letters to this brother were published in 1781 by Father Georges Pray.

HELMAN, Isidore-Stanislas (1743–1806 or 1809)
French engraver, pupil of J.-Ph. Le Bas. In 1785 he carried out a new series of *The Conquests of the Emperor of China* in a smaller format. Two copies are in the Musée Guimet.

HÉRISSON, Comte Maurice, d'Irisson d' (1840–1898)
French officer and publicist, General Cousin-Montauban's ordinance officer during the 1860 war with China. He has left an account in his memoirs of the sack of Yuan-ming-yuan, at which he was present.

HOUCKGEEST, Andrès Everardus van Braam (1739–1801)
In 1759 supercargo of the Dutch India Company at Canton and Macao. Later settled in the United States, but returned to Canton in 1790 as director of the Dutch trading post. He was a member of Macartney's embassy to Peking (1793–94). The story of his voyage was published in Philadelphia and Paris. His collection of engravings, drawings and paintings was sold at Christie's, London, in 1799. Drawings of Yuan-ming-yuan from this collection are today in the Bibliothèque Nationale, Paris (see p. 66 ff).

HUC, Father Régis-Evariste (1813–1860)
French priest at the mission. He arrived in China in 1839 and spent five years in Mongolia. In 1844, accompanied by Father Gabet, he

entered Tibet and dressed as a lama reached Lhasa. Back in Europe, he published his *Souvenirs d'un voyage dans la Tartarie et le Thibet*.

INCARVILLE, Father Pierre Chéron d' (1706–1757)
Born in Rouen and sent to Canada, where he taught at the college of Quebec. On his return to France he requested permission to go to China (1740), where he concerned himself especially with botany. He is the author of an excellent French-Chinese dictionary preserved in the Bibliothèque Nationale, Paris. He sent to France paintings of plants and animals executed in China. He introduced into France the first seeds of the 'China-aster', which he sent to his friend Antoine de Jussieu. He compiled an alphabetical catalogue of the plants of Peking—more than two hundred and sixty in number—which he sent to Moscow. He also wrote about the cultivation of the silk worm. Jussieu's library, sold in 1857, contained a manuscript by Father d'Incarville, *Peintures de plantes, d'animaux, exécutées en Chine*, which is today in the Muséum d'Histoire Naturelle.

KÖGLER, Father Ignatius (1680–1744)
Born in Bavaria, he entered the Jesuit noviciate at sixteen. A Master of Arts, he taught Latin literature, mathematics and Oriental languages at the University of Ingolstadt. He arrived in Peking in 1717 and was appointed president of the Tribunal of Astronomy, a position which he occupied for twenty-three years. In 1731 he was appointed a mandarin of the second order and vice-president of the Tribunal of Rites. On the occasion of his funeral in 1746, Emperor Ch'ien-lung sent two hundred ounces of silver and ten pieces of silk.

MACARTNEY, Lord George (1737–1806)
British diplomat and traveller. He accomplished numerous missions, notably in Russia in 1764. Chief secretary for Ireland from 1768 to 1772; Governor of Madras from 1780 to 1785; and finally special ambassador from George III to China. On arriving in Jehol (1793), where Ch'ien-lung was residing, he refused to perform the traditional kow-tow or prostration. His mission ended in failure on the diplomatic plane, but his travels in China gave rise to interesting accounts; Barrow's *Travels in China* and Staunton's *An Account of an Embassy from the King of Great Britain to the Emperor of China*.

MAIGROT, Father Charles (1652–1730)
Missionary from the Foreign Missions, Paris. He arrived in China in 1681 and became general administrator of the Missions in 1684. In 1696 he was apostolic vicar of Fu-k'ien. On being charged by Pope Innocent XII with examining the question of the Chinese rites, he condemned them. He was imprisoned at the same time as the legate de Tournon. In 1730 he returned to Rome, where he died.

MAILLAC, Father Joseph-Anne-Marie Moyria de (1669–1748)
French Jesuit missionary. Arrived in China in 1703. At the request of K'ang-hsi, he drew the map of China and Tartary that was engraved by d'Anville (1729–1733). He translated into French a summary of the Chinese Great Annals. The work was published in Paris by Abbé Groslier under the title *Histoire générale de la Chine*.

MARIGNY, Abel-François Poisson, Marquis de (1727–1781)
Brother of the Marquise de Pompadour. As director of the Académie Royale de Peinture he actively encouraged historical painting. It was he who entrusted to Cochin, historiographic secretary of the Académie, the task of supervising the execution of Ch'ien-lung's order for *The Conquests of the Emperor of China*.

MEZZABARBA, Giovanni Ambrogio (d. 1729)
Patriarch of Alexandria designated by Pope Clement XI as legate to China on the subject of the Rites Controversy, which was then dividing the Church and its missionaries in Peking. He brought back to Europe the body of Cardinal de Tournon, his predecessor in this mission.

MOGGI, Brother Ferdinando Bonavventura (1684–1761)
Architect born in Florence. In 1720 he set sail from Lisbon for China. He built the St Joseph's church in Peking and was appointed temporal coadjutor in 1727. He spent forty years in Peking, where he died.

MOURA, Father Jean (d. 1726)
Portuguese Jesuit missionary to China, where he converted several members of the princely family of the Su-nu. He was falsely accused of conspiring against Yung-cheng, condemned to death and executed in prison before the arrival of the special ambassador from Portugal, Dom Metello de Souza e Menezez.

NAPOLEON III, Charles-Louis-Napoléon Bonaparte (1803–1873)
Emperor of the French from 1852 to 1870. After the sack of Yuan-ming-yuan an Anglo-French commission presided over by General Jamin decided in the name of the expeditionary force to send to H. M. the Emperor Napoleon: 'two commander's batons about sixteen inches in length, a complete costume of the Emperor of China, a pagoda of gilded and chased bronze of remarkable workmanship, two enormous chimeras of gilded copper weighing more than 800 pounds each, two window blinds of immense length, etc.'. Some of these objects are today in the palace of Fontainebleau.

PANZI, Father Giuseppe (Joseph) (1734–1811)
Jesuit missionary painter in China. He sent to France a portrait of Ch'ien-lung which was engraved by Martinet. This portrait figures as a frontispiece to the *Mémoires concernant l'histoire des Chinois...* (Paris 1776) accompanied by the follow-ing verse:

'Occupé sans relâche à tous les soins divers
D'un gouvernement qu'on admire
Le plus grand potentat qui soit dans l'univers
Est le meilleur lettré qui soit dans son
Empire.'

(Occupied unceasingly with all the various cares / of a government that one admires / the greatest potentat in the universe / is the finest man of letters in his Empire.)

PARENNIN or PARRENIN, Father Dominique (1665–1741)
French Jesuit missionary. Arrived in China in 1698. Gained the confidence of K'ang-hsi and acted as adviser and interpreter to the Russians at the treaty of Kiakota between the Russians and Chinese (1727). He translated a number of European works into Manchu, chiefly books published by the Académie des Sciences. He was director of the college attended by young Manchus destined for a diplomatic career. At his death, Ch'ien-lung sent his own brother and ten members of the Imperial family to the funeral.

PEDRINI, Father (d. 1746)
A Lazarist. Arrived in China in 1711, died in Peking in 1746. A companion of Father Ripa, he was a scientist and a skilled musician. He was tutor to Emperor Yung-cheng while the latter was only a prince. During the persecutions that followed publication of the bull *Ex-Illa dies* in 1716 he was imprisoned, then released. His residence in the western quarter of the Tartar town became the Si-t'ang church.

PEREIRA or PEREYRA, Father Tomás (1645–1708)
Born in Portugal in 1645 of a noble family, the Costa Pereiras. He studied at Braga College.

In 1666 he left for India, where he completed his studies in Goa. He then lived in Macao. He was summoned to Peking in 1673 by Father Verbiest. A musician, he played Chinese tunes on the harpsichord for Emperor K'ang-hsi. He accompanied the Emperor to Tartary and acted as interpreter between the Russians and the Chinese for the purposes of the Treaty of Nerchinsk (1689). On the death of Father Verbiest he temporarily filled his post on the Tribunal of Mathematics. He wrote a *Vie du Père Verbiest*, which is today in the Bibliothèque Nationale, Paris, and, in Chinese, treatises on music in collaboration with Father Pedrini and Chinese *literati*. He was held in high esteem by the Portuguese and was an opponent of Cardinal de Tournon during the Rites Controversy. He died in Peking in 1708.

PINHEIRO, Father Domenico (1688–1748)
Born at Lourès in Portugal, professor at Evora, tutor to the Infante Don Joseph, brother of King John V. Came to China in 1725 as a mathematician member of Dom Metello de Souza e Menezez's embassy to Peking. For fifteen years he was superior of the St Joseph Residence of the Portuguese Jesuits in Peking.

POZZO, Brother Andrea (1642–1709)
A Jesuit painter famous for his decoration of the ceiling and cupola of the church of San Ignazio in Rome.
Author of a treatise entitled *Perspectiva Pictorum et Architectorum*.

RÉGIS, Father Jean-Baptiste (1633–1738)
Born at Istres in Provence, arrived in China in 1698. He was called to Peking on account of his knowledge of mathematics and astronomy. He drew a general map of China, translated the *I-ching*, wrote a treatise on Chinese chronology and a memoir on Korea.

RICCI, Father Laurent de (1703–1775)
General of the Jesuits. After the dissolution of the Society of Jesus by Clement XIV (1773) he was imprisoned in the château de Saint-Ange, where he died after writing a justificatory memorandum.

RICCI, Father Matteo (1552–1610)
Born in Italy at Macerata near Ancona. Entered the Society of Jesus at nineteen and left for Goa in 1578. Set out for China four years later. He lived in the Kuang-tung, learned Chinese and established relations with mandarins influential at Court. After several unsuccessful attempts, he succeeded in making his way to Peking and having himself presented to Emperor Wan-li, to whom he presented clocks

and various *objets d'art* unknown in China. He gained the right to reside in Peking and converted several Chinese, among them Li Teou, who translated into Chinese Euclid and Aristotle and a number of works on mathematics. Ricci wrote several works on the Christian religion in Chinese. His tolerant attitude with regard to the cult of Confucius and the ancestors was at the bottom of the Rites Controversy, which was disastrous for the missions in China. He died in 1610 and was buried in the Shala cemetery in a plot of ground donated by Emperor Wan-li.

RIPA, Father Matteo (1682–1745)
Secular priest and Italian missionary from the Propaganda. Arrived in China in 1711 and worked as a painter at the Court of K'ang-hsi. He also concerned himself with the training of monks in China. On returning to Naples he founded in 1732 a college for Chinese. He left interesting accounts of his travels published in Naples in 1832 and translated into English in 1861 under the title *Memoirs of Father Ripa during thirteen years' residence at the Court of Peking*.

SANZ, Father Pedro (1680–1747)
Spanish Dominican born in 1680 in Catalonia. Arrived in China in 1715 and became apostolic vicar of Fu-kien. He was accused of having baptized children in spite of the edict forbidding religious propaganda in China. He was condemned to death along with four other Dominicans and beheaded on 26 May 1747. Castiglione interceded for him with the Emperor in vain.

SCHALL, Father Adam (1591–1666)
Born in Cologne in 1591, arrived in China in 1622 in the company of Father Trigault. An astronomer, he calculated the eclipses, which won him the Emperor's esteem. In 1630 he worked in Peking. When the Manchus took power he became director of the Office of Astronomy. He suffered persecution at the same time as Verbiest in 1664, but was better treated than the other Jesuits thanks to his title of mandarin. He wrote a manual on the construction of spheres and a treatise on trigonometry; he mapped the stars and drew up a table of the eclipses. He sent to Rome a memoir on the foundations of Chinese chronology.

SICKELPART or SICHELBART, Father Ignatius (1708–1780)
Born at Neudeck in Bohemia, entered the noviciate in 1736. He arrived in China in 1745,

painted with Castiglione and made some drawings for *The Conquests of the Emperor of China*. Seven of his works are mentioned in the *Shih-ch'i pao-chi*. He executed a painting of ten horses in collaboration with Castiglione.

SOUZA E MENEZEZ, Dom Metello de (?)
Portuguese ambassador to China. He reached Peking in 1727 but was unable to intervene in favour of the Jesuits accused of plotting against Yung-cheng.

TAMBURINI, Father Michelangelo (?)
General of the Jesuits. At the assembly held in Rome on 20 November 1711, he submitted to the Sovereign Pontiff's decree condemning the Chinese religious rites.

TARTRE, Father de (1669–1724)
Born at Pont-à-Mousson in Lorraine. He did his noviciate at Nancy and left for China with Father de Fontaney and eight other Jesuits in 1701. He became almoner on board the *Amphitrite*. He went first to Kiangsi, then to Shan-si to evangelize. Being a good mathematician, he was called to Peking. In 1712 he drew a map of China. He is the author of an explanation of the *I-ching*.

THIBAULT, Brother Gilles (1703–1766)
A clockmaker born in Saint-Malo. He came to China with Father Attiret and constructed automata for Ch'ien-lung: tigers, lions, etc.

VENTAVON, Father de (1733–1787)
Arrived in Canton in 1766, left for Peking and immediately began working as a clockmaker and machine constructor. Thereafter he resided in Canton and became a mediocre sinologist. He supported the missionaries of the Propaganda after the dissolution of the Jesuits.

VERBIEST, Father Ferdinand (1623–1688)
Born in Pithem in Belgium. In 1656 he left Genoa for China, but his ship was captured by pirates in the Mediterranean. His ransom having been paid, he reached Macao in 1658 and in response to Emperor Shun-chih's request made his way to Peking. He worked at the Office of Astronomy with Schall and Buglio. He was imprisoned in 1664 and 1665 following accusations made by the mandarins but was afterwards rehabilitated. He gave lessons in mathematics to K'ang-hsi, drew a map of the terrestrial globe and wrote treatises on astronomy and geometry in Manchu, a Manchu grammar, and a treatise on the casting of cannon. His funeral in Peking in 1688 was official and elaborate.

CHINESE NAMES OF THE MISSIONARIES

Amiot, Father Jean-Joseph-Marie
Ts'ien Te-ming 錢德明

Attiret, Father Jean-Denis
Wang Chih-ch'eng 王致誠

Belleville, Brother Charles de
Wei Chia-lu 衛嘉祿

Benoist, Father Michel
a Chiang Yu-jen 蔣友仁
b Te-yi 德翊

Bouvet, Father Joachim
Pai Chin 白晉

Buglio, Father Luigi
Li Lei-ssu 利類思

Chalier, Father
a Sha Ju-yü 沙如玉
b Yung Heng 永衡

Cibot, Father Pierre-Martial
a Han Kuo-ying 韓國英
b Po-tu 伯篤

Damascène, Father Jean
a An T'ai 安泰
b An Che-wang 安者望

Entrecolles, Father d'
Yin Hung-hsü 殷弘緒

Gaubil, Father Antoine
a Sung Chün-jung 宋君榮
b Ch'i-ying 奇英

Gerbillon, Father Jean-François
Chang Ch'eng 張誠

Fiori, Brother Cristoforo
Fei 費

Gherardini, Brother Giovanni
Nien 年

Incarville, Father Pierre Chéron d'
a T'ang Chih-chung 湯執中
b Ching Yi 精一

Kögler, Father Ignatius
a Tai Chin-hsien 戴進賢
b Chia Pin 嘉賓

Maillac, Father Joseph-Anne-Marie Moyria de
a Fung Ping-cheng 馮秉正
b Tuan Yu 端友

Moggi, Brother Ferdinando Bonavventura
a Li Po-ming 利博明
b Min Kung 敏公

Panzi, Father Joseph
P'an T'ing-chang 潘廷璋

Parennin, Father Dominique
Pa To-ming 巴多明

Pedrini, Father
Te Li-ko 德理格

Pereira (or Pereyra), Tomás
a Hsü Jih-sheng 徐日昇
b Yin Kung 寅公

Régis, Father Jean-Baptiste
a Lei Hsiao-ssu 雷孝思
b Yung Wei 永維

Ricci, Father Matteo
Li Ma-tou 利瑪竇

Ripa, Father Matteo
Ma Kuo-hsien 馬國賢

Schall, Father Adam
a T'ang Jo-wang 湯若望
b Tao-wei 道未

Sickelpart (or Sichelbart), Father Ignatius
a Hsing An 醒菴
b Ai Ch'i-meng 艾啟蒙

Tartre, Father de
a T'ang Shang-hsien 湯尚賢
b Pin Chai 賓齋

Thibault, Brother Gilles
a Yang Tzu-hsin 楊自新
b Te Chang 德彰

Verbiest, Father Ferdinand
Nan Huai-jen 南懷仁

BIBLIOGRAPHY OF WESTERN PUBLICATIONS

We particularly recommend to our readers the books written by George Loehr about Castiglione and the important study by Mikinosuke Ishida in the Toyo Bunko (1960).

Adam, M.: *Yuen-ming-yuen, l'œuvre architecturale des Jésuites au XVIIIe siècle.* Imprimerie Lazariste, Peiping 1936.

Amiot, J.: 'Extrait d'une lettre du 1er Mars 1769 de Pékin, contenant l'éloge du Père Attiret' in *Journal des Savants*, June 1971. Chez Lacombe, Paris 1771.

Backhouse, E. und J. O. P. Bland: *Les premiers empereurs mandchous.* Payot, Paris 1934.

Balazs, E.: *La Bureaucratie céleste.* N.R.F. Gallimard, Paris 1968.

Barrow, Sir John: *Voyage en Chine, formant le complément du voyage de Lord Macartney.* F. Buisson, Paris 1805. (No English edition)

Bellevitch Stankevitch, H.: *Le goût chinois en France au temps de Louis XIV.* Jouve, Paris 1910.

Bernard, H.: *L'Eglise catholique des XVIIe et XVIIIe siècles et sa place dans l'évolution de la civilisation chinoise.* Monumenta Sinica, vol. I. Peiping 1935-6.

Bertin, H.: *Dans le sillage de la Chine 1720–1792.* Editions Cathasia des Belles-Lettres, Paris 1970.

Beurdeley, M.: *The Chinese Collector through the Centuries.* Charles E. Tuttle, Tokyo and Rutland, Vermont 1966.

Beurdeley, M.: 'Un extravagant Versailles, version chinoise' in *Connaissance des Arts*, February 1957.

Bouvet, J.: *Recueil de diverses pièces sur la philosophie... Avec II. Lettres où il est traité de la philosophie et de la mission chinoise envoyées à M. Leibniz.* Chrétien Kortholt. A. Vandenhoeck, Hamburg 1734.

Bouvet, J.: *L'état présent de la Chine en figures...* P. Giffard, Paris 1697.

Chambers, W.: *Traité des édifices, meubles et habits, machines, et ustentiles des Chinois.* Chez le Sieur Le Rouge, Paris 1776.

La Chine. Guide book. Nagel, Geneva 1967.

Combaz, G.: *Les Palais impériaux de la Chine.* Vormant et Cie, Brussels 1909.

Commeaux, C.: *De K'ang-hi à K'ien-long. Annales de l'Université de Lyon*, 3e série, *Lettres*, fasc. 29. Société d'Edition Les Belles-Lettres, Lyon 1957.

Contag, V. and Wang Chi-Ch'ien: *Seals of Chinese Painters and Collectors.* University of Hong Kong Press, Hong Kong 1966.

Cordier, H.: *Les Conquêtes de l'Empereur de la Chine. Mémoires concernant l'Asie orientale.* Académie des Inscriptions et Belles-Lettres, Paris 1919.

Cordier, H.: *Bibliographie des ouvrages publiés en Chine par les Européens aux XVIIe et XVIIIe siècles.* Paris 1883.

Cordier, H.: *La Chine en France au XVIIIe siècle.* Jouve, Paris 1910.

Cordier, H.: *Histoire générale de la Chine.* Librairie Paul Geuthner, Paris 1920.

Couling, S.: *The Encyclopaedia Sinica.* Kelly & Walsh, Shanghai 1964.

Cretineau-Joly, J.: *Histoire religieuse, politique et littéraire de la Compagnie de Jésus.* Paul Mellier, Paris 1884.

David, Lady: *Illustrated Catalogue of Ch'ing Enamelled Wares in the Percival David Foundation of Chinese Art.* London 1958.

Dehergne, J.: 'Le Père Gaubil et ses correspondants' in *Bulletin de l'Université de l'Aurore*, série 3, T.v. No. 2, 1944.

Dehergne, J.: *Les Biens de la Maison Française de Pékin en 1776–1778. Monumenta Sinica*, vol. XX, Peiping 1961.

Delatour, L.-F.: *Essai sur l'Architecture des Chinois.* Imprimerie de Clousier, Paris 1803.

Descriptive and Illustrative Catalogue of the Paintings in the National Palace Museum. China Color Printing Co. Inc., Taipei, Taiwan 1968.

Ducarme, P.: *Bulletin catholique de Pékin.* Peking, March 1915.

Encyclopedia Catholica, vol. III. Vatican, Rome 1949.

Etiemble, R.: *Connaissons-nous la Chine?* Gallimard, Paris 1964.

Favier, A.: *Pékin. Histoire et description.* Imprimerie des Lazaristes, Peking 1897.

Ferguson, J. C.: 'Painters among Catholic Missionaries' in *Journal of the North China Branch of the Royal Asiatic Society*, vol. 65. Kelly & Walsh, Shanghai 1934.

Ferguson, J. C.: *History of Chinese Painting.* Chicago University Press, Chicago, Illinois 1927.

Feuillet de Conches, M. F.: 'Les Peintres européens en Chine et les peintres chinois', abstracts from *Revue contemporaine*, series i, vol. 25. Imprimerie Dubuisson, Paris 1856.

Franco, A. S. J.: *Imagen de secundo seculo da Companhia de Jhesu da Provincia de Portugal, em que se contem et que nella ouve e se oubro nos secundos sincoenta annos. Começa do anno 1691 atte o anno 1732. Secunda parte.* Biblioteca Nacional de Lisboa. Fundo geral 750.

Fuchs, W.: *Die Schlachtenbilder aus Turkistan von 1765 als historische Quelle nebst Bemerkungen zu einigen späteren Serien.* Monumenta Sinica, vol. IV, Peiping 1939-40.

Goepper, R. H.: *T'ang Tai.* Staatliches Museum für Völkerkunde, Munich 1956.

Groslier, Abbé: *De la Chine, ou Description générale de cet Empire.* Pillet, Paris 1818.

Gulik, R. H. van: 'Chinese Pictorial Art' in *Serie Orientale* XIX. Rome 1958.

Hedin, S.: *Jehol, City of Emperors.* Trubner & Kegan Paul, London 1932.

Heinecken, C. H. von: *Dictionnaire des Artistes*, vols. 1-4. J. G. Breitkopf, Leipzig 1778-90.

Hérisson, comte Maurice d'Irisson de: *Journal d'un interprète en Chine.* Paul Ollendorf, Paris 1886.

Hobson, R. L.: *The Catalogue of Chinese Pottery and Porcelain in the Collection of Sir Percival David.* London 1934.

Hubrecht, A.: *Grandeur et suprématie de Pékin.* Imprimerie des Lazaristes, Pei-tang.

Huc, R. E.: *Le Christianisme en Chine.* Paris 1853.

Hummel, A. (ed.): *Eminent Chinese of the Ch'ing Period, 1644–1912.* Washington, D.C. 1944.

Illustrated London News, The ('Mecca for the Connoisseur'), June 1968.

Jenyns, R. Soame: *Later Chinese Porcelain.* Faber and Faber, London 1951.

Jourdain, M. and R. Soame Jenyns: *Chinese Export Art in the Eighteenth Century*. Country Life, London and Charles Scribner's Sons, New York 1950.

Kircher, A.: *La Chine...* Translated from Latin by F. S. Dalquié. Jean Jansson, Amsterdam 1670.

Kramer, P. (ed.): *P'u-i, Emperor of China...* an autobiography translated by Kuo Ying Paul Tsai. London 1967.

Le Boisselier, L.: 'Découverte d'une stèle en l'honneur du Frère Castiglione' in *Relation de la Chine*, October. Paris 1916.

Lecomte, H. L.: *Nouveaux Mémoires sur l'état présent de la Chine*. J. Anisson, Paris 1697–8.

Leibniz, G. W. von: *Novissima sinica historiam nostri temporis illustrata*. Edente G.G.L(eibnitio) 2 editio (S.L.) 1699.

Lettres édifiantes et curieuses écrites des missions étrangères. Mémoires de la Chine. Nouvelle édition. Noël-Etienne Sens et Auguste Gaude, Toulouse 1810.

Lippe, Prince of: 'A Christian Chinese Painter' in *Bulletin of the Metropolitan Museum of Art*, New York 1952.

Loehr, G.: *Giuseppe Castiglione, 1688–1766, pittore di corte di Ch'ien-lung, Imperatore della Cina*. Istituto italiano per il Medio ed Estremo Oriente, Rome 1940.

Loehr, G.: 'Missionary Artists at the Manchu Court' in *Transactions of the Oriental Ceramic Society*, vol. 34. 1962–3. London.

Loehr, G.: 'A. E. van Braam Houckgeest, the First American at the Court of China' in *The Princeton University Library Chronicle*, vol. XV, No. 4, Summer 1954.

Maillac J.-A.-M. Moyria de (trad.): *Histoire générale de la Chine, ou annales de cet empire*. Paris 1777–85.

Mallone, C. B.: *History of the Peking Summer Palace under the Chi'ng Dynasty. Illinois Studies in the Social Sciences*, vol. XIX. Urbana University, Illinois 1943.

March, B.: 'Linear Perspective in Chinese Painting' in *Eastern Art*, vol. III. Philadelphia, Pa. 1931.

Mémoires concernant l'histoire, les sciences, les arts, les mœurs, les usages... des Chinois, par les missionnaires de Pékin. Nyon aîné, Paris 1776–91.

Mikinosuke Ishida: 'A Biographical Study of Giuseppe Castiglione' in *The Memoirs of the Toyo Bunko*, No. 19, 1960.

Otsuka Kogusha: *The Pageant of Chinese Painting*. Tokyo 1928.

Parennin, D.: *Lettre du R.P. Parennin contenant diverses questions sur la Chine*. Imprimerie Royale, Paris 1770.

Pelliot, P.: 'Les Conquêtes de l'Empereur de la Chine' in *T'oung Pao*, vol. XX. Leyden 1921.

Pelliot, P.: *Les influences européennes sur l'art chinois*. A speech at the Musée Guimet in 1927. Imprimerie Nationale, Paris 1928.

Petrucci, R.: *Chinese Painters...* Translated by Frances Seaver. London and Norwood, Mass. 1922.

Petrucci, R.: *La Philosophie de la nature dans l'art d'Extrême-Orient*. H. Laurens, Paris 1911.

Peyronnet, J.: *Un correspondant de Bernard de Jussieu en Chine, Le Père Chéron d'Incarville. Cathasia, série culturelle des Hautes Etudes de Tien-tsin*. Tien-tsin 1949.

Pfister, L.: *Notices biographiques et bibliographiques sur les Jésuites de l'ancienne mission de la Chine. 1552–1773. Variétés sinologiques, Nos 59 et 60*. Shanghai 1932.

Pirazzoli-t'Serstevens, M.: *Gravures des conquêtes de l'Empereur de Chine K'ien-long, au Musée Guimet*. Musée Guimet, Paris 1969.

Pray, P. G.: *Imposturae CCXVIII in dissertatione R. P. Benedicti Cetto*. Budae 1781.

Ratti, C. G.: *Istruzione di quanto può vedersi di piu bello in Genova in pittura, scultura ed architettura. Genova dalle stampe di P. e A. Scronico*. Genoa 1756.

Reichwein, A.: *China and Europe...* Translated by J. C. Powell. Routledge Kegan Paul, London 1925, 1968.

Ripa, M.: *Storia della Fondazione della Congregazione e del Collegio de' Cinesi sotto il titolo della Sagra Famiglia di G.C. scritta dallo stesso fondatore M. Ripa, e de' viaggi da lui fatti*. Naples 1832.

Ripa, M.: *Memoirs of Father Ripa during thirteen years' residence at the Court of Peking*. Selected and translated from the Italian by Fortunato Prandi. John Murray, London 1844.

Rochemonteix, C. de: *Joseph Amiot et les derniers survivants de la Mission française à Pékin, 1750–1795*. Picard et Fils, Paris 1915.

Rodrigues, F. S.J.: *Historia da Companhia de Jhesu da assistencia de Portugal*. Libreria Apostolado da Imprensa, Porto 1950.

Roi, J.: 'Visite en 1764 de deux Chinois à la Manufacture Royale de Sèvres' in *Cahiers de la Céramique*, No. 33, Paris 1964.

Rowbotham, A.H.: *Missionary and Mandarin. The Jesuits at the Court of China*. The University of California Press, Berkeley, California 1942.

Rychmans, P.: 'Les propos sur la peinture de Shi Tao' in *Arts asiatiques*, vol. XIV, Annales des Musées Guimet et Cernuschi, Paris 1966.

Sayer, G.R.: *T'ao Ya or Pottery refinements*. Routledge Kegan Paul, London 1959.

Sayers, G.R. (trans.): *Ching-te-chen T'ao-lu* (The Potteries of China). Routledge Kegan Paul, London 1951.

Sirén, O.: *Les Palais Impériaux de Pékin*. G. Van Oest, Brussels 1925.

Sirén, O.: *Histoire de la peinture chinoise*. Les Editions d'Art et d'Histoire, Paris 1954.

Sirén, O.: *Chinese Painting*. 7 vols. Lund Humphries, London 1956.

Soares, E.: *Inventario da coleccao de registos de Santos*. Bibliotheca Nacional, Lisbon 1955.

Speiser, W.: *China: spirit and society*. Translated by George Lawrence. (Art of the World series, IV) Methuen, London 1960.

Speiser, W., R. Goepper and J. Fribourg: *Chinese Art*, vol. 3. Oldbourne Press, London and Universe Books, New York 1964.

Sullivan, M.: 'The Night Market at Yang-ch'eng in *Apollo*, November 1968.

Thomas, A.: *Histoire de la Mission de Pékin*. Louis Michaud, Paris 1923.

Ting Tchao-Ts'ing: *La description de la Chine par les Français, 1660–1750*. Librairie Paul Geuthner, Paris 1928.

Waley, A.: *An Index of Chinese Artists represented in the Sub-Department of Oriental Prints and Drawings in the British Museum*. London 1922.

Willetts, W.: *Foundations of Chinese Art*. Thames & Hudson, London 1965.

CHINESE AND JAPANESE BIBLIOGRAPHY

Chung-kuo huei-hua-shih
Commercial Press
Tai-pei 1960
中国绘画史 (商务)

Chung-kuo mei-shu-shih (Ch'en Pin-he)
Commercial Press
Shanghai 1930
中国美术史 (陳彬龢)

Chung-kuo mei-shu shih-kang (Li Yü)
Peking 1957
中国美术史綱 (李浴)

Chung-kuo ming-hua
(40 vols)
Shanghai 1904-1925
中国名画

Mei-shu ts'ung-shu (vol. 9)
Hsiao-shan hua-p'u (Tsou I-kuei)
Shanghai 1947, 4th edition
美术丛书
小山画谱 (鄒一桂)

Hua-chan-shih yen-tz'u (Lo Kuang)
Chung-yang jih-pao
16 May 1969
画展時演辞 (罗光)

Mei-shu ts'ung-shu (vol. 3)
Huei-shih fa-wei
(T'ang Tai)
Shanghai 1947, 4th edition
美术丛书
繪事發微 (唐岱)

Min shin no kai ga
Benlitō Tokyo Keigioshio
Tokyo 1962
明清の絵画

Ku-kung yi-yi shu-mu chiao-chu
(Ch'en Jen-t'ao)
Tung-ying Company
Hongkong 1936
(陳仁涛著)
故宫已佚书目校註

Ku-kung shu-hua-chi
(45 vols, 1930-1934)
Imperial Palace Museum
Peking 1930-1934
故宫书画集

Ku-kung shu-hua-lu
Taipei 1956
故宫书画录

Kuo-ch'ao yüan-hua lu (Hu Ching)
Peking 1816
国朝院画录 (胡敬)

Kokka (Japanese review)
Tokyo 1912
国華

Lang Shih-ning hua-chi
Imperial Palace Museum
Peking 1931
郎世宁画集

Lang Shih-ning hsiu-shih nien-p'u
(Liu Nai-yi)
Tientsin 1944
郎世宁修士年谱 (刘迺义)

Li-tai chu-lu hua-mu
Compiled by J. Ferguson
Centre for the Study of Chinese Civilization,
Ging-ling University
Nanking 1934
歷代著錄畫目

Ming-ch'ing shih (Li Hsün)
Peking 1957
明清史 (李洵)

Sheng-ching ku-kung chih hua-lu
Peking 1925
盛京故宫之画录

Shih-ch'ü pao-chi
Commercial Press
Shanghai 1918
石渠宝笈

Shih-ch'ü pao-chi san-pien
Edited by Lo Chen-yü
石渠宝笈三編

So gen min shin meiga daikan
Sung Yuan Ming Ch'ing min-hua ta-kuan
Otsuka Kogei-sha
Tokyo 1931
宋元明清名画大观

To so gen min meiga daikan
Otsuka Kogei-sha
Tokyo 1928
唐宋元明名画大观

Shina meiga ho kan
The Pageant of Chinese Painting
Otsuka Kogei-sha
Tokyo 1936
支那名画宝鑒

Index of Names

This index has been compiled from the main text only. All information concerning Castiglione's works, and museums and collections is to be found in the Catalogue (pp. 161-191); information on personalities, authors, publications, etc. is to be found in the appendix (pp. 192-201) which contains sections as follows: Biographical Notes, Chinese Names of Missionaries, Bibliography of Western Publications, Chinese and Japanese Bibliography.

Aliamet, Jacques 84
Amiot, Father Jean-Joseph-Marie 23, 28, 79, 94, 98
Amphitrite 18, 21, 28
Amursana 52, 71
An Ch'i 145
Andrade, Fernão Perez de 12
Araïlza, Michael 28
Attiret, Father Jean-Denis 23, 45, 47, 48, 50, 52, 79, 87, 98, 99, 101, 106, 128, 130

Belleville, Brother Charles de 28
Benoist, Father Michel 5, 45, 68, 74, 86, 102
Bertin, Henri-Léonard 84, 86, 145
Bourgeois, Father 74, 75
Bouvet, Father Joachim 28
Boxer Rising 87
Buglio, Father Luigi 138

Canton 12, 19, 21, 22, 23, 75, 79, 86, 147
Castiglione, Brother Giuseppe (*chin.* Lang Shih-ning, *portug.* Lamxinim); and the Chinese Painters of his Day 141-148; and the Conquests of the Emperor of China 79-88; and Religious Painting 91-94; Architect 65-75; Correspondence 152-155; Genre Painter 107-116; Life of 11-61; Painter of Animals 119-123; Painter of Flowers 126-131; Painter of Landscapes 132-138; Portrait Painter 97-106; Seen by Chinese Critics 151-152; works 161-191 (Catalogue)
Centurione, Father Luigi 152, 153, 155
Chalier, Father 39, 45
Chang Chao 143, 144, 146
Chang Jui 141
Chanseaume, Father Jean-Gaspard 42

Chao Ch'ang 128
Chao Meng-fu 151
Chao Shen-chen 93
Ch'eng Chih-tao 108
Ch'eng Liang 108
Ch'en Yung-chieh 112
Chia-ch'ing, Emperor 7, 33
Chiao Ping-cheng 138, 146
Ch'ien Ch'en-ch'un 143, 145
Ch'ien-lung, Emperor (Hung-li) 6, 7, 39-44, 45, 47, 48, 56, 59, 60, 65, 67, 68-75, 79-88, 97, 99, 106, 108, 113, 119, 130, 131, 138, 141, 144, 146, 147
Ch'ien Shu 145
Ch'ien Tsai 143, 145, 147
Ching-te-chen 46, 142
Chin K'un 108, 112
Choffard, Pierre-Philippe 84
Cibot, Father Pierre-Martial 39
Clement XI, Pope 21
Clement XIV, Pope 61
Cochin, Charles-Nicolas 84, 86, 88
Costa, Father G. 12, 22, 25, 26, 153
Cousin-Montauban, General Charles (Comte de Palikao) 74

Damascène, Father Jean 79, 86
Duarte, Father Gio 155
Ducarme, Father 11, 60

Elgin, Lord James Bruce (later Earl of) 74

Feng Ning 88
Fiori, Brother Cristoforo 28
Francis Xavier, Saint 18

Gaubil, Father Antoine 6, 138
Gerbillon, Father Jean-François 33
Gherardini, Brother Giovanni 28, 33, 147
Giampriano, Father Niccolò 152
Gravereau, Father Jean-Baptiste 29

Hai-tien 52, 68
Hallerstein, Father von 48
Han Kan 119, 151
Han-lin Academy 141, 143, 144, 145, 146
Helman, Isidore-Stanislas 87, 88
Hsiang Fei (Model Beauty) 71, 73, 100
Hsü Hsi 128
Huang Kung-wang 141
Huc, Father Régis-Evariste 93
Hung-li, *see* Ch'ien-lung

Ignatius (Loyola), Saint 11, 61, 91, 92
Incarville, Father Pierre Chéron d' 130
Innocent III, Pope 153

Jehol 7, 46, 52, 107, 141
Jen Jen-fa 119
Ju-i kuan 45

K'ang-hsi, Emperor 5, 6, 19, 21, 22, 25, 26, 28, 29, 31, 32, 33, 36, 46, 47, 59, 65, 97, 138, 141, 146
Kao Shih-ch'i 97
Kögler, Father Ignatius 36, 37, 39, 152, 155
Ku K'ai-chih 97
Kuo Hsi 135
Kuo Jo-hsü 128

Lamalle, Father 152
Lamxinim, *see* Castiglione

Lang Shih-ning, *see* Castiglione
Lang T'ing-chi 47
Launay, N. de 84
Le Bas, Jean-Philippe 84, 86, 87, 88
Le Febvre, Father 79
Leng Mei 138, 146
Liang Shih-cheng 143, 144
Li Hui-lin 108
Li Kung-lin 114, 119, 147, 151
Liu Erh, Father 39
Loyola, Saint Ignatius, *see* Ignatius, Saint

Macao 12, 19, 21, 22, 29, 152
Macartney, Lord George (later Earl) 6
Ma Fen 119
Maillac, Father Joseph-Anne-Marie Moyria de 37
Marigny, Abel-François Poisson, Marquis de 82, 86
Masquelier, Louis-Joseph 84
Mezzabarba, Giovanni Ambrogio 29
Mi Fei 126
Moggi, Brother Ferdinando Bonavventura 33, 68, 153, 154
Moura, Father João 32
Mukden 7, 144

Nanking 7
Née, Denis 84
Nien Hsi-yao 37, 47, 136, 141, 142
Notre-Dame-de-l'Espérance 12

P'an T'ung-wen 81
Panzi, Father Joseph 61, 145
Parennin (Parrenin), Father Dominique 5, 37, 39, 94, 142, 152
Pa-ta Shan-jen 128, 131, 141

Pedrini, Father 32, 152
Peking 6, 7, 19, 21, 22, 23, 25, 28, 29, 31, 32, 33, 36, 40, 45, 48, 52, 56, 59, 60, 65, 68, 79, 86, 93, 94, 97, 127, 135, 141, 142, 146, 152, 153, 154, 155; Nan-t'ang (Southern Church) 33, 36, 56, 60, 93, 138; Pei-t'ang (Northern Church) 28, 33, 36, 60, 138; Tung-t'ang (St Joseph's Church) 25, 33, 68
Pereira (Pereyra), Father Tomás 26, 152, 155
Perroni, Father 45
Pinheiro, Father Domenico 39, 155
Pozzo, Brother Andrea 37, 91, 92, 136
Prévôt, B. L. 84
Pu Yi (Hsüan-tung), Emperor 7

Retz, Father François de 152, 153, 155
Ricci, Father Laurent de 61, 147, 153
Ricci, Father Matteo 22, 26, 36
Ripa, Father Matteo 25, 26, 28, 29
Rites Controversy, *see* Society of Jesus

Saint-Aubin, Augustin de 84, 86
Sanz, Father Pedro 40, 42
Schall, Father Adam 19, 25, 33, 36
Shen Te-ch'ien 143, 145
Shen Yüan 138, 146
Shih-ch'i 141
Shih-t'ao 138, 141
Shun-chih, Emperor 19, 26
Sickelpart (Sichelbart), Father Ignatius 48, 52, 56, 68, 79
Sigismond, Brother 45
Society of Jesus 11, 91, 155; Dissolution of 6, 61, 153; Rites Controversy 21, 26
Souza e Menezez, Dom Metello de 32
Stadlin, Father 153

Tamburini, Father Michele 21, 152, 153, 154
T'ang Tai 132, 138, 146
T'ang Yin 142
Tartre, Father de 17
Thibault, Brother Gilles 45, 70
Tientsin 7
Ting Kuan-ho 108
Ting Kuan-p'eng 108, 112
Tomacelli, Brother 46
Tournon, Cardinal de 21, 29
Tsou I-kuei 147
Tung Ch'i-ch'ang 141
Turcotti, Father 22

Ventavon, Father de 100
Verbiest, Father Ferdinand 19
Visconti, Father Ignazio 153

Wang Chien 141
Wang Hui 141
Wang Shih-min 141
Wang Yuan-ch'i 141, 146
Wanyen Liang, Emperor 65
Wu Li 6, 141, 147

Yang-chow 131, 141
Yang Hsiao-ku 46
Yin-chen, *see* Yung-cheng
Yuan-ming-yuan 7, 45, 48, 56, 65-75, 114, 132, 141, 146
Yu Min-chung 143, 144
Yün Shou-p'ing 141
Yung-cheng, Emperor (Yin-chen) 6, 32, 36, 37, 39, 47, 65, 97, 119

This book was printed in June 1972 in the workshops of Imprimeries Réunies S.A., Lausanne. The binding is by Mayer & Soutter, Renens-Lausanne. Design by André Rosselet.

Index of Names

This index has been compiled from the main text only. All information concerning Castiglione's works, and museums and collections is to be found in the Catalogue (pp. 161-191); information on personalities, authors, publications, etc. is to be found in the appendix (pp. 192-201) which contains sections as follows: Biographical Notes, Chinese Names of Missionaries, Bibliography of Western Publications, Chinese and Japanese Bibliography.

Aliamet, Jacques 84
Amiot, Father Jean-Joseph-Marie 23, 28, 79, 94, 98
Amphitrite 18, 21, 28
Amursana 52, 71
An Ch'i 145
Andrade, Fernão Perez de 12
Araïlza, Michael 28
Attiret, Father Jean-Denis 23, 45, 47, 48, 50, 52, 79, 87, 98, 99, 101, 106, 128, 130

Belleville, Brother Charles de 28
Benoist, Father Michel 5, 45, 68, 74, 86, 102
Bertin, Henri-Léonard 84, 86, 145
Bourgeois, Father 74, 75
Bouvet, Father Joachim 28
Boxer Rising 87
Buglio, Father Luigi 138

Canton 12, 19, 21, 22, 23, 75, 79, 86, 147
Castiglione, Brother Giuseppe (*chin.* Lang Shih-ning, *portug.* Lamxinim); and the Chinese Painters of his Day 141-148; and the Conquests of the Emperor of China 79-88; and Religious Painting 91-94; Architect 65-75; Correspondence 152-155; Genre Painter 107-116; Life of 11-61; Painter of Animals 119-123; Painter of Flowers 126-131; Painter of Landscapes 132-138; Portrait Painter 97-106; Seen by Chinese Critics 151-152; works 161-191 (Catalogue)
Centurione, Father Luigi 152, 153, 155
Chalier, Father 39, 45
Chang Chao 143, 144, 146
Chang Jui 141
Chanseaume, Father Jean-Gaspard 42

Chao Ch'ang 128
Chao Meng-fu 151
Chao Shen-chen 93
Ch'eng Chih-tao 108
Ch'eng Liang 108
Ch'en Yung-chieh 112
Chia-ch'ing, Emperor 7, 33
Chiao Ping-cheng 138, 146
Ch'ien Ch'en-ch'un 143, 145
Ch'ien-lung, Emperor (Hung-li) 6, 7, 39-44, 45, 47, 48, 56, 59, 60, 65, 67, 68-75, 79-88, 97, 99, 106, 108, 113, 119, 130, 131, 138, 141, 144, 146, 147
Ch'ien Shu 145
Ch'ien Tsai 143, 145, 147
Ching-te-chen 46, 142
Chin K'un 108, 112
Choffard, Pierre Philippe 84
Cibot, Father Pierre-Martial 39
Clement XI, Pope 21
Clement XIV, Pope 61
Cochin, Charles-Nicolas 84, 86, 88
Costa, Father G. 12, 22, 25, 26, 153
Cousin-Montauban, General Charles (Comte de Palikao) 74

Damascène, Father Jean 79, 86
Duarte, Father Gio 155
Ducarme, Father 11, 60

Elgin, Lord James Bruce (later Earl of) 74

Feng Ning 88
Fiori, Brother Cristoforo 28
Francis Xavier, Saint 18

Gaubil, Father Antoine 6, 138
Gerbillon, Father Jean-François 33
Gherardini, Brother Giovanni 28, 33, 147
Giampriano, Father Niccolò 152
Gravereau, Father Jean-Baptiste 29

Hai-tien 52, 68
Hallerstein, Father von 48
Han Kan 119, 151
Han-lin Academy 141, 143, 144, 145, 146
Helman, Isidore-Stanislas 87, 88
Hsiang Fei (Model Beauty) 71, 73, 100
Hsü Hsi 128
Huang Kung-wang 141
Huc, Father Régis-Evariste 93
Hung-li, *see* Ch'ien-lung

Ignatius (Loyola), Saint 11, 61, 91, 92
Incarville, Father Pierre Chéron d' 130
Innocent III, Pope 153

Jehol 7, 46, 52, 107, 141
Jen Jen-fa 119
Ju-i kuan 45

K'ang-hsi, Emperor 5, 6, 19, 21, 22, 25, 26, 28, 29, 31, 32, 33, 36, 46, 47, 59, 65, 97, 138, 141, 146
Kao Shih-ch'i 97
Kögler, Father Ignatius 36, 37, 39, 152, 155
Ku K'ai-chih 97
Kuo Hsi 135
Kuo Jo-hsü 128

Lamalle, Father 152
Lamxinim, *see* Castiglione

Lang Shih-ning, *see* Castiglione
Lang T'ing-chi 47
Launay, N. de 84
Le Bas, Jean-Philippe 84, 86, 87, 88
Le Febvre, Father 79
Leng Mei 138, 146
Liang Shih-cheng 143, 144
Li Hui-lin 108
Li Kung-lin 114, 119, 147, 151
Liu Erh, Father 39
Loyola, Saint Ignatius, *see* Ignatius, Saint

Macao 12, 19, 21, 22, 29, 152
Macartney, Lord George (later Earl) 6
Ma Fen 119
Maillac, Father Joseph-Anne-Marie Moyria de 37
Marigny, Abel-François Poisson, Marquis de 82, 86
Masquelier, Louis-Joseph 84
Mezzabarba, Giovanni Ambrogio 29
Mi Fei 126
Moggi, Brother Ferdinando Bonavventura 33, 68, 153, 154
Moura, Father João 32
Mukden 7, 144

Nanking 7
Née, Denis 84
Nien Hsi-yao 37, 47, 136, 141, 142
Notre-Dame-de-l'Espérance 12

P'an T'ung-wen 81
Panzi, Father Joseph 61, 145
Parennin (Parrenin), Father Dominique 5, 37, 39, 94, 142, 152
Pa-ta Shan-jen 128, 131, 141

Pedrini, Father 32, 152
Peking 6, 7, 19, 21, 22, 23, 25, 28, 29, 31, 32, 33, 36, 40, 45, 48, 52, 56, 59, 60, 65, 68, 79, 86, 93, 94, 97, 127, 135, 141, 142, 146, 152, 153, 154, 155; Nan-t'ang (Southern Church) 33, 36, 56, 60, 93, 138; Pei-t'ang (Northern Church) 28, 33, 36, 60, 138; Tung-t'ang (St Joseph's Church) 25, 33, 68
Pereira (Pereyra), Father Tomás 26, 152, 155
Perroni, Father 45
Pinheiro, Father Domenico 39, 155
Pozzo, Brother Andrea 37, 91, 92, 136
Prévôt, B. L. 84
Pu Yi (Hsüan-tung), Emperor 7

Retz, Father François de 152, 153, 155
Ricci, Father Laurent de 61, 147, 153
Ricci, Father Matteo 22, 26, 36
Ripa, Father Matteo 25, 26, 28, 29
Rites Controversy, *see* Society of Jesus

Saint-Aubin, Augustin de 84, 86
Sanz, Father Pedro 40, 42
Schall, Father Adam 19, 25, 33, 36
Shen Te-ch'ien 143, 145
Shen Yüan 138, 146
Shih-ch'i 141
Shih-t'ao 138, 141
Shun-chih, Emperor 19, 26
Sickelpart (Sichelbart), Father Ignatius 48, 52, 56, 68, 79
Sigismond, Brother 45
Society of Jesus 11, 91, 155; Dissolution of 6, 61, 153; Rites Controversy 21, 26
Souza e Menezez, Dom Metello de 32
Stadlin, Father 153

Tamburini, Father Michele 21, 152, 153, 154
T'ang Tai 132, 138, 146
T'ang Yin 142
Tartre, Father de 17
Thibault, Brother Gilles 45, 70
Tientsin 7
Ting Kuan-ho 108
Ting Kuan-p'eng 108, 112
Tomacelli, Brother 46
Tournon, Cardinal de 21, 29
Tsou I-kuei 147
Tung Ch'i-ch'ang 141
Turcotti, Father 22

Ventavon, Father de 100
Verbiest, Father Ferdinand 19
Visconti, Father Ignazio 153

Wang Chien 141
Wang Hui 141
Wang Shih-min 141
Wang Yuan-ch'i 141, 146
Wanyen Liang, Emperor 65
Wu Li 6, 141, 147

Yang-chow 131, 141
Yang Hsiao-ku 46
Yin-chen, *see* Yung-cheng
Yuan-ming-yuan 7, 45, 48, 56, 65-75, 114, 132, 141, 146
Yu Min-chung 143, 144
Yün Shou-p'ing 141
Yung-cheng, Emperor (Yin-chen) 6, 32, 36, 37, 39, 47, 65, 97, 119

This book was printed in June 1972 in the workshops of Imprimeries Réunies S.A., Lausanne. The binding is by Mayer & Soutter, Renens-Lausanne. Design by André Rosselet.